Conversations

Conversations on Violence

An Anthology

Brad Evans and Adrian Parr

PLUTO PRESS

First published 2021 by Pluto Press
345 Archway Road, London N6 5AA

www.plutobooks.com

British Library Cataloguing in Publication Data
A catalogue record for this book is available from the British Library

ISBN 978 0 7453 4167 5 Hardback
ISBN 978 0 7453 4168 2 Paperback
ISBN 978 1 7868 0735 9 PDF eBook
ISBN 978 1 7868 0737 3 Kindle eBook
ISBN 978 1 7868 0736 6 EPUB eBook

Typeset by Stanford DTP Services, Northampton, England

Simultaneously printed in the United Kingdom and United States of America

Contents

Introduction

Brad Evans and Adrian Parr

The discussions in this anthology are part of an ongoing public conversation, which aims to question, rethink, and critique violence in all its varied forms. We are not content to simply reduce violence to questions of physical harm; neither do we believe that violence is something that can be neatly solved through some scientific explanation, as if its "root causes" could be identified and acted upon through righteous intervention. Often it seems we can only barely grasp the true lived effects of violence, hoping that we can still rescue something of the human out of its worst experiences. This is why we insist that conversations need to take place across all sectors of society, especially in terms of bringing together those who bring critical force to bear upon violence, along with those artists and creative producers who understand that any critique of violence must take seriously human emotions and our capacity to imagine better worlds. We are certainly not idealists, though we do cling to the idea that the world can be better than the one we currently live in—where all forms of prejudice have seemingly been liberated, where new forms of fascism are on the rise, where everyday forms of humiliation are paraded as entertainment, and where the persecution of others can be enacted on a whim for those continually seduced by the entrapments of power. This anthology then, we believe, takes us directly to the heart of what it means to be human in the twenty-first century. For whilst violence may appear timeless, demanding an appreciation of the histories of its occurrence, it also needs to be accounted for in terms of its contemporary logics, its effects, and its intellectual justifications.

Critics may counter and suggest this endeavor stretches the concept of violence too far. And that, as a result, the concept itself loses all meaning and definitive purpose. What does it mean to say violence is psychological as much as it is physical? Just tell the petrified child who awaits his abusive father every night that violence should only be "labelled" once the body feels physical pain. Or tell the addict—who

feels alone in this world, their emaciated body suspended as it clings to life—that they are not feeling the violence of a society that finds it easier to marginalize and criminalize those in need. But these examples also raise distinct problems. Too often we see how the focus on emotions can lead to oppressive interventionist practices in the name of therapeutic governance. Moreover, there is an evident danger to the promotion of ontological vulnerability, wherein all claims of victimhood are collapsed and new hierarchies of suffering—which are often far removed from the actual experience of violence—are imposed. And we only need look at the internet today to see how easily the hyperarousal of victimization easily slips into the public shaming and verbal abuse of others. Thus, as part of introducing a critique of violence in its many different forms, our response certainly isn't to advocate a new tyranny, whether of a digital or emotional kind. It is rather to take far more seriously the art of the political as an open field of dignified possibility.

As such, readers will find in this volume that we give equal importance to the voices of artists, cultural producers, and literary writers. Yet even this comes with its challenges. Is this not just a cultural pastime, we can already hear the sceptics ask? No work of art, they may argue, has ever stopped a bullet. Well, comes the riposte, only on the rarest of occasions has a bullet has ever stopped a bullet (except in death). And might we not ask how many would remember the bombardment of Guernica today were it not for Picasso's intervention? This, however, still involves thinking about art and aesthetics as modes of representation. By contrast, our understanding of art is affirmative, creative, and transgressive; in short, it exhibits precisely those characteristics that stand in direct opposition to the violence of negation, destruction, and suppression.

Originally published as part of the "Histories of Violence" series in the *Los Angeles Review of Books*, these dialogues are ultimately a provocation to think. If Hannah Arendt was correct in her insistence that violence triumphs when thinking is denied, our task must be to remain open to the idea that thinking matters and confronting the intolerability of violence using multiple grammars is at least an important start. It is also important to note that the publication of this volume was delayed due to the global lockdown following the Coronavirus pandemic. This planetary event has already proven itself

crucially relevant to our concerns in many evident and urgent ways. Indeed, the virus itself has revealed more fully the structural violence of our societies—that this violence was compounded by the killing of George Floyd and the subsequent protests this provoked, serves as a timely reminder of the struggles we must contend with on a daily basis. Added to this, a worrying trend has emerged on the left that openly calls for a position where engaging in debate with the opposition should no longer be tolerated. Violence is intolerable. For that reason, it needs to be confronted. This requires dealing with difficult and challenging thoughts and ideas. If history shows us anything, it is that oppressive thoughts cannot be banned or bombed out of existence. Instead, we must rise to the intellectual challenges they present. To echo the beautiful and timeless words of the El Salvadorian poet Roque Dalton:

> I believe the world is beautiful
> and that poetry, like bread, is for everyone.
> And that my veins don't end in me
> but in the unanimous blood
> of those who struggle for life,
> love,
> little things,
> landscape and bread,
> the poetry of everyone.

(Roque Dalton, *Like You*)

1

The Poetry of Resistance

Adrian Parr interviews Malcolm London,
January 2017

Malcolm London is an internationally recognized Chicago poet, activist, educator, and musician who has been called "the Gil Scott-Heron of this generation" by Cornel West. This conversation deals with the politics of poetry, performativity, the meaning of education, life growing up in conditions of poverty in the West side of Chicago, along with the importance of the art of the spoken word in challenging narratives of violence.

ADRIAN PARR: The content of your spoken-word performances mixes intense personal experiences with social critique and commentary. Can you describe what motivates your writing and performance?

MALCOLM LONDON: The motivation is very simple, and it really has to do with how I began as a young poet, which is in the vein of art poet Gwendolyn Brooks, who is also from Chicago. She says that *our duty as poets is only to tell the story of what is right in front of our nose.* I learned that early on by simply being in programs like Louder Than A Bomb, which is a youth poetry slam in Chicago and elsewhere. It simply began by understanding I am an expert on my own experience. It then becomes relatively easy to talk about social and political issues when you are born into the city that is the most segregated city in the nation and on the West Side of Chicago.

Initially, it may not have been my intention as a 16-year-old to write about social justice issues, but I wrote about what I saw. What I saw was my brothers, my cousins, and my friends in trouble and arrested. What I saw was corpses of neighbors and people that I loved piling up

around me. What I saw was that my educational experience was a lot different than other folks in the city. What I saw was a mother who would work extremely hard for a hard life, and who could barely keep two young boys, and a roof over our heads.

I think the pedagogy and philosophy around spoken-word poetry is to provide spaces and platforms for young people who are deliberately unheard, to begin to tell their story. As a learner and now as an educator of spoken word, you listen to the stories of so many young people and you begin to realize how many of these stories overlap. Through their stories you understand the many issues that touch their lives. You begin to hear how capitalism affects young people—whether or not they know how to spell that word, they inherently understand it. You begin to hear about the wage gap. You begin to hear about achievement gaps. You begin to hear all these things, but with poetic license, and in a way that hopefully reimagines the situation that a lot of people talk about and the situations that they come from.

You mention that your educational experiences are different. Could you expand upon that a little more?

I often say that I got my education on the Number 66 Chicago Avenue bus. I say this because in a city like Chicago, which I imagine is like a lot of American cities, you see segregation firsthand. What I learned was definitely not in a textbook, but I definitely learned it on the journey home each day. That education came from seeing how one side of the city experiences police repression, and another side of the city experiences tall buildings and cleaner neighborhoods. On one side of the city, homicide rates soar, and on the other side, people get to go to bed safe.

It's not that I want anybody from the other side of the city, or from the more affluent neighborhoods, to have less, but it occurred to me that in my neighborhood, folks didn't have enough. So when young people like myself begin to tell that story, they begin to see there are gaps in the story, there are missing pages from the books you are reading and learning from. So it becomes necessary to rewrite those pages and rewrite that history of segregation and inequality.

When you describe yourself as an educator are you referring to this rewriting of history and retelling stories by telling your own story?

When I use the term "educator," I mean someone who is both a happy and determined learner. I think that anybody who is actively learning can also be an educator. For me, an educator inspires other young people to learn about themselves and other things.

How does spoken-word poetry test the limits of language and do you see this as being a political act in itself?

Cornel West once told me: "Poets are the legislation of the people." That sums up perfectly what poetry is for me. For me, spoken word pushes the limits. It allows young people of color to define themselves on their own terms by how they use language. In a country that is not made for young people of color, but a country that has been made on their backs, spoken word allows young people of color to appropriate and change language in ways that make it their own. This is what makes spoken word a political act. Especially now, at this moment in American history, with Donald Trump, this is an increasingly dangerous time for young Black, Latino, and Muslim people.

By using a language that has excluded me and has been used to discourage me, I simultaneously reclaim that language and rename the world. This makes spoken word a political act.

Can you describe how your work is connected to Black queer feminism?

My work doesn't draw on Black queer feminism. My work is educated by it as best as it can be. In the context of my political organizing, the phrase *Black queer feminism* ensures that when we are talking about ending oppression we place the most marginalized folks in our community at the center and not on the outskirts of our struggles. They can't be mere tokens of our activism. I think Black queer folks are at the intersection of many forms of oppression. In order to have work that is both liberatory and revolutionary it needs to be informed by Black queer feminism. That is what I hope my work does.

As a young Black man living in America, who grew up on the West Side of Chicago, what is your firsthand experience of state violence, and in your view are race relations in America improving or worsening? And why?

I think the West Side of Chicago exists primarily because of state violence. There are many ways state violence works. Whether it comes from interactions with police, living in neighborhoods that have an extreme police presence for no other reason than the false idea that more people who live where I live are criminals or are criminalized more, or whether it be the poverty that exists. I think poverty exists because the state fails to respond. In this respect poverty exists because of the state. Some of the tangible ways state violence works is by the closing of Planned Parenthoods on the West Side of Chicago.

Being a young Black person from the West Side of Chicago, I am affected by state violence. In a lot of ways, I am alive because of state violence. I continue to struggle, to build, and to imagine because of state violence and to hopefully eradicate it.

Are race relations in America getting any better? Absolutely not. All you have to do is look at who is unfortunately in the White House and there lies the answer. It's 2017 and Native Americans are still fighting for grounds and treaties they were given over 200 years ago. There are more Black people in prison now than there were in 1865. And this has continued to occur under a Black presidency. So, race relations in America are not getting any better. Unfortunately, I think they are getting a lot worse. It became harder to see these things when America aligned itself with a post-racial identity. Having a few people of color in positions of power has made it harder to see how racism is getting worse. Right now, we are seeing a rise in hate crimes and explicit forms of racism. Things are getting a lot worse because it is becoming a lot harder to have these conversations, particularly from those who benefit from not having these conversations, such as folks invested in upholding white supremacy and the privileges that it allows.

I think emotionally we are in a worse place than where we were. This is because the *enemies of progress* are allowed to continue to flourish both in a covert manner and through the use of coded forms of language, as you see with the *alternative right*. It allows people who are indifferent to continue to ignore the rise in racism. People

might not necessarily be lynched on a tree, but they are lynched on the branches of government. There are so many different ways racism works, whether this is through imprisonment or by the Congress diminishing necessary public resources. Unfortunately, racism in America is getting worse.

There was a news report that came out today from Mississippi. I don't know if you have read it yet, but it is terribly upsetting: a white student tied a noose around a Black team player's neck and yanked on it. The police discouraged the parents of the terrified Black student from filing a report. The white student's parent used to be a former law enforcement officer. We are in 2016, not 1916, and that something like that could be taking place in America today is shameful. It prompts me to think about something you just said and that I want to pick up on. You said: "I'm alive because of state violence." How so?

What I mean by that is that the West Side of Chicago does not exist in a vacuum. The poverty I was born into, I did not create. The poverty my mother was born into, she also did not create. So when I say that I am alive because of state violence I mean that the conditions that I was raised in were not conditions I had any control over. In a lot of ways these conditions were created because of explicit forms of state violence and the nuances of how state violence works.

I have always deeply admired your work. I think it brings to life a lot of things that remain invisible and unheard within the political landscape of the United States. And it also taps into other minority struggles that are occurring around the world both in terms of the energy and force you bring to issues of inequity and violence. In a way your work comes to life because of state violence. Do you think it is this context of state violence that makes spoken word so lively, charged, and politically resonant?

These struggles make my art more necessary. I think for people who share my skin or share the same struggles, art has always been something that is functional. No artist that I know in my communities has the luxury of making art for art's sake. We don't have the luxury of

writing poems about flowers just for the sake of writing poems about flowers. I do not have that privilege. The way art functions in my life is directly connected to very real, lived experiences, and to this specific time in history.

I want to be careful because I don't want to say that because there is crime on the West Side of Chicago, that makes my art more living and more intense. Although that is true, I am ultimately writing art so that pain and trauma does not exist.

Do you think spoken word can be used as a tool for political activism and social change?

I am an artist. I see myself as a poet. I've been always intrigued by what poetry can do. Mostly what I have learned about politics comes from writers. I've been in gifted classes and programs, but it wasn't until I wrestled with a James Baldwin book, for instance, that I could digest the information. Statistics or political science only captures a partial reality. Art brings something else to our understanding of politics. It makes politics more tangible.

It is often hard to have honest conversations about political struggles in the absence of art. Spoken word helps a young person develop their internal "eye/I" to see the "we," the "they," and the "us." It is not just spoken word that does this. I think any art form does. It is the moment when the classroom is no longer just the journey to a better taxpaying citizen, but becomes a journey on how to leave the classroom and become a better human being.

2

Breaking the World

Adrian Parr interviews Marina Abramović,
April 2017

Marina Abramović is an internationally renowned and widely celebrated Yugoslavia-born performance artist. In this conversation she discusses the encounter with the body, the community of affective relations, the art of democratization, the genealogy of her work from paintings to the performative, on to the illusion of freedom and the power of the imagination.

ADRIAN PARR: I have always been intrigued by the ways in which your body occupies space and time and how it encounters other bodies. In a world where space and time are increasingly being filled to the brink with political exaggeration, alternative facts, and endless consumption, your minimalist gesture of silently occupying a space and slowing down routine time invokes another reality, almost a forgotten one. Would you like to comment on that?

MARINA ABRAMOVIĆ: My relationship to the audience has slowly been changing over the course of my career. I think this is an important turning point. The performance community was very live in the 1970s and gradually it completely disappeared from the 1980s onward when art became more and more a commodity.

Today, people are tired of just looking at something; they want to be part of something; and they want to have their own personal experience. So what I am trying to do now is to create large community events where I give people the tools to forge their own experience. I am a conductor, staying more in the background of the activity. Most recently, I did a very large community event called *The Cleaner*, at Eric Ericsonhallen church at Moderna Museet in Stockholm. The total

attendance reached 8,000 for the event, which lasted eight hours a day for seven days.

I try to understand the need of the different communities in the places I conduct these events. There is a population of refugees in Sweden right now. Socially, it is a complicated situation. The Swedish people are often very closed off and don't open their emotions. But one phenomenon is that everyone sings there. There are many choirs of all kinds. Together with my collaborator, Lynsey Peisinger, we held auditions for over 120 choirs including two homeless choirs, an all-female Iraqi choir, which is the only one in Europe, a choir of Syrian refugees, a Slavic choir, a Gypsy choir, and various different religious choirs. Before entering the church, the public was required to leave behind all technological devices like laptops, cell phones, and watches. We kept the choirs singing continuously, so the music never stopped. I gave the choirs complete freedom to choose their own repertoire. We had people waiting outside in freezing temperatures to participate. People across different ages, races, and religions have a shared human need to be connected by sound, and to come together in one special space.

This is what I am doing now, community events. I don't call them "performances" anymore. I realized over a long period of time I became an obstacle for experience, because the moment I am physically there in a space and people engage with me, I become an obstacle to my own work. So now I do everything from behind the scenes. I am more like a conductor, where, using simple tools, I facilitate the public's experience.

So it sounds like you are describing an art of democratization, which for me is not the same as the democratization of art, where art is understood as a practice anyone can engage in; rather, it seems to me that in this instance art is creating a democratic phenomenon where all kinds of differences come together and through the sharing of those differences a moment is created, one through which art is realized. Is this how you understand it?

Very much so. The important thing is that there is no conversation; apart from the music there is silence. If you stand next to a total stranger, and touch them on the shoulder with your hand instead of talking, the feeling is so much stronger. This is something amazing

because people are not having normal conversations anymore. People connect through the silence and human touch. It is the simple event of human being to human being.

In 2016, the Marina Abramović Institute (MAI) in collaboration with NEON at the Benaki Museum in Athens, Greece, created *As One*. Fifty-two thousand people went through this process. Now MAI has been invited to do something at PinchukArtCentre in Ukraine. This kind of work is very subtle. It is not a huge, loud event. The reason for this is that people are like antennae, and in a minimal environment, a depth of collective experience and feeling arises. You create a situation based on frequencies and people exist in the space through this shared vibration. They exist in space as a community.

That is fascinating, because you have often talked about the importance of the body in your work and that the art is made through the body, and I was looking back at many different performances of yours and it seems to me that rhythm is just as important as the body in your work. Obviously, you have the *Rhythm* series you did back in the '70s, and even if you consider the pieces you did with Ulay. I remember those pieces with Ulay from when I was a child. For a child to sit through a durational performance could be unbearable at times, but the rhythm was hypnotic for me and that is what I remember most about those performances. And then I was thinking about the piece you did at MoMa. Rhythm emerges once more, because you sit still at the table, but a rhythm arises with each person who joins you at the table and their emotional state is shared with you.

And now you are talking about these collective works that are about sound, not necessarily speaking, but a voice, and the ways in which voices come together as one is the result of a variety of rhythms and vibrations. So I wanted to ask you about how you see the role of rhythm in your work?

That is very interesting because I just had a retrospective at Moderna Museet in Stockholm and it is going to Louisiana Museum in Humlebæk, Denmark, in June. The show starts with my early paintings. When I stopped painting, I started with sound, and sound brought me to use the body, and the use of the body brought me to performance.

So, there is a really strong connection here with rhythm because I did a lot of sound works, which I call sound environments, that people don't know much about, that I am now trying to reconstruct. There was a sound piece called *The Airport*, another called *The Tree*, and these sound pieces were really thinking about rhythm and repetition. Repetition is very important in my work because it is also relevant in many cultures since ancient times. You find rituals and practices based on repetition in the histories of the Australian Aborigines, the Tibetan Buddhists, and Brazilian Shamans. There is always the same exercise or ritual being performed over and over again over hundreds and thousands of years. Repetition like this creates a particular kind of quality and energy. It also creates rhythm.

Speaking of repetition and cultural memory, it is interesting that you are now working with collectives of people. There is a politics to engaging collective memory here. I am thinking of the *Balkan Baroque*, for which you won the Golden Lion at the Venice Biennale in 1997. In this work, you sat for over four days cleaning the flesh and blood off a pile of bones. Here, performance art seems to become strategic. It is like a politics of encountering the collective memory and trauma of the Yugoslavian war and it is also a way of occupying space whereby art emerges in association with bodies that are both whole and broken, and in relationship to different times that harken back to the past, such as a collective trauma, and the present. For example, the duration or endurance of the performance itself. I wanted to ask you about the strategic placement and occupation of bodies and times and whether you see this as a politics of performance at all.

I think this was probably the most political piece I have ever made. It was in response to the war at that time, and I was so ashamed by this war. I wanted to create an image that would be relevant not only for that particular moment, but which could also become an image that invokes any war at any moment anywhere. At the same time, I was doing an act that I could never finish, washing or cleaning blood off bones is an impossible action because you never fully clean away the memory of the killing. Human beings have always been killing each other throughout history. We have done this since the beginning of

time through to today. Even now, in the twenty-first century, we are still killing. This image is a really important reminder to us of that.

This piece was also related in a way to my own situation, and in the same piece I interview my mother and father, and a professional *rat catcher*. I tell a story of how to catch a wolf rat in the Balkans. The wolf rat became a synonym for war.

Rats don't usually kill members of their own family, but if you put them in certain circumstances they do; they turn into a wolf rat where they just don't care anymore who they kill. This story seemed a lot like the war to me, where you had neighbors who once lived next to each other peacefully for 35 years, neighbors who shared everything and then from one day to the next day they are killing each other.

The wolf rat story seems to be the human story of war. In this way, it became a political piece. Although there is no longer a war in Yugoslavia, there are wars everywhere, in Syria, in Iraq. So you can take this image of me scrubbing away flesh and blood from a pile of bones, and it invokes other forms of violence. It becomes a universal image.

That said, I am not so interested in making political art. Political art is like an old newspaper, today's news is tomorrow's old news, it is not relevant anymore. So I am really more interested in art that has different layers, layers of meaning, one layer can be political but another layer might be the layer of futurity, to me that is very important. How do artists predict the future? They can if they are really connected to intuition. Some artists are more in touch with intuition than others. I think intuition in art is really important. I made a piece in 1971 called *Freeing the Horizon* where I took photographs of Belgrade and with paint, blocked out the buildings in the landscape to expose the horizon. It is amazing my dream of freeing the horizon came into being quite literally, as many years later, some of the buildings I painted out of the photograph were actually bombed by NATO during the war in 1999.

The way I understand the political is different from institutionalized politics. It concerns how politics works. Politics as inherently emancipatory and transformational. And I think that a lot of the work you do taps into those principles of the political. In this regard, to what extent can art be political if what we understand by politics is a process of remaking the world?

That is a complex question. Eighty percent of what you read, you have to read behind the lines and see things in context. How politics is represented to us is one thing, but in reality, things are very different.

We are just part of this strange scenario, like we are in a macabre opera and we don't actually change anything. The idea that we have political freedom and democracy is a farce.

In my country, where I came from, ex-Yugoslavia, it was so much more honest because the restrictions were clear and visible. If you told political jokes, you went to prison for four years and if the joke was really bad you went for six years. But also, you knew what the restrictions were and what the consequences were when you crossed them. But here in America, everything is sugarcoated.

Someone once asked me if you could suggest a book for politicians to read, and I immediately suggested the biography of Gandhi. He was such a unique politician. He succeeded without a drop of blood.

In order to change anything, you have to change yourself, then you can change thousands and that is exactly what Gandhi did.

What we see happening is not the way it really is. In order to see clearly, you have to stop the world. You literally have to imagine the world coming to a halt and then you get to work to rearrange reality. My contribution as an artist is to propose a different perspective.

3

Trans-species Encounters

Adrian Parr interviews David Rothenberg,
August 2017

David Rothenberg is professor of Philosophy and Music at the New Jersey Institute of Technology, and a widely acclaimed musician and composer whose work explores the relationship between humanity and nature. This conversation explores questions of extinction, trans-species collaborations, the ethical potential of music, on to melodic subversions.

ADRIAN PARR: Human activities are to blame for the sixth great extinction currently underway. The main issue is that evolution cannot keep up with the current rate of extinction. As a species, humans have become the earth's number-one predator. Human activities are taking over the world's resources, habitats, and atmosphere. This is leading to dramatic habitat destruction, climate change, and loss of biodiversity. Previous mass extinctions have taken 10 to 30 million years to bounce back from. In this context, and given that your sound-works emerge through inter-species encounters, would you say that your sound art engages in acts of resistance against the violence that humans are inflicting on other-than-human species?

DAVID ROTHENBERG: Ah, the violence we enact on other species! Part of the general tragedy of being human, I suppose—we have to own up to it. As we develop and evolve, the rest of the world's species suffer. But it doesn't entirely have to be that way. We can be more sensitive to them. After all, the music of birds, whales, and bugs is some of the oldest music we know. It is the real classical music, evolved to perfection, essential, necessary, and *right* for millions of years longer than we have been on this planet. Some respect and investigation of

it is due, don't you think? Everyone who studies music should in part study animal music, and if we dare to interact with this music, we connect ourselves to the whole fabric of life in a real, tangible, and yet hard-to-explain way. Music doesn't specifically save the world in anything but a metaphoric sense—sure, I know that, but the closer we feel to our fellow musicians on this planet, the more we will respect them and will work to live in a way that allows them to flourish as well.

Can you describe how the *Why Birds Sing* and *Whale Music* projects came about and how they expand the traditional model of music composition where a composer authors a piece?

For a long time, I was interested in music and the environment separately and I always wondered how to combine them.

In the '70s, the environment became an important issue of our time and, as a teenager, I thought I really should do something about this, but I wasn't sure how to connect this to my own interest in playing and composing jazz. I grew up in Connecticut, where Paul Winter also lives. I met him as a teenager, and he was pretty much the only musician at the time who made environmentalism central to his work. He was doing performances with whale and bird songs. So I learned about that as a teenager but didn't do very much with it for about 20 years.

Then I came back to the problem of connecting music and the environment when I became interested in a Canadian composer R. Murray Schafer. He was interested in both listening to the soundscape of the natural world and what we can do with environmentalism. He was a more traditional composer, not a jazz musician, but his approach was "let's just write pieces to be performed on wilderness lakes, in canoes in the forest, or a bunch of trombones on mountain tops," and he has continued to do this to this day, culminating with a performance that has taken years—the *Wolf Project*—of performing in the woods outside of Toronto. The project is so vast that they just disappeared into the forest. Who knows if it will ever be completed? At the same time, I realized there was much more to do be done.

One thing people hadn't done was to take actually playing music together with animals, such as birds, seriously and to learn something

from it. The moment of encountering another and taking them seriously musically, not just to learn who they are but to listen to them.

I don't know if you can hear that sound in the background, but the white-throated sparrows are starting to sing. They are supposed to sing, "boo boo boo dirdir dir dirdir dir ... Old Sam peabody peabody peabody," but they don't, because they have forgotten how to sing. Spring is just beginning, and they are just playing around. They are trying to figure it out. This week is the week.

You can communicate with other species as a musician if you take them seriously. The music of birds is more like music than language. They are not trying to say something that we can translate. They are making music. They are putting together sounds and patterns whose identity is those sounds and patterns. They don't stand for anything that can be deciphered.

It strikes me that there are parts of your work that embrace aspects of how John Cage composed, if we think about living in that indeterminate moment of an encounter as the basis for composition—giving up the control of the composer. Would you agree?

Yes, I would. He was very influential for me. He would surprise you. I knew him a bit, and the best thing about John Cage is that he didn't talk just about himself. He was very interested in everyone else. He worked those stories into his own work. That is rare among people with a singular vision. That is the best thing to learn from him: pay attention to everything, take other things seriously, things you don't expect, don't follow the exact straight path. He said he was so interested in chance, but when I watched him assembling things by chance, he would also edit them very closely. He was a composer with very precise ideas. Even though he said free yourself from your likes and dislikes, this didn't mean "do anything," it meant look for guidance elsewhere on how to structure things. He was very precise. It was a precise way of learning from something unexpected. I take something from that in learning to play music with birds. You take what they are doing seriously and listen attentively. What can we accomplish here, what is happening? You don't get too fixated on your sense of function.

So much of how you compose, such as your *Whale Music* project or *Why Birds Sing*, maintains a presence with another being, so there is this durational expanse to the work, which prompted me to wonder: At what point do you determine the piece has come to an end?

That's a great question. A lot of that depends upon what is the actual work.

At the moment, I am playing music with nightingales. Now nightingales are going to sing all night, they are going to keep singing and singing and singing. What counts as a work for these birds is very different from what it is for humans. It is nothing for them to sing all night. They just do it.

If I make a recording of this, I want to present it to people at different scales. One part of me says there are several minutes that are really interesting, when it sounds like something is happening. And I offer these moments to people. On the other hand, other people who I have worked with retort that I am breaking this up into little units like human music. They explain that we spent an hour and a half playing with this bird, we need to present that. So we put one record out that is just one 49-minute track that includes me, a singer, an accordion player, and this one nightingale that we know is an amazing singer. I know this because I have performed with him several times; he comes back to the same tree in Berlin every year. This bird is special. I have also performed live with a recording of the same nightingale for a one-hour concert. If you want to hear ten pieces in this hour you are not going to, you are going to hear this one thing. This is going to change your sense of time.

I have done the same with whale song. Whales have a lot in common, musically, with what nightingales are doing, but their song is slower. We play along with the whale song for 45 minutes. At first people are not going to want that. However, their perception slowly changes.

So, what makes the work? If the work is this encounter it almost has no beginning and no end but the structures of life dictate things, so you decide how much to bend toward people's attention span and the sense of what you are doing.

So are you using the affective potential of chance to compose sonic elements in this trans-species exchange—is that how you view it?

Many times, things are not going to work. Like the birds are not interested in you and they fly away. Whales are particularly hard to play live with given all the equipment needed, then there is the question of whether it will all work, or if the whale will stick around, or if there too many boats around, or too many people on board who want to swim with the whales. More people want to swim with the whales than listen to them and musically connect with them. So usually there is someone who announces: "Enough music, I am jumping in, go away!"

In the *Whale Music* project, you seem to transcend the differential power between human and non-human species by subverting the species boundary through a percussive and melodic weaving of bodies and the sounds bodies emit. So there seems to be an existential consequence whereby the identity of a person as a musician is suspended, or that identity is recomposed and bifurcates in connection with another species. Would you like to speak a little about the experience of this process?

There is something very special about humpback whale song. Nobody knew about it until the 1950s. It was an unknown phenomenon. When people first heard it, they would sometimes burst into tears, it seemed so moving. And why is it that the sound of these whales seemed so emotional? It is structured, it is very organized, and strangely it is about the same frequency as the human voice. The lowest to the highest sounds the humpback whale makes cover about the same range as the human voice. The scale of their song is slower than human music, but it is accessible to us. We can slow down into that shape and form.

When I figured out it was possible to play live with them, it filled me with a sense of surprise and possibility. You really can play an instrument on a boat and broadcast down to water and mix it together live with what whales are doing. They are hearing and listening. They sometimes change what they are doing. They acknowledge that the sounds are there, and at the same time you join into this phenomenon. You don't know what it is. We don't know what this whale song means. There is no attempt to find a function for it. It is simply the richness

of its musical quality. They also change their song together as a group. One day they are going, "Rhoop whoop," and three months later they are going, "Rhoop whoop whoop." The pattern changes, and they all seem to change together. So they don't want to sound different from each other, they want to sound like each other but they change what they are doing, and we have no idea why. That is not very common in the animal world to have this group movement. A nightingale wants to sound different from other nightingales. The whales want to sound the same.

As a being in the midst of this, I forget all these explanations I am telling you. I listen to the overlap of sounds and realize that you too are a sound making being. Who knows what it is all for, but it is just amazing. There is something going on. We can participate in it. We can join in with this mystery. We can make sense of it while having no idea what it is about.

It strikes me as a wonderful moment of commoning, of inclusion, of different voices coming together and resonating with one another. I would like to ask you about this process of sharing. Sharing human and non-human sounds as the basis for music composition, when I listened to your performance in Canada, it really felt like this music expands and deepens the human experience by bringing it into relationship with another species. This music directs our emotional attention to a fundamental relationship of solidarity, where the music is created through an alliance formed across species. In this way it strikes me that it is a minoritarian practice, a micro-political aesthetic that deterritorializes the fixed relations underpinning dominant aesthetic forms if we think about the fixed, organized spatial and temporal configurations arising from harmony, melody, and rhythm. Your pieces appear to break such fixed relations apart.

Take the example of playing along with the hermit thrush. People have always admired the beauty of its song. They have talked about how there is something especially musical and diverse, something continually changing in its song. But if you actually listen closely, it has notes and scales that are very different to the ones humans use. Yet we recognize this as being musical right away even though they are from some other world.

Today we are fortunate of being more open to sounds from nature because we accept so many more sounds as musical. This is because of John Cage, electrified music, noise and feedback, and things like this. We accept the possibility that all kinds of sounds can become musical sounds.

So as much as we are threatening the planet and using up resources and bumping up against everything nature offers, we are more prepared to listen to it and take it seriously than ever before. Today, because we appreciate all these sounds, we take these sounds and join in with them and learn from them. We don't have to fit them into our systems; we can open up into their systems. You have to train yourself to want to listen to these things and take them seriously and not grab them too easily and put them into your systems.

If you think what animals are doing is musical, it is a lot easier to make sense of it. We value music so much without necessarily knowing what music really means. We know that it is important to us. You can't translate music or explain it away, no matter how much you analyze it. Music touches us even if we don't know what is being sung.

You can relate to a culture's music without having to translate what is being said, and that shows the possibility of reaching across species lines. It is important to learn to care about all these creatures. We are rapidly using up the planet, and the more we value what is going on out there in the world the more we are going to think twice about harming it.

It is well known that environmentalism was not interested in saving the humpback whales until the whale song became famous. When their sounds reached us, people were just so moved. I am doing this because an interesting kind of music can be made that humans couldn't make alone and that further connects us to the environment. That is so important in an age when the whole civilization is bumping up against nature as a whole. We are really threatening everything. The more we pay attention to it and value it the more we will find new ways to respect what is around us.

The trans-species encounters central to your sound works intervene in the global-scale violence human beings are waging against other-than-human species by challenging the violence permeating contemporary social relations with responsive moments of egalitar-

ian diversification. Put simply, your work seems to rest upon one simple, elegant principle: one species enriching the life world of another. Would you like to comment on this?

I hope it works that way! Just as listening to, appreciating, and joining in with the music of other species is beneficial for us humans, I would like to believe the animals can enjoy it. We know that dopamine is released inside the brains of birds as they sing, they are addicted to singing, they love it, they need it. All of us musical beings share that need. I would like to believe that nightingales enjoy the challenge of singing along with human musicians, that humpback whales would rather hear human music underwater than droning ships or piercing sonar tests. I mean, that's not hard to believe, is it? Musical creatures should be treated to music, and we might all treat each other better. It's not a war out there; it's a booming, buzzing celebration of sound, life, and possibility.

4

Recovering from an Addicted Life

Brad Evans interviews Russell Brand,
November 2017

Russell Brand is a renowned comedian, actor, author, and activist, who has struggled with addiction throughout his life. This conversation discussed his book, *Recovery: Freedom from Our Addictions*, in which he shared the hard lessons he has learned over the years.

BRAD EVANS: We all know any book is the outcome of months and sometimes years of procrastination. What really compelled you to write this book at this moment in your life?

RUSSELL BRAND: I felt that anybody who is in recovery has an experience where the initial attempt to tackle addiction—in my case crack and heroin—ends up being utilized in every aspect of your life. Working through and following the same principles can alter all behaviors and all forms of destructive attachments. So what I felt was I'd reached a point in my life where I have gone through so many layers of disillusionment, with sex, fame, Hollywood, and the rest, and the recovery lens through which I live my life offered something.

Don't get me wrong—disillusionment is a good thing. After all, who wants to be bloody illusioned! Now I by no means do it perfectly. Far from it! But I have seen the techniques that I followed change lives. So I wanted to expound these to offer a counter-weight to the prevailing addictive ideologies of our times, which is a determined and yet unconscious self-centeredness.

When reading the manuscript, I was trying to figure out what type of book it actually was. Ironic, I know, for a so-called post-modernist! I think, in an affirmative way, it's like an "Anti-Self-Help-Book." And what I mean is the central message I see jumping off the pages

is that it's precisely the traits of the self-centered, individualistic, fuck-the-world-and-its-loving-sentiments attitudes that get you precisely into the fix in the first place. Hence, it's not about self-help; rather it's all about a sober and truthful cry for human connection.

I think our culture and our biochemistry can collude to become our worst allies. They can create a kind of chronic individualism. And I feel the natural conclusion of a secular rejection of the mystical leads us to the point where we are just individuals. We are only here for ourselves, surviving alone, and learning how to dominate certain situations so we can fulfill our own impulses and desires.

When I try to find personal fulfilment in my life I still often find myself in a sort of peculiar despair. I start to feel lonely and disconnected. Then I remind myself. Hence why I feel qualified to write about addiction is my life is like a map of addicted lines from money, crack, fame, sex, relationships, and seeking out other people's approval. And so I see this phenomena appearing again and again in my own life. Maybe the label "addiction" itself is too confining, and what we are actually dealing with is the human condition in motion. We live in a culture that uses as its fuel this will to acquire and possess. But the tragedy is such a desire to possess things ends up possessing us.

But this is a constant battle. Every day I wake, and I am bewitched and hypnotized by the seductive lure of materialism. And yet I know that when I go and help other people, sometimes in blatant sub-Princess Diana ways or even on a more basic human level by just listening to other people's problems, that's when I feel genuinely fulfilled and my life has meaning and significance. There is an indescribable energy there when you begin to help somebody else. It's a kind of elevated sense of human connection. And you also start to see the real beauty of a person when they help somebody less fortunate. A life of unselfish purpose, empathy, compassion, all those words that are excluded from the political and social ideologies of our times suddenly become accessible through the most basic of human actions and behaviors.

So why do you think then that we often act and behave against our better judgments? I am thinking here of our attraction to relation-

ships and people we know to be detrimental and indeed toxic to our physical and emotional well-being.

Possibly a misplaced sense of romanticism. What I mean by this is the individualistic notion that you can find fulfilment by being with some aspirational figure that comes from the desire to be with some deity or earthly goddess. I'll find salvation if I find the true one, like your own personal Jesus. This idea I think is highly prevalent. And yet even more toxic I think is the commodification and objectification of all relationships. To view somebody like an object that can serve you, make you feel better, and improve your social status. Now I have to admit that in my case this happened all too easily. I have to work to not approach relationships in this indulgent way. But these are just tendencies. And that's what a recovery program means to me. It is to learn to acknowledge and deal with these tendencies on a daily basis.

It's also important to recognize it's not the difference between having a program and no program. We are socially and culturally programmed to behave in certain ways, not least the program of vapid consumerism. And so if you don't undo that program, decode yourself from the "I'll never be good enough unless I get my hand on that object" like somebody who is leaving an all too consuming cult, then that's the program which will come to shape your existence.

We have to learn to untangle the strands that bind us to materialism. We know the material world is an illusion that is transmitted into our consciousness through the senses. This is why personal crisis is important here. It gives us the opportunity to reevaluate our lives and ask difficult questions.

There is invariably a deep philosophical underpinning to this project. And that is the attempt to connect with something, which in the most inexplicable but no less real ways gives meaning to this all too fleeting life. Am I right in saying this is truly a search for the substantive over the superficial? Or to put it another way, maybe it's an embrace of something irreducibly spiritual, which only comes from certain courage to tell the truth about your existence?

What is substantial about the spiritual to me is its efficacy. I know it works. When I do these things, I feel better in ways I can't explain but

know are real. It doesn't require any science to tell me this. When I am kind, loving, and when I surrender, I know that I am becoming a better me. These things can't be measured. Nor can they be mechanized or monetized. They are in fact affective. They have a truth, which is different and difficult to legislate or iterate. This again is the deception of secular materialism. It teaches you to become suspicious of those feelings you know to be true. And then it sells us solutions to our problems that come from living under the false ideals of consumerism. This is how addictions take hold. They don't appear as problems but solutions in our attempts at seeking some form of human connection. And this is why I think we are all somewhere on the addictive scale.

I know that I could lapse at any moment. I don't know what's around the corner. What unforeseen event might push me back into the depths of loneliness and despair? This is why I haven't written this book from a position of authority. It's written from a position of an experience I am still living. And it's when I actually think that I'll take full control of this situation that the ego starts to reappear, armed with its desire, pleasure, and fear to send me down the wrong path. So the reason why the spiritual is important is that it is the only thing that can transcend the material and passive consumerism.

You talk in the book of the need to confide in others about your troubles. I would like to read out this particular segment, not only because it brought tears to my eyes, but also because I think it really addresses what's at stake here:

Suddenly my fraught and freighted childhood became reasonable and soothed. "My mum was doing her best, so was my dad." Yes, people made mistakes but that's what humans do, and I am under no obligation to hoard these errors and allow them to clutter my perception of the present. Yes, it is wrong that I was abused as a child but there is no reason for me to relive it, consciously or unconsciously, in the way I conduct my adult relationships. My perceptions of reality, even my own memories, are not objective or absolute, they are a biased account and they can be altered.

The moves here from the deeply personal and tragic to the transformative are powerful. And it no doubt takes a great deal of courage to

put this on to paper. How do you hope these words can help in the healing of others who carry such difficult memories?

As Jarvis Cocker once put it, "without people we are nothing." Recovery and spirituality are collective and communal activities. They cannot be achieved by being stuck into a pod and shot into outer space. Primarily it is about how you relate to yourself and how you relate to others as people. Just to clarify, the abuse you referred to in the passage happened outside of my family and the issue, I feel, is that it's possible to alter our perception of the past, and in doing so we also alter our perception of the present. But you can't just say this to yourself stuck in some room. It has to be related.

Let's now connect this more specifically to your earlier work on the War on Drugs. Historically, the drugs issue has often been neatly separated into war/law versus development/health paradigms. Now while the critique of the former is most welcome, too often the latter can reduce this to questions of individual pathology or deviance. It is simply the individual who screws up! How might we learn to better connect the social to the individual in this context?

The criminalization of drugs is a useful social tool in the management of populations. And I agree with your critique of the health model as a determinate means for reducing what is a social issue to some individual pathology. Addiction can affect anybody, but it is certainly exacerbated by economic deprivation. But there are different forms of deprivation too, like emotional deprivation, so it's not like the poor simply have full ownership of this. Though it would be nice for them to have exclusive control of something! What I mean is that its effects are felt more there in terms of the experience, the treatments, whether you are criminalized or not, and often whether it takes your life.

A while back I went on a police raid in west London. This was a very revelatory experience for me. They battered the door in of this "crack house"—which in itself is an interesting description for a deprived home—and what dwelled within was not monsters. It was like booting down the door of a leukemia ward. It was full of thin, emaciated, and broken people who were slumped and pale in chairs, denied sunlight of every variety—literal and spiritual.

These were people who were just holding their lives together. And what I realized here was that it's precisely those programs, which take you from the individual narcissism and nihilism to forms of social care and compassion, that are most needed here. If we have an inclusive, empathetic society then by definition you don't abandon people to the fate of forces beyond their control. We need to help people so that they are not defined by problems, which are often social problems. If we have systems that emphasize the corollary and connection between us, then we will build a better society that is more inclusive.

I want to push you a bit on this term "recovery," which is used for the title. The way you seem to use and deploy the term here is different from more simplistic understandings, which might refer to the rediscovering of some essential self that's been somehow trapped or frozen in time and just needs to be *re*-discovered. And yet this book seems to also be a critique of such perfectible lifestyles. Or that to recover means to also accept that sometimes it's actually okay not to be okay in life, and that all of us struggle with our identities.

This again is something I have only found in spiritual conversations. You accept fallibility as part of the human condition. And you don't punish yourself because of it. Humanity needs to relinquish the idea of perfectibility. Now a natural biochemical entity like the human does have a code. It will grow a certain way, if in our case unimpeded by social, political, cultural forces. But we know those forces exist. So, when I use the term "recovery" I am talking more about an intended path, which doesn't condemn us to live addicted lives and to succumb to the logics of passivity and its false material prophets. We must be reborn from a world that sees us only as a statistic.

To conclude, I'd like to end on the issue you begin with at the very start of the book—namely the big impending "D" or death question. As you point out in the introduction, we don't like to talk about the reality of death individually, and it certainly is not something we like to talk about publicly. And yet since Plato onward, it has been thought that "to philosophize is to learn how to die."
I don't think however this goes far enough, or at least it needs to be taken a stage further. As they say, "Religion is for people who fear

hell. Spirituality is for people who have been there." With this in mind, your book leaves me asking: How can we examine our life, to learn to appreciate its finitude and the impending death we all face by actually crossing over and looking at life from the perspective of death? Or, as you say, to ask serious questions about our life, our present, and our hopes from the future, while already knee-deep in the mud of our tragic and yet still wondrous condition?

This requires actually some rather simplistic shifts in acceptance and gratitude. To begin, on an all too human level, I relinquish the idea that I am not homeless, lying in a gutter and smacked up on crack because I am now somehow a superior being literally looking down. It's more because of some random set of coordinates and unforeseen events, which have deposited me into a comfortable life, and I'm really lucky and gracious. So I don't have a punitive attitude toward those people who by chance find themselves in desperate states.

I always find it a real honor that when I am among addicts, they will often just take me for who I am. They know my past and my fallibilities. And it's in these moments that I also realize we are all ultimately connected. We are all experiencing this thing called life together as part of a shared consciousness, for better and worse. And when I realize this, I know I am not on my own anymore. I am no longer afraid. I don't have these obligations to prop up some avatar of myself, some deification that people might love or give me approval in order for me to ameliorate some inner sense of worthlessness and isolation.

When the self feels like it's worthless or nothing, I feel we are searching for a deeper truth. How can we not be disconnected or divided, separate from everything? Clearly the retreat into individualism is more than self-defeating here. Because if we separate, we are condemning ourselves to nothingness! This is not about the annihilation of the self as in the subjugation in a violent or destructive way. But the recognition that there is no need for fear because we are already one, and these things are not just philosophical tropes or empty mantras, they are things you can live by recognizing that your own suffering is an opportunity and call to break out from the imposed paradigm that reduces worthiness simply to what objects you accumulate. And this is what it means I think to find out the truth about ourselves.

5

Non-Violence and the
Ghost of Fascism

Brad Evans interviews Todd May, May 2018

Todd May is a political philosopher and social activist based at Clemson University, who has written extensively on ethics and non-violence. This conversation deals with the history of non-violence, the legacy of fascism, the affirmative nature of civil disobedience, the continued importance of French intellectual thought, on to the question of dignity.

BRAD EVANS: Your work deals with two of the most pressing challenges of our era—namely how can we rethink violence as a political strategy, while taking seriously the multiple ways the ghost of fascism reappears in everyday life. How would you counter those who insist that fascism can only be dealt with through direct confrontation?

TODD MAY: First, Brad, let me offer thanks for the opportunity to address these urgent questions. I can approach the first one like a true philosopher: by raising the question of what might fall under the category of "fascism," and then the question of what might fall under the category of "direct confrontation." We often think of fascism in the extreme, as in Nazism or Italian fascism. In these cases, it is difficult to see how nonviolence can successfully overcome them. There are some people, mostly pacifists, who claim that a nonviolent approach could successfully confront Nazism, but I'm not convinced. However, when we pose the issue in this way, we're taking Nazism and fascism as already established power relationships.

Suppose instead that we consider the period *before* these movements became entrenched. That may be the situation we currently find

ourselves in in the United States. Here there are important roles for nonviolence to play, among them offering the people (or sometimes *a* people) a more positive image through which to see themselves, providing a model for political engagement, and inspiring people to act. Among these roles there is a place for direct confrontation.

Turning to direction confrontation, then, we need not see such confrontation solely in terms of violence. Nonviolence often involves direct confrontation. For instance, the Freedom Riders of the American Civil Rights movement directly confronted those who maintained segregated travel arrangements, the citizens of the Philippines directly confronted Ferdinand Marcos's army in 1986, and the Palestinians who march against Israeli oppression are all engaged in direct confrontation.

Nonviolent direct confrontation displays a different dynamic from violent direct confrontation. For the latter, the goal is to defeat the adversary militarily, to make it surrender. For the former, there are several important goals on the way to eventual victory: to display the violence of the adversary for others to see, to confront the adversary with an unflattering image of itself, and to empower the people who participate with a sense of their own dignity. We should not underestimate the last of these. It is often one of the most damaging effects of oppression that people's sense of dignity is violated. Nonviolent action can help restore that.

Your understanding of fascism pulls away from state or even ideological moorings, which tend to equate it with a failure of liberal and democratic modernity. How might we better see the recurring motif of fascism in the twenty-first century?

The term "fascism" is thrown around a lot these days by both left and right. Outside of its application to the historical zenith of fascism in the twentieth century one might wonder whether it is a very useful term. It stands in contrast to terms like "apartheid," which can refer not only to the South African context but also to other contexts in which a people is geographically, politically, and economically marginalized in the way Black South Africans were. (One thinks here of the Israeli occupation as a trenchant current example.)

Fascism tends to be ascribed to many egregious dominant power relationships that have no common structure. However, if we think of it with reference to Nazism and Italian fascism it can be seen as something roughly along the lines of an authoritarian regime that privileges a particular group of people, often defined by the notoriously ambiguous idea of race. Moreover, this privileging is generally done through reference to previous glories that are under siege by impure others. In this sense, the Jim Crow South was not fascist because it was not authoritarian and China's current government, while authoritarian, is not particularly racist (except perhaps at the margins).

If we take the term this way—and admittedly, this is not the only way we might take it—then while we should deny that the United States is currently fascist, we should worry about its inclination in that direction. There is, as everyone with eyes can see, an authoritarian tilt to Trump's governance, one that is reinforced by the lock-step way the Republican Party follows him. And the privileging of white Americans, exemplified by the racist, anti-immigrant, anti-LGBTQ rhetoric and practice of the administration is in line with earlier fascist movements. If this is right, then we are in a moment where nonviolent resistance is not only appropriate, but also indeed urgent, if we are to push back against the current authoritarian movement before it becomes entrenched.

I would like to push you more on the politics of nonviolence as a viable political alternative. What can we learn from history in terms of thinking about nonviolence as a form of empowerment to take us beyond reductive narratives of passivity?

Gandhi long insisted that nonviolence is not a weapon of the weak but rather of the strong. That's why he rejected the term "passive resistance" in regard to nonviolent action. Moreover, we have historical lessons in the empowering character of nonviolence and empirical support for the idea that it is not only a viable alternative to violence but actually more effective. As for the former, we can turn to the classic examples of the Indian Independence and American Civil Rights movements. They were not only successful at overcoming powerful adversaries; they were at the same time empowering for those who engaged in them. This is why, for instance, so many significant American Civil

Rights leaders are still involved in teaching others how to engage in successful resistance.

As for the empirical support, we can turn to Erica Chenoweth and Maria J. Stephan's seminal book, *Why Civil Resistance Works*. Their study of over 200 campaigns between 1900 and 2006 shows that nonviolence is generally far more effective and has better long-term prospects for justice than violent resistance. If we think about it, this should not be surprising. Nonviolence, as they note, offers wider opportunities for resistance than violence: it tends to garner more sympathy both locally and in a more widespread fashion; it often creates cognitive dissonance among those who count themselves as among its adversaries; and it can make suppression of its activities appear to be morally objectionable.

As a case study, we can compare the First and Second Palestinian Intifadas. The first one, which was largely nonviolent, allowed for broad participation on a variety of levels and gained world sympathy, negotiations with Israel, and ultimately an agreement that ushered in a period of peace. (To be sure, Israel's violations of that agreement eventually undermined it.) The Second Intifada, which was fought largely with weapons, excluded much of the Palestinian people (who were unarmed) from participation, failed to garner international sympathy, and gained nothing, even temporarily, for the Palestinian people.

In your writings, you continue to highlight the contemporary importance of continental thinkers such as Michel Foucault, Gilles Deleuze, and Jacques Rancière, among others. How do they still help us develop a critique of violence adequate to our times?

Let me address this in two parts: the issue of the critique of violence and then the alternative of nonviolence. Regarding violence, we need to ask a bit about what violence is. In my book on nonviolence, I confessed to being unable to come up with an adequate overall definition of violence. However, traditionally violence is considered to be of at least three types: physical, psychological, and structural. It is structural violence that is most relevant to consider here. Let me focus on Foucault and Rancière. In his most famous works, *Discipline and Punish* and the first volume of *The History of Sexuality*, Foucault

can be read—rightfully so, in my view—as offering us genealogies of particular kinds of structural violence, violence that stems not from direct person-to-person contact but instead emerges from the structure of a social situation.

In *Discipline and Punish*, for instance, Foucault traces the rise of systems of discipline that, by constraining us to certain kinds of behavior and self-understandings, marginalize large groups of people as well as limiting the options for resistance to current oppressive arrangements. While this kind of violence may seem to be something very different from physical or psychological violence, it isn't. In particular, systems of power that marginalize people are psychologically violent in ways that are similar to person-to-person psychological violence. They deny people's dignity, as I mentioned above. In addition, they limit the kinds of resources people have access to in order to create meaningful lives, they make interaction with other social groups difficult, and they often directly circumscribe the kind of activities people have access to.

Rancière's perspective is less historically nuanced than Foucault's. He takes a wider view, insisting that what he calls "police orders" are characterized by hierarchical relations in which some people's views and contributions count and others' do not. For Rancière, the denial of people's equality runs deep, and to confront it successfully often involves a collective assertion of equality. This leads to his contribution to nonviolence. Rancière has not, to my knowledge, written much on nonviolence. However, I have argued that it is implicit in his thought. The presupposition of equality that he believes animates real democratic movements requires nonviolence as a default. This does not mean that such movements must always be nonviolent. But that must be the default position. The reason for this is that the presupposition of equality is a presupposition of the equality of everyone. It cannot be just those who struggle who are presupposed equal; the presupposition must also encompass the adversary.

If this is right—and, again, he does not say this, but I believe it follows from his view—then the default position of a democratic movement must be nonviolent. One might ask here: When a movement of equality is forced into a position where it must be violent, does that undermine its character as a movement of equality? It is, admittedly, a vexed question, one that I have struggled to answer in a way that I am finally comfortable with.

Returning to the question you raised earlier concerning human dignity and the challenges we confront when actually trying to define violence, how might we use this concept of dignity to gain a real, tangible, purchase on what violence actually means at the level of everyday human existence beyond mere bodily violations?

The term "dignity" is often associated with the philosopher Immanuel Kant. He used it to refer to the particular dignity associated with rational creatures. However, historically the term has several uses. Michael Rosen, in his book *Dignity: Its History and Meaning*, isolates three different strands of dignity before proposing a fourth one. There is dignity as an inherent value deriving from the history of Catholicism, Kantian dignity, and dignity as a way of behaving—as in a dignified bearing. Rosen proposes a fourth definition of dignity as a right to a certain respectfulness, a right that he thinks is foundational for other rights. I am sympathetic with this view, but it leaves open the question of what it is that is to be respected.

In my book *Nonviolent Resistance*, I propose the following definition of the dignity to be respected: to engage in projects and relationships that unfold over time; to be aware of one's death in a way that affects how one sees the arc of one's life; to have biological needs like food, shelter, and sleep; to have basic psychological needs like care and a sense of attachment to one's surroundings. It's broader than Kantian dignity, because it refers not solely to rationality but to a recognizably human way of living. It also leaves room for modification in ways that can take account of the dignity of nonhuman animals.

With this definition of dignity in mind, it is easy to see how the structural violence I discussed above violates people's dignity. On the other side of things, it allows us to understand what characterizes movements of nonviolent resistance and perhaps even offers some help to those who are constructing one. In my book, I argue that a movement is nonviolent to the extent that it respects the dignity of everyone involved—participants, adversaries, and bystanders.

It is important to emphasize, however, that this view of nonviolence does not preclude coercion. There can be many forms of nonviolent coercion, and contrary to what Gandhi held, I believe that most successful nonviolent movements are in fact coercive. They rarely work through the moral conversion of the adversary but instead through

a dynamic that puts the adversary in a situation where continuation of its activities is morally, economically, and/or politically impossible. (Conversion, if it happens, is often after the fact.) And this can be done while respecting that the adversary or its members have lives to lead in the sense I mentioned in the previous paragraph.

6

Without Exception: On the Ordinariness of Violence

Brad Evans interviews Lauren Berlant, July 2018

Lauren Berlant is George M. Pullman Distinguished Service Professor of English at the University of Chicago. She is a renowned author working on queer theory and the politics of affect. This conversation addresses the question of violence by attending to the intersections between structure and vulnerability, the economy of affective relations, limitations of theories of the exception, the unbearable, on to the #MeToo movement and what it means for a life in academia.

BRAD EVANS: I'd like to begin this discussion with a rather generic question on the concept of "violence." What do you understand by the term? And how might we think of its relevance in the contemporary climate where we are witness almost on a daily basis to declarations and liberation of prejudice in the so-called "mainstream"?

LAUREN BERLANT: Politics is a war of attrition. In the contemporary moment from so many positions of structural privilege and vulnerability the friction is ratcheted up, disinhibited, refusing to constrain itself along the lines of an older mask of aspirational civility or the liberal model that calls on natural empathy to ground inclusion in the social and political field. But the current intensification of what feels like the direct action called "violence" does not point to a new kind of violence. Calvin Warren and Fred Moten have argued that the worlds of white privilege have long been held together by the pervasive violence of their reduction of Black being to the something that is deemed a nothing. Wendy Brown has argued that the enjoyment of class and gender inequality and the righteous affect of contempt among

the privileged include the weapon of the "toleration" of difference, which actually fixes subordinating hierarchies. Michael Dawson and other theorists of racial capitalism show how these histories saturate modernity.

But both structural and direct violence have intensified during the current phase of the global rise of the reactionary, national-xenophobic right. The very multiplication and convergence of activist genres now tell us something about the contemporary breakup of what were always thin hegemonic coexistence agreements. As Lyotard and Rancière have written, politics is constituted by a disagreement about whose representation of the event will secure protocols and resources for valuing some claims and grievances over others. This is why people's moods and gestures appear so out of scale now—activists of all ideologies are refusing to be reasonable—flexible, adaptable—in the old ways. Lots of this is reactionary: among the structurally privileged there's an epidemic of complaint that repudiates belonging and wishes for the expulsion of people with whom they have lived, politically speaking, side by side. But also, thanks to the refreshed consciousness among subordinated publics of the ordinary of sexual, racial, national, and class privilege and violence, there are fewer and fewer agreed-on principles in place for assessing pervasive assault, insult, and injury. I've called one symptom of this new exposure "genre flailing."

We see it everywhere in attempts to find analogies for events that disturb how we process cause and consequence in the historical present. For example, the concept of the "microaggression" had to be invented to create a disagreement about whether events that happen between people are specific to the unique situation or are general expressions of structural inequality. Of course, the answer is always both. But even if we agree that a microaggression is a macroaggression that appears in an episode, and see that its smallness is not evidence of its unimportance, we may not agree on how things add up and where accountability lies. Then we debate the genre of the event, drawing lines across what feels singular and personal and what's a predictable expression of the general social infrastructure (racism, misogyny, homophobia, class prejudice, national exceptionalism, religious bigotry). Often, to serve the privileged, what appears in the capital letters of scandal is amplified to whisk attention away from the social

infrastructure toward a localized scene of urgency. Scandals blow over but structures don't.

So I would say that, in this intense moment of orchestrated movements and shifting alliances, this renewed dream of an awakened civil society, we're in a transitional time in our assessment of the relation of the incident and the event to our sense of how to shift the scale and texture of violence. We are fighting for new ways to care about, redress, and refuse the reproduction of the ordinary of violence. We are fighting to pay a different price for struggle and to force consequences on those who historically have minimized their exposure. It is a hard and necessary time for activists to be suffering the enigma of a suffering that doesn't, at the visceral level, feel very enigmatic at all. But refusing the self-evidence of violence, insisting on tracking its intricate technologies, finding new genres for naming and responding to it (see all the proliferating Twitter handles) is necessary for reconceiving and doing damage to the reproduction of structural—predictable and conventional—violence.

We know that violence is something much more than mere bodily violation. Mindful of this, not only is there a need, as you have stressed in your work, to appreciate more rigorously the politics of time and how this often shapes modes of perception (especially regarding endangerment), there is also a need to address what is heard and unheard from victims of history. How do you understand the act of silencing?

For many of us who've lived on the bottom or in the dark corners of social value, the desire to make a claim on the world is accompanied by fear, shame, and a history of humiliation both directly, by other people, and indirectly, in the sense that one comes to expect nothing while wanting to force into existence so much. Much of what we call silence isn't silence at all but political speech and communication that is not listened to. So, if some of the violence of silencing is a genuine suppression of speech, most of it is really the experience of communicative impotence: the experience of others' aversion to taking in and becoming different in response to the force of what one says.

More concretely, during teaching quarters I tattoo a phrase on my arm: "What would it mean to have that thought?" It points us to the

inadequacy of the silence/speech dichotomy. It's not that we aren't talking, or aren't being heard in a way that could be repeated technically. It means that people often can't bear to be changed by what they hear. "What would it mean to have that thought?" means, what would it mean to see the world through those lenses, that framework, that proposition? What would it mean really to take in what we hear and to walk around the world with it and test it out, rehearsing what it would mean for it to be the case? When even our political allies phrase proposals and demands that jar us, to "silence" them means to rest with our first resistance to what we've heard: and to allow it to be speech means to sit with it, to generate cases and examples—to give the speech potential life. It's much harder to de-silence inconvenient speech than it seems.

Your work is widely accredited for pushing forward thinking on the issues of vulnerability. In particular you have insisted upon moving away from universalizing tendencies, which often risk flattening out gendered-, racial-, and class-based distinctions. What does vulnerability offer us today in developing a meaningful critique of violence?

A few things. As a scholar of affect I tend to look at the difference between a structure and an experience of the impact of the world. So structurally *everyone* is vulnerable. We are all taking in the world and responding to it, being disturbed even by people and institutions we're attached to and people we don't know but somehow take personally as though their very existence were a challenge to us. Authoritarians are motivated by many things, such as [their desire] to consolidate ownership and control of the whole scope of life, but they also recognize their vulnerability to the uncontrollability of labor power and non-normative minds; so much terrible bullying and aggression live in the same space as the vulnerability that feels like an unbearable tenderness. The question isn't how does vulnerability provide a measure for restorative justice—it doesn't—but, what are the different costs people pay for defending themselves? That's another way to measure privilege: by way of the available cushions and defenses against the impediments of vulnerability.

Secondly, the structure of vulnerability—from living in toxic and unequal intimacies, working unlivable work lives that barely sustain our bodies and the comfort worlds we scavenge together—isn't always felt as vulnerability. It can be felt as desperation, numbness, realism, misery, mania, rage at others, radical confidence loss, or exhaustion and depletion. So one thing thinking with "vulnerability" can do is to expand our understanding of the difference between structural vulnerability and the piercing social atmospheres it generates. Another thing it can do is to make us realize that the ambition *not* to feel vulnerability is an asocial desire, since sociality produces being vulnerable to each other at many scales, in many senses.

I could go on, but thinking with your question makes me realize a few things. One is that the reason many of us choose "precarity" over "vulnerability" to describe a wearing state of exposure is that the latter seems more personal and visceral whereas the former always also points to what's formal and structural—impersonal—about what pressures ordinary living are on at the moment. The other resistance is that I don't share your desire for levers that allow for "a meaningful critique of violence," if "meaningful" means that a good critique will shift the terms in which violence reproduces its banality or predictability. I don't believe that a well-phrased critique will break the world-sustaining processes that protect the privileged, although that brokenness won't happen without critique. To break the back of the reproduction of the violence we repudiate (inequality, unfairness, racist/sexist/class biopolitics, for example) we have to disturb the intelligibility of the world, the terms of fairness, responsibility, and of consent, which actually is more likely in the short term to *increase* the experience of vulnerability rather than protect us from further proximity to it. That's another way to describe the machinery that animates the intensified frictions of the crisis of the historical present.

I fully accept here your concerns with "meaningful" critique as a critical leveller and the need to shift the terms of engagement in the order of what is rendered (in)telligible. I'd like to connect this back to your powerful phrase "unbearable tenderness." Can you explain a bit more about this in the context of the normalization of violence and abuse?

We call things unbearable when we are at a breaking point or broken one; we call things unbearable when we have to bear them. Unbearable tenderness is the state of recognizing that there's no protecting oneself from the world one is trying to survive—unwelcome, under-resourced, or with exhausted defenses. It points to an unrelenting receptivity that resists defenses. For activists, the ambition to survive the world *and* further disturb it produces psychic loads so very difficult to carry, seeking out breathing room for life while seeking to make *more* disturbance.

You have continuously warned of the dangers of focusing on the politics of the exception. Why do you think political philosophy has such a fascination with the concept? And what might we do differently when thinking about those ritualistic abuses, which are so normalized and part of the social fabric, they appear hidden in plain sight?

People are so powerfully attached to an image of the ordinary world as offering potentially a smooth life that they have to classify radical disturbance as an exception. Plus, critical theorists tend to cite Walter Benjamin's "state of exception" as though this is what he meant. There are lots of problems with this model of interruption, but to me the strongest problem is that to exceptionalize trauma presumes too much about the scale of the event, as though the first moment of intensity reveals an ontology of the event's significance. This especially matters in relation to the ordinary abrasions of unfairness or inequality, and is deeply ahistorical. Traumas happen within life, over time; so do ordinary disturbances. They spread throughout the lifeworld, the tradition, the constraints on imagining consequences, the projection of qualities on kinds of persons, the association of some kinds of person with some kinds of injury, one's own visceral responses, one's own dreamlife, one's conscious and unconscious bargaining and arguing with the world, et cetera. This is why trauma theorists have to talk both about events and environments, the atmospheres that shape one's capacity to attach to the world. The exception is an argument about and a wish that life doesn't have to be constantly disturbed this way. But to me, to stay clear-eyed in the scene of violence, we have to follow the many causes that induce incidents with a world-jolting force that

shakes our confidence in how to live. Exceptionality as a genre and desire gets in the way of that.

To conclude, I'd like to ask your thoughts on the recent high-profile cases and political responses to sexual violence in the workplace. How do you understand the intimacy of such violence, and what might we learn from this as it relates to academic settings where power relations are so apparent and also the capacity for abuse increasingly exposed?

Apart from my essay "The Predator and the Jokester," I've mostly been holding my public tongue on this topic because so many of the public writers on #MeToo and sexuality in academia are friends or ex-friends, and I can't depersonalize the debates sufficiently. My previous responses on genre flailing in the face of specific incidents point to the symptomatic distortions that we are *by necessity* offering in this early phase of the public exposure of the open secret of abuse, manipulation, and desire in workplaces.

Workplaces are at once vertical—demanding deference—and horizontal, demanding collaboration. You see in the terrible examples of cajoling, seduction, and threat that toggle between the equality presumption of collegial interdependence and the enforcement of deference hierarchies when power feels neglected or insufficiently amplified. Virginia Woolf predicted this long ago in *A Room of One's Own*, representing woman as that being who's forced, simply by convention and not by extraordinary monsters, to lubricate every situation of difference by magnifying the power source back to himself as twice his size. Femininity as a training in flattery and the going-underground of critique.

My main response to this moment of revolt is to be flooded by flashbacks to all of the crap I've given and eaten in my career. I needed and continue to need an education in how to deal with the queasy combo of interdependency and violence involved in maintaining a gatekeeping hierarchy, as academia is. Then there are all of the manifest and tacit misogynist insults I've been hit by that are not just against women in general but against the way I wear gender—all my desperate attempts to be a clarity machine but not too scary, but being too scary and compensating with an amped-up warmth, while committed to

being reliable and direct but not a jerk, and not always succeeding at that. Then there's the difficulty of bearing the pressure of what feels like an over-personal commentary stream—women are policed, including by each other, like crazy. Then there's trying to propose concepts that might clarify the costs of the difference machine whose wreckage is everywhere around us.

Living as the negative subject of *any* inequality requires *so* much creative energy to be taken up in microadjustments and improvised defenses: at least the intimate publics of subordinated peoples communicate these strategies and provide life-affirming solace and generative direction. Thus, it's a moment of increased and uncomfortable exposure here too in #MeToo, where a better adjudication of injustice is being worked out but only in some places, and there, inevitably, awkwardly. To change our genres we have to be stupid and exposed in front of each other; it's no good to retreat into some free past that was never free, but to unlearn the habits of maintaining a system just to get through the day, the week, the month, the life.

7

The Anatomy of Destruction

Brad Evans interviews Gil Anidjar, September 2018

Gil Anidjar is a professor in the Department of Religion and the Department of Middle Eastern, South Asian, and African Studies (MESAAS) at Columbia University. This conversation explores the theme of destruction through weaponization, the unbearable thresholds for existence, the intellectual legacy of Derrida, historicism, and blood.

BRAD EVANS: We cannot think about violence without some relationship to destruction. Whether we are talking about the destruction of bodies, lives, cities, or potentially the entire planet, to maim or to kill something implies a certain devastation and negation. And yet, as you have argued, the concept of destruction itself is under-theorized. What do you understand by the concept, especially in terms of violence and its affects?

GIL ANIDJAR: Following the conversation we had for the "disposable life" project, I began to work on weapons, and more broadly, on means of destruction, a topic that seems to have interested primarily military historians and students of science and technology, rather than philosophers debating power or violence. Beyond the question of means, however, and specifically with regard to destruction, I found myself predictably looking for a vocabulary. In the nuclear age (the phrase seems as quaint as it remains accurate), which is also the age of drones, of global immiseration, and of environmental devastation, it would be banal to assert that the word "violence" has lost its capacity to describe and its power to affect us. Its numerous qualifiers notwithstanding (ethnic and religious violence have long been at the top of the list, along with political violence, with sexual violence perhaps rising in the current consciousness), we seem to have endowed every aspect of

existence with a measure of violence, at the same time as we continue to dream (awake, as Steven Pinker seems to) of a world with less, or even without, violence. A more positive way of saying this is simply that the word "violence" (just like the word "war"—on cancer, drugs, poverty, or terror) is made to bear too much of a burden, made to account for too much. I am still uncertain of the value of what I seek, but I do wonder whether we might gain a different measure of understanding were we to disentangle violence from destruction.

One consequence, it seems to me, would be to recognize that, just as worlds may end with a whimper, destruction can occur with no violence to speak of. Consider plastic (it might once have seemed trivial to juxtapose it to war) and what it is doing to oceans and to life as a whole. Or think of the effects of corn syrup on human health, think of antibiotics or of radioactivity, of animal extinction. Much is being destroyed with no violence at all, far away from any field of open conflict, and short of immediate lethality too (but we know very well that death is not always the worst that can happen, that much can occur that brings life to unthinkable thresholds of unbearability, with torture techniques or entire camps, for instance, or else a "health system" seemingly designed to keep death somehow at bay, and letting in much worse). Granted, it remains possible to identify a certain kind of violence in these, in survival itself, in the privatization of water or of schooling, which makes both inaccessible. One might also argue that violence is *always* destructive. But even then, it would mean thinking violence under a different, perhaps a larger, more differentiated heading. It would require that we suspend, if only for analytic purposes, the question of violence and turn our attention to destruction. It would mean altering the map of our concerns and render thinkable a different range of things in their vanishing, however extended, complete, or final.

A second aspect of my sense of an impoverished vocabulary has to do with the manifest expanse of our lexicon of action and of production, of making and of doing, of work and agency, construction and performance. The no-doubt necessary hegemony of activity and activism (barely countered by a few thinkers of passivity, and fluctuating victimologies) has left us with few resources to think destruction outside of dialectics (the proverbial omelet), or as anything else than a kind of waste or "collateral damage." Destruction, although

it is clearly ubiquitous, and increasingly visible around us, has no analytics, no typology, no dedicated perspective—assuming such is even possible. Even violence, unleashed in and by collectives and, of course, by states, can often be discussed with no consideration of the means by which it is exercised (even Clausewitz could not be bothered to think about weapons in any serious manner). Everything is as if politics (what Hannah Arendt insisted on calling "world-making") is only destructive, world-destroying, by a kind of unfortunate necessity, by accident, perversity, or evil. The misuse, perhaps, of a technology that could go both ways, always both ways. Law, to take, perhaps, a different example, has destroyed countless lives (from property to slavery and genocide) but it is doggedly conceived as "constructive," a realm of deeds, actions, and decisions. "Just do it" is a ruling motto as we strive to be, or imagine ourselves, *make* ourselves (great again) into some version of *homo faber* or *homo laborans*. Never *homo vastans*. Like Aristotle, we appear to think that becoming nothing is merely the reverse, if not a mere side effect, of becoming, of coming to be.

Destruction is, as I said, everywhere. And it is many. We are surrounded by it and it is all over the news, all over history. Think of the old and not so old gods of destruction, of biblical or medieval plagues (one could go, literally, kabbalistic on the beginning and the end of the world); think of "creative destruction" (Marx, Schumpeter) or think, again, of the ongoing destruction of the environment. We know that destruction is upon us, and we can recognize it in everything we see, watch, and read (the spectacular destruction that takes place in film and popular culture would deserve a discussion of its own). We are, you could say, witnesses to it, albeit hardly passive witnesses. Few, at any rate, have seriously pondered destruction in a sustained manner.

Learning from Avital Ronell, I have tried to argue that Heidegger is among a handful who did pursue a thinking of destruction. Heidegger did not advocate for destruction—he was no Nietzsche—but he proposed a typology of destruction (incidentally, a highly troubling one, as troubling as other and very much related issues that have attracted much more attention), where he discriminates between destruction, extermination, and devastation. Anticipating Foucault, who distinguished oppressive and coercive power from productive and enabling power, Walter Benjamin had earlier identified three modalities of power: constructive, preserving, and destructive. It is, I

think, crucial that Benjamin placed that last one in radical discontinuity with the previous two and called it "divine."

Simona Forti intrigues me, therefore, when she argues in *New Demons* that, under the "Dostoevsky paradigm," power is dominantly thought of as primarily destructive. On the one hand, I completely agree. On the other hand, I keep encountering, and puzzling over, iterations of the Foucauldian *doxa* I just mentioned (one might call it a Vichian *doxa*, after Giambattista Vico and his "verum factum" principle). Georges Bataille could have put it even more paradoxically than he did in *The Accursed Share*, when he wrote that "[w]e can ignore or forget the fact that the ground we live on is little other than a field of multiple destructions. Our ignorance only has this incontestable effect: it causes us to *undergo* what we could *bring about* in our own way, if we understood." But "we" (whoever this we might be) are bringing it about, and Bataille's prophetic tone is sadly warranted as this ignorance "consigns men and their work to catastrophic destructions."

When we encounter forms of destruction in our media-saturated age, often the focus is concentrated upon exceptional events that have a distinct temporality and spatial reckoning. Such destruction often centers on the spectacular eruption and apocalyptic narratives of ruination. What happens to our understanding of violence if the speed and intensities for worldly destruction are slowed down and re-concentrated?

It would be excessive to propose that there is always something manifest or spectacular in every instance of violence. Violence can be hidden, covert, and most importantly, denied. If I insist on the need to disentangle violence and destruction, it is because the temporality of destruction is not only distinct from the temporality of construction (the atomic bomb vaporized people and buildings in an instant, at a speed which no construction site could ever match, let alone repair or redeem). Destruction may also be distinct from the realm of action (at least any legal model of action), or again, from any recognizable violence (*Atomic Homefront*, the HBO documentary, exposes the radioactivity still found in St. Louis, Missouri, the effects of the uranium imported from the Belgian-colonized Congo during World War II for the making of the bomb). The role of the bulldozer (a word

with roots in the violence inflicted on Blacks in America) in what we still call the reshaping of the American landscape is as evident—and as invisible in its destructiveness—as the effect it continues to have on Palestinians. In this country, nonwhite and poor minorities have been repeatedly displaced, their dwellings destroyed by this "constructive" technology.

But how do we even measure the destructiveness of BPA, of insecticides, and of the endless array of chemicals that are now an "active" part of our environment? What do we make of surveillance as a destructive weapon? Ivan Illich spoke of the siren of an ambulance as destroying the most basic of solidarities. In a proximate register, what might we recognize as "economic weapons"? What national and international laws? What policies? And what exactly is the nature of our current regime of consumption (a word which the dictionary still lists first as a synonym for destruction)? What "destructive drives" (to invoke psychoanalyst André Green) have ruled and governed us? And if they have, should we not think of regimes and of conditions, of modes and means of destruction? In addition to documenting instances of violent destruction, or countering them with more destruction, should we not try to formulate an account of destruction? An account of ourselves as and among vectors of destruction?

I sense your work has been notably indebted to many scholars within the so-called "continental" tradition, notably Jacques Derrida. I have always been struck by his often-forgotten work on ruins and how this allows us to rethink the violence of time. How do you understand ruination and are we not already walking among the ruins of the present?

Derrida has been a constant inspiration, yes. I had not realized the extent to which destruction is inscribed throughout his work. From the first book to the last, for instance, Derrida returned to Husserl's *Ideas*, and to a paragraph in it (§ 49) that formulates the phenomenological approach as a kind of apocalyptic exercise, in which consciousness operates as a remnant of the annihilation of the world (*Weltvernichtung*). But destruction, the destruction of the book and the famous destruction by fire of *The Postcard*'s correspondence, Freud's death drive and the Holocaust, and yes, you are right, traces and ruins,

are found all over his work. Derrida early on made clear that decon-struction stood in a difficult proximity to Heidegger's *Destruktion* and to Husserl's *Abbau* (these two concepts were cited again and again in Derrida's early work). The oft-repeated claim that none of these terms have anything to do with destruction (every word purified to some catachrestic core) opens a space of interrogation, the rudiments of an analytics. The necessary possibility of death that is the condition of possibility of writing, of the mark, in general, implies a sustained reflection on the question of destruction, on technology as a means of destruction, and it is one that Derrida sustained in his writings on Heidegger and Freud, Benjamin and Celan, and more. The seminars on the death penalty are meticulous in their attentiveness to the means of execution. But I have barely scratched the surface in what I have written about destruction in Derrida and elsewhere.

If Nietzsche was true in his claim about nihilism as being the devas-tating motor of modern history, then we might see the capacity for destruction as something intimately woven into the fabric of those societies that claim to eradicate its presence. How does the destruc-tive impulse lead into self-destruction and the self-authoring of a certain will to extinction?

I hesitate to equate destruction with nihilism (and vice versa), or even to historicize destruction. Since Vico, history has, after all, been the history of *making* and of *production*, which may have to be recognized, albeit too easily, as ultimate markers of nihilism. On the other hand, I am certainly struck by the fact that modern weapons have all originated in the West (which would finally come to existence, perhaps, as a series of exercises in "destructive creation"), but I am trying not to draw familiar conclusions, unavoidable as they might be. Nor would I presume to offer an account that ties destruction in a determined manner to the desire to eradicate it, to destroy it. We do know (from Derrida, among others) the violence involved in the effort to eradicate violence. And I very much agree with you that, as we think about destruction—with and without psychoanalysis—we must attend to self-destruction. I already mentioned André Green, but after Sabina Spielrein, after Freud and Melanie Klein, and also away from them, it was Donald Winnicott who famously established destruction as a

necessary condition for learning to cope with and make "use" of reality, an essential moment in the relation of parent and child (the fear and willingness to be destroyed), though I imagine the psychoanalysts, like the Heideggerians, will rightly say that "destruction" does not mean destruction here either. Catachresis returns. And yet ...

Derrida's elaborations on the auto-immune, whereby a protective mechanism functions as a vector of destruction away from production as its binary opposite, provide another opening. There is crucial guidance here (closing all borders to everything "foreign" would not be a good plan, would it? Then again, there is cause to wonder, in this context, about the meaning and consequences of the claim, or the desire, for autonomy and independence). Let me refer to the nuclear, again. Joseph Masco has brilliantly described in *Nuclear Borderlands* how the USA is a country that has bombed itself—and poisoned itself—to an extraordinary extent, and always in the name of self-defense and self-preservation, protection and security. Every nuclear "test" (which is to say, the actual, devastating explosion of a nuclear device above or underground) has raised the level of radioactive contamination and caused untold damage to the country, to the planet, and to life as a whole. Is this protection or destruction? Does it matter, in this context, that the word "fence" (think: the art of fencing) bears the meaning of both *offense* and *defense*? That each of these terms is, to some extent, pleonastic? The best defense is offense, we often say. But are we so certain of the difference? Erecting a wall—forgive me, a security fence—is hardly a friendly gesture, nor is it merely protective, if at all. And what to make of the fact that the Israeli nuclear option (which does not officially exist, but is well documented) was named "the Samson option"? Is this not—in the 1950s—the introduction of suicide bombing in the political imaginary of the region? A collective program of suicide bombing? But "the suicide state" takes many forms. Hannah Arendt understood the launching of Sputnik as strictly parallel to the development of the atomic bomb: the "making" expendable of the planet. The path to its destruction.

I'd like to conclude by turning to a quote from Michel Foucault's *Society Must Be Defended* lectures in which he argues, "We are always writing the history of the same war, even when we are writing the history of peace and its institution." We know that war is often

carried out in the name of the human. And that in the name of civ-
ilization and global security, we are able to bring our very existence
and survival into question. But how might we rethink the violence
and destructive impulses of the human in more intimate ways?
Might a return once again to the concept of blood (which you wrote
about extensively) allow us to open a better ethical discussion into
the wounds of the earth?

I admit to having long been intrigued by historicism, and by Foucault's
version of it in particular. History—whatever that word designates
today—is certainly something to learn from. But there are other
concerns, other ways of knowing that seem to me equally important to
consider and deploy. And Foucault himself, protean as he was in the
objects he studied and the way he studied them, could certainly not
be content with war and peace. At this late hour, it is ever so daunting
a challenge to know what it is that we are studying, what it is that we
should be attentive to, and whether we are truly capable of learning.
We know many of the ways and means through which the planet has
reached its present stage. Do we still want to call it progress? Talal Asad
has pointed out a peculiar "style" of the West. Asad recalls that, for the
longest time, the accomplishments of progress were claimed—are still
claimed—by one particular segment of "humanity." This segment saw
itself, still sees itself, as more advanced, more discerning, than what it
called the "lower races." Now that the planet may be past the point of
no return, it would be all of us, all of us humans, who, finally equal (in
responsibility if not in privileges), are supposed to assume responsibil-
ity for what "we" have done. I find this puzzling too.

The spread of blood as the element of Christianity was for me an
attempt to contend with political transformations that occurred and
implicated the state, the making of race and of nations, science and
political economy. I am now curious about destruction, but again,
primarily as a collective problem, indeed, as a political vector or
dimension. I do not mean to sound heretical, but I am less sanguine
about locating or studying destruction in terms of subjectivity or sub-
jectivation. I do not think the question is whether guns or people kill
people. Ethics cannot replace politics, for it takes more than individual
men to mass produce and market guns, to create a culture of impunity,
where one can demean and assault women—or kill Black men; more

than a village to invent and spread race as a mode of governance, extract oil and palm oil too, make corporate law, deregulate banks and cage children at a border, or drown thousands in the sea at another; more to create Sarin or napalm, build ICBMs or fleets of drones, and declare the war on terror, transform every airport in the world as well as the way we "communicate" with each other in an age of echo chambers. If destruction takes us away from the formation of subjects and from social construction, what remains with and after destruction? What is war? What is peace? What is destruction? What destructions are there?

8

The Intimate Witness: Art and the Disappeared of History

Brad Evans interviews Chantal Meza, October 2018

Chantal Meza is a Mexico-based painter and sculptor, whose award-winning work has been exhibited widely. Beginning with a mediation on the importance of art and aesthetics, this conversation engages with a number of problems, including the witnessing of suffering, violence in contemporary Mexico, the importance of the abstract, on to states of disappearance.

BRAD EVANS: Not only does your art capture in a compelling way the raw passions and emotions of life, it also shows evident traces of life's pains, traumas, and its violence. As an emerging artist whose work is already being widely celebrated and recognized, why do these subjects command your attention?

CHANTAL MEZA: I turn my attention to what causes pain and suffering because I consider that life has to deal with these realities. Many things concern me as an artist. But I feel that when I paint, not only am I recognizing the pain, I am also able to expel it from me. It allows me to deal with the traumas of life. But I don't try to deal with this reasonably or rationally. Such coldness is often the cause of so much cruelty, anguish, and human devastation on this planet.

Countering pain through art demands paying close attention to the sensations that life offers. As Byron once said, "The great art of life is sensation, to feel that we exist, even in pain." It is to connect with something of the human *in* life, to absorb the world around us, and to master the explosion of emotions and to be able to download them in a pictorial way. Painting is a creative explosion as opposed to a devastating one.

But I have nevertheless still questioned my profession on many occasions. I am continuously burdened by the question of the usefulness of art. This has become more and more acute as I have tried connecting my work with realities in my country. Confronting injustice has brought about a dramatic change in how I see this land and the purpose of art. If I paint the horrors, the traumas, the violence, it is because I believe it hasn't been given proper attention. Art can bring light to that which is somehow occluded. And it allows us to dwell on widespread problems that are affecting us, slowly, gradually, and yet surely. There is still a profound indifference to social problems in this country. I find it terrifying to witness people's amazement when they see what is happening. It's as if they have been living in some trance, which denies any mutual responsibility. In order to improve social justice, there is always a need for a constant commitment in battle concerning how we see and relate to the world around us.

The best resources I can bring to the realities of social injustice and ongoing suffering are through my paintings. And I then try to let the work speak for itself. I am not interested in producing propaganda. I simply want to change perception and feeling, which is the real revolution, is it not?

I do appreciate sometimes it is more comfortable to ignore the plight of others. We can even, as societies, reduce terrifying events to pitiful facts in ways that ultimately absolve us of any need to fight them. This has everything to do with individualism, which in contemporary Mexico is so deep in our subconscious, that when we are now faced with the suffering of others, it is removed from any sense of obligation. We know the pain is there yet refuse to acknowledge it unless it becomes our problem and concern. This is a form of exclusion—a retreat into our own mental universe that leads to the greatest selfishness.

Like many countries, Mexico is a land full of contradictions. Why do you think the arts have an important political and social function for people there today?

In Mexico, as you say, the contradictions are so apparent, its pain and poverty, its love and terror, its color and despair. It can be beautiful and monstrous at the very same time. But Mexico is not unique in

this regard. Certainly, Mexico has its own distinct history and culture. And it retains its unique magical resonances. But humans are full of contradictions. And so, the things they create can be contradictory. We can produce tanks and nuclear bombs and we can produce the most inspiring works of art and cultural outputs.

Art is a human creation. And it is something I like to consider as divine. I don't mean divine here in an orthodox religious sense. Though it is certainly spiritual. I like to think of art as being something that allows us to tap into those human qualities that are often difficult to put into words. Hence, while the work might be abstract it is not *abstracting*. Just because something appears abstract doesn't mean to say it's not real or doesn't connect in a meaningful way to people's everyday lives. It is messy, complicated, and disrupting, because life is messy, complicated, and disrupting, especially once we factor in our emotions.

Let's just take the human capacity for empathy, for example, which I would argue is one of the fundamental ethical values and qualities of art. Art is about showing empathy for the suffering of the world. As a tool of expression, it confronts in its own unique way those intrinsic qualities that exalt and raise in an unusual fashion the events that have shaped our society throughout its history. Just as we might talk about Mexico being profoundly shaped by its wars and revolutions, we can also talk about its artistic transformations, from early indigenous artisans, the Mexican Baroque, the great muralists such as Diego Rivera, David Alfaro Siqueiros, and José Clemente Orozco, on to more contemporary forms of artistic expression that arguably began with Frida Kahlo.

All of these artists have changed the inner and outer qualities of Mexican life. They have also shown the extent to which art talks about social and political issues. It can put on the walls issues that are lived on a daily basis, and in doing so expose people in alternative ways to problems that can generate dialogue. Knowing problems exist is one thing. Talking about them is another. And this is the challenge modern Mexico faces.

You've mentioned having self-doubts about the relevance of art when confronting violence. How would you counter criticism of art

as being self-indulgent or complicit in the logics of power? And can art truly lead to profound political transformation?

It depends what we mean by transformation. It is difficult to see art changing established structures of power. And I am not so naïve to think a painting can absolve crimes against humanity, whether they take place in Mexico or anywhere else on this planet. But let's not forget the importance of art in documenting historical atrocities. And let's not also forget that painting is a language, it is my language, through which I am able to think and rethink, to criticize and propose, to question and reframe difficult social issues and their legacies. Art in this context is not about retreating into one's studio or exhibition hall, as much as writing is not about simply being sat at a lonely desk or to be subsequently read quietly in the peaceful and tranquil setting of a library. If art has any meaning, its presence must be felt on the streets and in the homes.

In this regard, I would argue that what art can reflect, at its best, is the awareness that we have an enormous potential to transform without doing harm and that we have the real and tangible capacity to recreate this reality. Art can be the counterweight to violence. It is the poetry of nature. In order to change things for the better, we need to believe transformation is possible. This can only be achieved by overcoming states of inertia, which paints us in an image of mere nothingness, helplessness. Art shows the human in a state of elevation, where its potential rises, and spreads through its creations something as amazing as nature itself. This is why the natural world so illuminates me.

But going back to your question, I would also say it's not about whether art can help overcome injustice. This is too reactionary. It is more compelling to ask: What might a world without art actually look like? Well, it would be uniform, dull, gray, suffocating, and unimaginative. And now ask what this would mean for our understanding of politics.

Your work is noted for bringing together contemporary abstract styling with very traditional methods, which are local to your area of birth. Can you tell me more about the methods you use and why

you feel it's important to retain these older artisan techniques when you paint and sculpt?

I am fascinated by the rich history of artisanal culture in this country. My father was an artisan. I come from a family of artisans and I have grown up among many local artisans and craft-persons, whose unique regional skills date back to the pre-Hispanic period. My methods have incorporated these skills, from subconscious memories and direct family participation, learning to apply them in novel ways. I like to think I offer a synergy of styles that represents both a marriage and crossover between the old artisan techniques, which include the direct use of hands, and materials such as Onyx, and more contemporary ideas about the need for sensual abstract engagement with the world. I like to think my art provides a visual memory of experience.

That is why the methods I use are linked closely to these more traditional crafts. I often paint with my hands and not with brushes. This gives me a certain freedom, to feel free in my expression, in a contradictory peace with my surroundings and lived environment. I would however like to say that this didn't start out as a conscious choice. But I think having not gone to an art school was perhaps an advantage. Or at least I was forced to use what was already in me. Having no pictorial influences as such, I took the forms which were already registered in my memory, coupled with past generations, to express myself.

I think it is important to make a connection with these crafts, because in Mexico we have an immense number of artisans who are underappreciated and yet give us huge creative wealth. It is incumbent upon contemporary artists to collaborate more with the craft-persons, because then I think we could create a better language that is more reflective of the artistic heritage of this country. While the importance of artisans has diminished, they can and should be a great source of inspiration, not only in terms of how we see our history, but also reimagining the future of Mexico. To achieve this, artists need to show more humility toward the artisan, allowing us to forge now collaborations with that cultural wealth and learn to build expressive partnerships.

This would also allow us to connect better with our natural environments. Artisans have always appreciated the beauty of nature and its resources. Inspired by this tradition, my natural influence has always

been the charm and mysticism of the stone; its streaks, colors, the way its textures melt. Maybe it is right to say that nature is the greatest artist of all!

As you have already mentioned, when we think of the history of Mexico and its art, it's difficult not to be drawn back to the work of the great muralists such as Diego Rivera or José Clemente Orozco or the more intimate and yet no less political work of Frida Kahlo. Can you tell me about the artists who have influenced your work and its direction?

Each of the artists you mention is important because they are very marked with political speech. I think it is important what they did at the time, but there are many others who are less known in other countries. As I said at the beginning, I didn't have a real influence from other artists, as I never studied the history of art even though I knew of their work. We need new forms of expression that connect to the life of this nation. But I also see how historical works and painters come to mean something to you at different stages in your life and your work. I can look at the same painting on two separate days, and its meaning and relevance can be altogether different. I also feel the same when I paint. The work lives and breathes, like we live and breathe.

At this new stage of my work, I am touched by the art of Francisco Goitia, Rafael Coronel, and Francisco Toledo. I admire the force with which they can transmit the desolation, the loneliness, even the black humor so representative of our country. They also address the darkest parts of the human being, its more disturbing inner psyche, powerfully expressing the emptiness of the people and places that were lived in those times. But I also can see that relationship with the time I am living in. So, I am still learning and looking at their work every now and then, which not only shocks me each time knowing things haven't changed that much, but allows me to rethink the present moment.

There is a particular piece by Goitia called *The Witch*, which for me expresses our current life and emotional state of mind in Mexico. The painting is small, dark, rough, and simple. In the middle is the face of a woman, whose features give the impression of a cave, which opens onto a place you wish you didn't have to enter. Her other features, such as the nose, cheekbones, and eyebrows, are indistinguishable due

to her disfigured face, which looks like it has been attacked by fire, emphasized by the use of thick oils.

But it's the witch's eyes that capture your attention, though not in a simple way. She has the eyes of a fallen woman, and yet they see you. Her eyes look lost in the wilderness; but despite the horror, they do not yell at you, they do not implore you, they do not demand or judge you, they are holding your gaze. This for me invokes the most intense contradictions. One of the most surprising things for me is that despite the truly horrible aspect of this image, it continues to demand your attention. I cannot look away. And yet, what is also disturbing is that you cannot distinguish what this woman asks of you—it is only a representation that causes you anguish because you cannot really decipher its call.

And so, thrown into this stream of confused emotions, when you walk away and observe it from a distance, you feel and hear a devastating shriek that comes from the image, from eyes that no longer look down but appear exorbitant, and in that moment you can feel the madness on display, like you are observing the unbearable. Such madness, which Goitia captured as a testimony for his time, I see happening and being continued in my country today. Where the image of that woman is being reproduced in our society, over and over, screaming in silence.

To conclude, I'd like to ask you about the current *State of Disappearance* project, which we started developing (as a result of numerous conversations about your work) and which invariably addresses violence head-on. Why do you think it's important for artists to deal with disappearance and what message do you hope the work will communicate?

If art is to deal with the question of violence, then it must confront the kidnappings, femicides, repressions, clandestine graves, enforced disappearances, the murders of journalists, extrajudicial executions, as well as the indifference to such horrifying crimes. More insidious than state brutality, this type of violence I find truly terrifying, especially as a woman who lives in a society where such violence is endemic. I really believe it is essential to generate a critical discussion and insist upon new approaches to these pressing issues.

The main concern for me is to deal with the relationship between the viewer, the perpetrator, and the victim. How can we witness something that is beyond witnessing? And through this we might ask: How do people end up in that position of vulnerability? Are we only spectators to these crimes in the absence of their physical presence? And to what extent could we help by trying to recover something of the memory of the victims by producing new visual testimonies, which dignify their existence?

Elena Poniatowska recently said, "Maybe you want to write a love novel with lots of kisses and you wake up with a lot of enthusiasm to do it, but you find that last night 43 students were disappeared, or they killed people in a colony, etc. There is such a terrible reality that also pulls you to the street, that you feel that reality comes to your house and annihilates you." Daily violence insists that you have to address these issues. It requires turning your gaze and looking no matter how horrifying that reality is, because then we can offer solidarity with those people who have needlessly suffered. Once we are aware of these states of terror, it is possible to ignore the circumstances or deny their existence. I want to convey the thunderous cry which echoes the devastation many are feeling, and try to awaken others with its call. This is where I truly believe art can do something positive. For what is art if not an ethically and empathetically considered testimony to the idea that we are born as collective individuals, who, forced to confront the pain of existence, still retain something magical in how we make sense of the world?

9

The Death of Humanitarianism

Brad Evans interviews Mark Duffield, November 2018

Mark Duffield is Emeritus Professor at the Global Insecurities Centre, University of Bristol. Outside of academia, Mark was Oxfam's country representative in Sudan during the latter half of the 1980s. He has extensive experience of conflict and humanitarian disasters in Africa, the Balkans, and Afghanistan. This conversation reflects on the changing nature of humanitarianism, post-coloniality, and the digital recoupment of aid.

BRAD EVANS: For many decades you have been writing about the dangers of humanitarian interventions, especially the way in which aid has become complicit in the politicization of very particular notions of endangerment and how this leads to the de-politicization of containment of populations. What do you think have been the most significant changes when dealing with such issues in recent times?

MARK DUFFIELD: The world has changed. Or at least, late capitalism arrived with the comprehensive penetration of all aspects of social, economic, and political life made possible by information and logistical technologies. We know that global interconnectivity has been accelerating for decades. What's new—*or late in the case of this stage of capitalism*—is that the digital world no longer requires the direct intellectual mastery, management, or even the skilled labor it once relied upon. Humans are out of the loop, as it were. But rather than resist, we seem to be exchanging what autonomy we had for—at most—the promised security of a social-robotic future. This is not the world of science fiction. It is the exclusionary violence of our digital present.

My current work has been examining the global implications of this computational turn. In particular, I have been interested in looking at

the leapfrogging of mobile telephony into the vast informal economies of the Global South. While important differences remain—not least in terms of the speed and reliability (including surveillance) of technology—North–South distinctions have narrowed and blurred.

With China's Belt and Road Initiative as an example, huge privately financed continental, and even transcontinental, infrastructural mega-corridors are emerging globally. These logistical conduits interconnect transnational archipelagos of smart-hubs, high-bandwidth portals, and fast inter-connectors. Special economic zones have stretched into multi-juridical ribbons stretching across and between the Global North and South, while integrating commodity chains with growing hinterlands of grounded production, assembly, distribution, and marketing infrastructures. We cannot underestimate the impact this is having on all aspects of our shared planetary existence.

Matching this revolution in business logistics (which has been championed for some time, just think for example of Bill Gates's *Business @ the Speed of Thought* that also has a disturbing chapter on war), a global precariat has emerged to service these sites and infrastructures. Global precarity marks the advent of what could be called a post-social world. Associated with the casualization and disappearance (if not outright obliteration) of formal work and its contractual protections, precarity now thrives in an economy that has become a site of permanent emergency. An economy that seamlessly shifts from crisis to crisis. So, compared to our modernist past that at least offered some semblance of equilibrium, volatile market forces are unmediated by any national-, public-, or company-based forms of collective social protection. The zeitgeist of this re-wilding is resilience.

Mega-corridor investment bypasses the precariat. Or at least, the growing hinterlands of urban decay, slums, camps, and ruins that have no access to a fixed grid of services. It works by constructing the physical network that is necessary for a connected world, while excluding most humans from its processes. In particular, the boundary architectures that distinguish corridors of international mobility from hinterlands of terrestrial immobility. These corridors simultaneously demarcate and interconnect the smart city and the wired slum, so to speak.

How does all this force a reconceptualization in the understanding of "underdevelopment," which, although often reduced to economic concerns, has more often been a catalyst for political intervention?

As you point out, in the past, the vast informal economies in the South were seen as epitomizing "underdevelopment." Given that poverty was argued to increase the probability of violence, the parallel economy was often depicted as a source of endangerment. Development was about the formal incorporation and regulation of informal behavior. This is no longer the case. Slogans like "inclusive capitalism" or the "gig economy" have helped positively revalue the casualization of work. As one of its greatest achievements, late capitalism has captured connectivity and repurposed it to exploit precarity itself.

All of this has been made possible with the introduction of smart technologies, which have the ability to fold downward, if you will, into the social fabric of society. Smart design adapts to and personalizes the inequalities, speed differentials, and mobility entitlements encountered on the ground. What we also see is how connectivity continually unearths new behavioral profiles while building smart architectures to contain and exploit them. Rather than eliminate precarity, it encodes and reproduces it. And in doing so, it normalizes insecurity across the planet.

These broad structural changes are the foundations of a design-driven post-humanitarianism. Rooted in the business sector, it is concerned with trialing the technologies and nomadic infrastructures that can govern and support life in an off-grid post-social wilderness.

In separating itself from the failure of past development efforts, post-humanitarianism changes the meaning of "indignation" and "community." The political scorn once directed against want has been transferred to indignant automated humanitarian technologies. Rather than reconstruction, they aim to resolve the absence of fixed utilities, services, and social protections through the medium of personalized smart survivalist solutions. If the state won't save you in times of crises, there is an "app" fit for purpose. Whereas communities once aspired to local self-management, smart technology creates "user" communities permanently enrolled in prototyping their data-dependent governance. While this post-humanitarianism may be logoed, glitzy, and smart, it has to be questioned.

In mapping out the changing nature of humanitarianism—not least the advent and legacies of humanitarian warfare and the violence carried out upon and yet mobilized in the name of the globally dispossessed, you have shown how the concept has, through its own hubris and enthusiasm to govern global populations, put itself into crisis. I am thinking in particular here of the ways aid policy remains racially coded and continued to operate by seeing "Others" as a problem to be solved. How do you think this all connects to the history of colonialism and so-called "enlightenment" principles?

The world we have inherited has been shaped by colonialism and the struggle against it. Since the mid-twentieth century, each new generation has continued to think and respond to that struggle anew. Today, colonialism is popularly depicted by referencing its violent and exterminatory episodes, like King Leopold's infamous Belgian Congo. In answering your question, this understanding has to be enlarged. Importantly, there is an enduring relationship between colonialism's exterminatory impulse and what nineteenth-century liberals celebrated as an enlightened "new imperialism."

Liberal imperialism during this period defined itself as morally superior to the exterminatory excesses of the time. While willing to use force, it publicly embodied a more enlightened, even progressive, evolutionary and paternalistic tutelage. Liberals imagined the colonial future as a process whereby representatives drawn from the "better" racial stock (those capable of being trained and "ordered") would incrementally assume—*in the fullness of time*—more self-management responsibilities.

When anti-colonial struggle was at its peak in the 1960s, the disappearance of old colonialism overlapped with an expanding aid industry. Many former colonial officers, especially those wanting to give something back, transferred to the new UN agencies and NGOs. Liberal imperialism was reborn as an even more "enlightened" education-based developmental tutelage. Through the pastoral teacher/ pupil categories of information, skill, and technical know-how, old race, class, and gender divisions were reworked and reimposed in the nuanced distinction between "development" and "underdevelopment."

In response to the multiple expressions of resistance in the Global South, more recently an assertive liberal interventionism emerged.

Compared to the past, however, this was different. Rather than promote or impose "civilization," it was a call to defend a civilization now felt to be exposed to widespread new threats. Is it possible to read in this loss of confidence a defeat? Does it explain why late liberalism appears to have reached back, as it were, and become more exterminatory?

When one takes into account the vast destruction of urban infrastructure, social dislocation, and associated blowback (the refugee crisis being an obvious example), the violence and political bankruptcy of liberal interventionism has been extraordinary. Working through a range of forces, since the 1980s, modernizing countries like Lebanon, Iraq, Libya, and Syria have been, counter to the political proclamations, subject to urbicidal de-development. A mixture of physical destruction, punitive sanctions, and external interventions has scattered their professional and scientific classes, collapsed public life, destroyed fixed services, and shortened life expectancy. Established multicultural milieus have been torn and divided into their competing component groups.

This violence seems intrinsic to a polarizing world, a world that is pulling apart just as connectivity is deepening. Borders are being entrenched, architectures of containment are spreading while, at the same time, xenophobic currents are mobilizing around the expulsion of difference.

If there is today a connection between colonialism and enlightenment principles, it is that these principles have died. Or at least, they no longer hold back the exterminatory techno-barbarism that was always lurking within modernism. While there are many dangers, however, it is also a call and opportunity for recalcitrance.

While you have always shown a healthy suspicion with the triumph of technical modes of thinking, more recently you have been addressing the explicit technologization of humanitarian interventions to show how we are becoming increasingly remote from the intimate realities of suffering at an all-too-human level. Why does this focus on the technological now concern you as a critical theorist?

My worry is that the possibility of critical theory and critical agency is being eliminated. Technology is usually thought of as prosthe-

sis. It is seen as a force multiplier for human will and effort. With humans out of the loop, this is difficult. Moreover, reflecting the rise to dominance of a cybernetic episteme, the different historic potentialities of knowledge and data are now becoming clearer.

Knowledge is framed by deductive narratives of history, causation, and reciprocity. It can be used for good or ill—from the most remarkable cultural and scientific achievements to genocides and unspeakable evil. Knowledge is essentially ambiguous because it is not closed on itself. It allows doubling-back, reflection, and critique. Since knowledge can reorder the past in order to call forth the future, it is political. Unlike a machine, even the slave can dream of freedom.

Data is different. As an aid to sense-making, it privileges inductive reasoning and algorithmic pattern recognition. Thinking becomes calculation. Let's not forget that cybernetics emerged in the mid-twentieth century as a New World solution to the ideological catastrophes of the Old World. To achieve mathematical objectivity, ambiguity was designed out of an increasingly black-boxed human–machine interface, as pessimism regarding the human condition grew.

Reinforced by the shock of the Anthropocene, the "necessarily ignorant" neoliberal subject has replaced the rational *homo economicus* to become our new guide to the connected world. Save for our own backyards, it is a world now deemed too complex for human comprehension.

The rise of an empirical and behaviorist post-humanism within the academy reflects this renunciation of knowledge. Necessarily ignorant individuals exist in a direct and unmediated cognitive relationship with the signals and alerts of their unique environments. The only knowable world reduces to the what, when, and where of an individual's changing network connections.

Post-humanism casts doubt on the distinction that knowledge draws between a lived reality and a shared world. Without this separation, there is no space for a political commons of contrasting life chances, disputed histories, and resolution mechanisms that are essential for sharing the world with Others. Rather than see this as a departure or a new beginning, for me it feels more like an arrival and an end point. Instead of freedom, what we are witnessing is the advent of a new authoritarianism. And this reflects the logic of late capitalism's long downturn. A desperation to squeeze the last from a dying

system, even to the extent of embracing precarity and uncertainty, in order to survive.

One of the principal lessons I take from your work is the idea that those of us still living in the relatively prosperous zone of affluence no longer see ourselves in a system of progressive completion; rather our fears are born of the dystopian notion we might all be going "South." I have also been thinking about this with the case of Haiti, which, enduring catastrophe upon catastrophe, seems to offer a prophetic model that could be illustrative of all our collective futures.

Such fears point to a tension within late capitalism. An existing compulsion for risk has now embraced catastrophe and disruption as necessary for survival itself. Shocks eliminate the useless while helping "the resilient" bounce back better, as it were. A line has been crossed between believing disasters promote adaptive renewal, and a dependence upon them to reinvigorate an otherwise disappointing human condition.

Capitalism is now bent on finally eliminating all autonomy and opposition to itself. Rather than governing through freedom as such, late liberalism harnesses freedom to the uncertainties of its own survival. Shocks and disruption are needed, even celebrated as essential, in order to better mediate, exploit, and direct their impacts. To this extent, as a model for our collective future, the dystopia of permanent emergency has to be resisted.

This challenge has appeared at a time when the possibility of revolution has long passed. We know from the Frankfurt School that there is no natural law of progress. While early capitalism may have battered down Chinese walls, late capitalism is more likely to degenerate into an entropic techno-barbarism. Now faced with such a reality, rather than revolution, the more urgent and practical task is that of resistance, of helping something new emerge by holding back the gathering shitstorm.

The disruption that late capitalism has unleashed presses disproportionately on a contained global precariat. There is no renewal or betterment through disaster—just cumulative loss and abjection. This negative outcome, however, is occluded and suppressed by a positive

techno-design culture. This denial reveals the depth of liberalism's detachment and retreat.

Pacing the celebrated densification of the electronic atmosphere—terrestrial border fences, check points, holding areas, biometric portals, and secure enclaves have globally exploded. International space has striated into surveilled and automated fast, slow, and stopped lanes as grounded architectures of containment have spread.

To conclude, as someone who has spent considerable time working in zones of crisis and conflict, I'd like to ask: How do you think all this has transformed the role and possible engagement of the researcher?

One evident example relates to the difficulties of completing face-to-face research in today's challenging environments. Increasing, universities' risk aversion, insurance requirements, and ethical demands have seen travel restrictions and safe-channeling grow. This limiting of circulation is reinforced from the other end, as it were.

Difficulties in obtaining entry visas, travel permits, and independent access have also increased across the Global South. During the 1980s, for example, NGOs in Sudan could travel relatively widely—but their use of short-wave radio was controlled and restricted. Given the computational turn, however, non-liberal states now struggle to limit connectivity. Today, they instead control the ground and restrict circulation that way. While the ability to geo-spatially sense the Darfur crisis from outer space was celebrated by techno-science—you can no longer independently "go there."

Late liberalism's turn to catastrophism is a response to global recalcitrance. A quarter-century ago, an emergent liberal interventionism boasted that the age of absolute sovereignty was over. As a result of pushback, however, such exceptionalism has evaporated. Coupled with the downturn, liberalism seems but one among many competing powers and truths. Greeted with alarm in the West and dismissed as so much backward or populist reaction, we have to be more open to the run of the present.

If the computational turn has allowed a post-humanist vision of a world that is smaller than the sum of its parts to consolidate, then late liberalism has authored a realist ontopolitics of accepting this world as

it is—rather than worrying about how it ought to be. It is a connected world of disruptive logistics, mobility differentials, data asymmetries, vast inequalities, and remote violence: a world of precarity.

Populism is seemingly an inevitable response to an unwanted future through the reassertion of autonomy. As a political model, it is instructive. Resistance requires the active recreation of autonomy. During the 1960s, large areas of social, economic, and cultural life still lay outside capitalism. The university campus, the shop floor, and the "Third World" as it was termed, already existed as areas of effective autonomy. For the New Left, this made them potential sites for liberation and revolution. In a connected world, such a nurturing autonomy no longer exists.

Political pushback involves the recreation of autonomy via the repoliticization of ground and place through their imbrications with history, culture, and the life that should be lived. It is a resistance that seeks to renegotiate its position and reconnect with the world anew. And so the question we confront is: Can we reassert a progressive autonomy, or at least a humanitarian autonomy based on a resistance to the dystopia of permanent emergency?

When post-humanism holds that design has supplanted revolution, perhaps it's time to imbue a new humanitarian ethic based on resisting design. A resistance that privileges more the sentiments of spontaneity, circulation, and necessary difference. We cannot imagine the yet to be. We can, however, encourage its arrival by resisting the negative loss and abjection of precarity through a politics of humanitarian critique.

10

The Expulsion of Humanity

Brad Evans interviews Saskia Sassen, January 2019

Saskia Sassen is the Robert S. Lynd Professor of Sociology at Columbia University and Centennial Visiting Professor at the London School of Economics. In this conversation, she discusses her latest book *Expulsions: Brutality and Complexity in the Global Economy*, including the spatial dimensions of human disposability and the hidden catastrophes of the everyday.

BRAD EVANS: Your work has attended in rigorous detail to the multiple ways marginalization and social abandonment take place across the planet. I was particularly taken by the concept of "expulsions," which was the title of your latest book. Rather than seeing marginalization as merely arbitrary, this concept links it directly to human decisions and the operations of power. Was this part of the intention when developing this project?

SASKIA SASSEN: Yes! I found that a mere range—i.e., more of this or that—is not enough to capture the more extreme conditions. These extreme conditions can, of course, also be described as "more poverty" and such. But I wondered if there are ruptures—as when you lose a leg … that is a rupture; but in a way some might argue that well, you still have one leg, and look what all kinds of people who have lost a leg can actually do! In a way, we have interpreted the growing inequality evident in the United States, and so many other countries, as a bit more of the same—a bit more inequality than ten years ago, a bit more expensive housing, and so on. And that is where my engagement with the question of dead land allowed me to argue for radical ruptures. There is something taking place here that's more devastating than the "more than" account to survey the everyday archipelagos of human misery. And it also takes a kind of weird courage as an academic to

decide that "a bit more inequality" is not enough to capture what we should see as a new reality, a reality that breaks with the past even if it just looks as if it is simply "a bit more inequality, a bit more misery, a bit more homelessness."

In many ways, in fact, the statistics continue to hide more than what is being revealed. The numbers often appear "inclusive," and yet it is in the drama of being expelled—truly expelled regardless of the numbers—that the violence of invisibility sets in. The lived experience of the truly destitute, those for whom the term "expulsion" continually applies, remains beyond the realms of visibility; even if we glimpse from time to time the violence of its hunger, peoples systematically starved of all possible opportunities.

Recognizing the many ways in which human life is rendered disposable on a daily basis, how does the concept of expulsions speak directly to narratives of violence?

Expulsions got me out of the infamous more inequality, more poverty, and more homelessness mode of human quantification. No. It's not ethically right to sustain this more than/less than understanding on the quality of life. At some point, we are dealing with a rupture, a deep one, what we might call a systemic rupture. We have always had inequality, and any complex system is marked by differences, though these need not aim at privileging some types of workers or people and destroying others.

Here is one possible interpretation of our current period—at least in the West. By West, broadly understood, I include Latin America, parts of Africa and Asia with North America and Europe, supposedly the "good pupils" of the system (no matter the raging poverty and alienation that are also present).

Complex systems are not easy to decode. At its most extreme, you might need new language to capture a transformation in a complex system, especially if it is a foundational transformation. But in such complex systems (think any of our societies in the so-called developed world) it can be very difficult to detect a major rupture. If a dam breaks down, you can see it. If a car stops working, you can see it. But if a deep switch of logics is happening in one of our societies, you cannot necessarily see it (even if it reveals subtle traces). You can of course see a

revolution taking place in the standard meaning of the term, but much change can happen in our societies that is not in the shape of a revolution or where the revolutionary contours are less self-evident to established forms of power.

Could it be, as I argue in *Expulsions*, that something we have long lived with, is dead, finished? What does it mean to proclaim the death of anything social or political? A society where the modest and middle "middle classes" are at the heart of the society, the biggest sector of a society, as we have experienced it in the West for much of the twentieth century, is facing the kind of rupture I have in mind.

The loss of this middle cannot be simply measured by its relative share in wealth and production alone. We are witnessing the end of a development. It is in the process of ending as it appeared for nearly a century. The ground beneath it is gone. Think of the old-style big corporations, which employed in-house all the types of workers they needed, more or less. This meant that a hard-working worker could actually move up the scale. That was a good system, where the hard work of the lower levels and the poorer workers could actually be recognized and rewarded. That is mostly gone. Hard-working low-level workers are barely recognized, because they have become invisible—they may be working in Bangladesh, or in Brooklyn, but they are a separate entity from the core firm that wants the products they make. This is a form of ghettoized production, which offers no social mobility. Or just think about the vanishing of the industrial "working classes" in Britain, which live in areas where the term "working" is itself redundant for many of its fixed and localized populations. The intermediate moment between what are now separate firms is about cost, not about good work.

Natural resources, especially land and water, are increasingly getting the same treatment. It is about profit and cost, not the protection of a resource across generations. The cultures that emerged before our current fascination with large-scale projects enabled the long life of land and water bodies over the centuries. That is rapidly disappearing given the escalating land grabs by big corporations that are pushing smallholders out of habitats, often in extremely violent ways. The only place the smallholders can go to are, increasingly, the large poor areas of abandonment—the geographical and social peripheries that have

emerged around many major cities. The city itself as such is being violently restructured through its own expulsions.

I'd like to focus more on the spatial dimensions to human expulsion. We are still often presented with a picture in the mass media where endemic social dislocation happens "elsewhere." And yet as you have suggested, every global city (to use your term) reveals multiple cracks into which entire communities are trapped. How can we overcome crude spatial assessments in our attempts to map out the human dimensions of expulsion?

You said it correctly. We do tend to think that it is happening elsewhere. By the "we" I guess we are referring to mostly we, the middle classes who are doing fine even when we think we should be doing better. One way of putting it is that there has been a far deeper transformation in the innards of our system, than we recognize or are able to recognize. Change in complex systems is often hard to track. We can easily see the innovations, but that can be surface change—easy to grasp—say the iPhone. It made a lot of difference and the difference is highly visible. But a complex system—say the economy in a country such as the United States—can often undergo foundational transformations in a few sectors with large shadow effects over the rest of the economy without these being particularly visible.

How many US residents noticed way back in the 1980s—when this foundational change began—that besides banking (which is commerce: the bank sells money) there was a vast expansion of high finance, which introduced a whole new system? And what made it a bit invisible, for instance was that it presented itself as banking and used the conventional language as a screen for acceptability. But it was not traditional banking. It was a far more complex, and innovative system of power. As I argue in *Expulsions*, high finance should be seen precisely as an extractive sector. It does not extract metals; it is another mode of extraction. It has developed truly brilliant instruments that allow it to grab. And the human consequences of what it takes can be truly devastating.

A simple example: The traditional bank does not know what to do with student debt; no matter that it has reached over a trillion dollars. Finance? "A trillion dollars? Negative money? I can work with

that." And work with it it has, including succeeding in passing a law in Congress that establishes this is a debt than can never be excused. So there is a capability at work here that the traditional bank never had. I am not saying debt is a new phenomenon, but this type of debt is part of a new regime of power that is capable of binding and expelling in ways that are novel. Those students will have that debt until they die, but the debt will not die, even when they die. It passes on to whoever is pertinent. And in the meantime, finance can make it work for its purposes—it is not just sitting there. Via algorithmic mass you can transform it into a working element. You know, when I describe finance in these terms, I think it becomes a kind of Frankenstein of a special kind: it can never lose.

If expulsion, as you explain, is less about some exceptional or spectacular event and more about a slow, hidden catastrophe, which like a toxic tide comes wave after wave to slowly drown a people and humanity in the process, how might we rethink the question of resistance in our attempts at rehumanizing politics?

Oh, this is so well put! Can I borrow that sentence sometime? One first elementary step in this process is something I like to capture with a provocation: "Do I really need a multinational to have a cup of coffee in my neighborhood?" No, I do not. I do need a franchise if I want to buy a computer or a truck. But I do not require the expansive reach of corporate forms of power for so many of the basics of daily life. There is nothing complicated about this in terms of the choices we make over consumables. My concern here is: How do we re-localize the production, the making of what we can do locally but has now been taken over by the big conglomerates? There is much that we can re-localize, and in that process build communities of mutual support.

And yet, while we are seeing more of this re-localizing taking place across the country, I am not proposing a new ethical puritanism. In my new project on "Ethics in the City," I confront the difficulty of escaping the voracious capture of just about everything by large firms. Bringing in the notion of an ethics of the city almost by definition is an ethics that cannot be pure, since inequality is built into the design and structure of the city. But it could still be an ethics—an urban ethics. The challenge is to understand what is truly offensive, unacceptable,

seen as unnecessary and yet violently experienced by the poor in our cities. And to supplement this with the experiential understanding that we, the nice middle classes, do not necessarily know even when we think we do what is truly offensive to the poor. This could open up a new ethics so badly needed for the precarious world in which we live.

11

When Art is Born of Resistance

Brad Evans interviews Martha Rosler, February 2019

Martha Rosler is an American artist who works in video, photography, text, installation, and performance, and whose work focuses on the public sphere, exploring issues from everyday life and the media to architecture and the built environment, especially as they affect women. She has for many years produced works on war and the national security climate, connecting life at home with the conduct of war abroad. This conversation offers a reflection on her role as an artist in countering violence.

BRAD EVANS: I would like to begin with a question on the issue of violence. What role do you think artists have when confronting this all-too-human problem?

MARTHA ROSLER: First, I'd like to be sure I know what we mean by violence; it's such an elastic term. I often think, though, that the term "violence" has become reified, overly broad, and is losing its contours. We may feel that although we can't really define it, we know it when we see it. We don't generally associate violence with humanity alone, as I'm sure you'd agree. We have a fairly complex or differentiated ranking of acts of violence and who or what is likely to use it. So let's say violence is the excessive use of force, in one form or another, beyond a certain accepted baseline, so we can see violence as exerted even by natural events, such as storms. Violence, then, is sudden force that is likely to break things—or rules or norms.

Our system itself glorifies a kind of violence towards the what-is, that is now modishly called "disruption" or "creative disruption"; in the thinking of the age, disruption is to innovation what automobiles are to buggy whips, to haul out a favored comparison. It is clear that capitalism cannot sustain itself without violence, the violence of expansion

and change, which along the way chews up a lot of lives, lays waste to the natural and the built environment, and demolishes the folkways associated with settled ways of life, all at varying rates of speed.

Humans, as carnivores, have a long history of violence simply in the pursuit of living. To look at violence in the context of human societies, violence is related to both law and justice. It assumes there is a power differential among people and groups or classes and that certain uses of force are legitimate—the very word attests to the structure of laws—while others are unacceptable and thus classifiable as violent. More informally, we can class violence as an expression of conflict that in our society at least is regarded as inevitable and inbuilt, on the one hand, but on the other is possibly controllable or (perhaps, aspirationally) eradicable.

If you are asking me how do artists, and even ordinary people—citizens, residents—cope with violence against them or others, on the part of the state or state-like actors, or, conversely, on the part of lawbreakers and other criminals, the answer here is that art can present a certain degree of distilled clarity in the face of what may be felt as chaos. Art can open a space for a new framing of information, it can work to delegitimate uses of violence widely regarded as legitimate, such as attacking and killing protesters—themselves often treated as posing a threat of imminent violence against the established order—or criminal suspects, carrying out a death sentence on people convicted of common crimes, or on a grander scale, invading other countries by use of force or manipulation, or even, more broadly and less anthropomorphically, against the natural world.

I am writing this at a moment when our government uses law as the justification for forcibly removing children from parents crossing without papers at our Southern border, yet a shocking number of people are willing to pretend this is justified because it is exercised against a class of people repeatedly dehumanized by this administration and its enthusiastic press and supporters. This is an instance of psychological violence, a category that can slide into metaphor but also is a perfectly reasonable way to talk about the use of authority, law, or ideological messaging to weaken others in pursuit of a desired result—commonly the creation of a stereotypical enemy or interloper.

Conversely, the tactics of delegitimation of others is matched by a concerted campaign of legitimation of the actions of state, often

by naming (we're straying into the "alternate truths" universe here). Dead civilians are labeled collateral damage. The US was long a vocal opponent of torture—until we were caught doing it, at which point it was renamed, following the Israelis, as harsh, stressful, or (most egregious of all) "enhanced" interrogation techniques, and a White House attorney or two obligingly crafted an opinion proclaiming it legal. The military—the arm of legally sanctioned violence—is a fantastically rich source of calling things by other names in order to control the narrative and hence the reactions on the part of the restive. The new tactics of drone warfare have led to many new terms of art, such as "painting a target" or "blue on blue" that hardly disclose their meaning to the uninitiated.

Those examples you just cited clearly indicate how the aesthetic field is intimately bound to the power and violence of discourse. Politics in this regard, we might argue, is always aesthetic insomuch as it is bound to the creation of images of thought. As an artist, what is it about the discursive field that commands your attention?

Control of language in the face of war extended some time ago to the popular press. Early in World War I, for example, the war minister, Lord Kitchener, threatened to kill any journalist found on the front lines. But exercising war censorship proved far less valuable than recruiting publishers and journalists into collusion with the government by suppressing bad news and disseminating government propaganda— (fake news). President Wilson maintained tight control through his new Committee on Public Information and the support of the new Sedition Act of 1918, which specifically criminalized anti-war expression. But today's public has been less trusting of war reportage, and the aphorism "In war, the first casualty is truth" (of uncertain attribution), has been in wide circulation since the Iraq/Afghanistan War, although it long precedes that.

And then there is the practice of disinformation—*really* fake news—(as opposed to more guileless misinformation), the stream of confusing and often irrational targeted messages deployed by state actors and designed to produce confusion in unguarded populations, often foreign ones, for the purposes of electoral or other means of "regime change." Although diplomacy is itself a highly coded system

of negotiation over what labels and narratives to hang on events in the interest of international relations, it is conducted among a cadre of the highly trained; disinformation is a weapon wielded against whole peoples without their consent. Both Russia and the United States deployed this tactic even well before the Cold War.

In the preface to my videotape *Vital Statistics of a Citizen, Simply Obtained* of 1977, heard over a black screen, I try to draw a distinction between the crime of mass murder and the "ordinary" crime of having people—women in particular, but also non-European foreigners—tagged with "not measuring up." This voice-over was intended to suggest that violence resides on a spectrum only part of which is regarded as outright violence.

I am mindful here of the importance for stressing (as you have continually done in your own work) the resistive potential of art in response to the oppressive triangulation between discourse, aesthetics, and their affective human registries. What can we take from alternative histories in terms of rethinking the very possibilities for viable resistance?

Opposing civil protests, actions, and uprisings of various sorts simply on the grounds of violence leaves us in a quandary of doubt and certainly goes against "history"—as it tends to assume, shortsightedly, that all human conflict can be captured under the rubric of violence erupting in an otherwise orderly civil society. I leave aside religious violence, against oneself or sacrificial others, meant to actualize the divine. I am also ignoring the use of torture against captives or sacrifices as a ritualized embodiment of group solidarity or even, as in Roman jurisprudence and later, the use of torture on witnesses or the accused to prove—that is, to test—the verity of testimony and confessions extracted from slaves and plebs. Uprisings, revolts, riots, and revolutions, as well as invasions and wars, punctuate human history, and artists—if not employed or commissioned by royals and rulers—often have partisan involvements beyond mere opinions. Historicizing forms of representation, such as "classical style," and the tradition of history painting use both formal styles and narrative content to glorify certain incidences of violence and decry others. A signal example is the painter Jacques-Louis David, well known for his paintings in support

of the French Revolution (and later of Napoleon); I recently saw his rapidly executed sketch of the deposed queen Marie Antoinette in the tumbrel on the way to the guillotine.

A question closer to us is whether artists during the (slightly earlier) American Revolution should have deplored the rebels' use of violence? These questions seem paltry, if not juvenile, against the backdrop of world events. Poets and painters have made political choices in support of war—Lord Byron lost his life in Greece's fight for independence from the Ottomans, and the Italian Futurists, who glorified violence or simply the shock of modern life, joined the Italian army in World War I, many losing their lives on the battlefield. Famously, Marinetti became an enthusiastic fascist, and many other fascists glorified the aesthetic effects of war. Conversely, as we can see from governmental action against war resisters (refusers, dissenters, opponents) in many countries, just speaking out against war can be seen as actionable and often includes charges of inciting others similarly to resist.

At various times in the US, those who refused army service were arrested and imprisoned; a notable example is the socialist leader Eugene V. Debs, imprisoned for advocating draft resistance during World War I. In World War II, however, pacifism was not widely supported by the populace, in part because of the global threat posed by Hitler and the Axis powers. But now, especially after the Nuremberg trials at the end of World War II, there is deemed to be an absolute imperative for even members of the armed forces to refuse an illegal order.

Looking back to your powerful series _House Beautiful: Bringing the War Home_, which provided a more personal and intimate critique of the war imaginary, how do you think these works resonate in a world seemingly governed by media spectacles that are no less mediated in their suffering?

I take your use of the term "personal" here to mean centered on individuals, not masses of people. The photomontages you are referring to can perhaps be characterized as familial or on the level of daily life, but to ask how they resonate in a world seemingly governed by media spectacles—I have to remind you that that is an apt description of the world in the period from which those works emerged. By the 1960s,

advanced industrial economies like ours had already entered a human-made environment that can be characterized as mass spectacle, as numerous observers, many of them Europeans—Siegfried Kracauer in the 1930s, Adorno and Horkheimer in the 1940s, Herbert Marcuse and Guy Debord in the 1960s are notable examples—had decried both before and after its emergence, and at many opportunities since.

I would like to call attention to your use of the word "powerful" in relation to those works; some have also labeled them, and other works I've done, such as the satirical video *Semiotics of the Kitchen*, as violent. That requires a strong degree of projection (though I would agree that in the case of the video, there is a certain gesturing toward a release of repressed violence, without any particular recipient). But there are no violent acts depicted in any of those photomontages, and you haven't suggested there is. They conjure recognition of violence in the viewer as a means of arguing against war and repression but still refusing to reproduce it. I would say the same about the video *A Simple Case for Torture, or How to Sleep at Night*, which has no scenes of bodily torture but a great deal of information—too much information to take in—about state violence, both legitimized and covert.

You have drawn attention here to a very important point concerning the difference between violence (directly physical or psychological) and the power of critique, as then presented as violence because it offends a certain dogmatic sensibility, and often in such cases speaks truth to those who impose power relations through violent means. I am especially taken by the notion that the purpose of art is precisely to confront what seems intolerable, yet to do so in a way that refuses to reproduce the logics of violence. Do you think this is what art should aspire toward?

I wouldn't begin to propose what art should aspire toward, but I think you have described my intentions in using my work to address injustice, to expose its inherent violence, if you will, without resorting to its tactics, but also to outline the matter at hand as *a problem* possibly with solutions within human reach. In other words, to frame as comprehensible those matters that have been globalized, demonized, naturalized, rendered intractable, without sensationalizing them—but not necessarily following a formula. I want to establish always a space for

reflection, even if only after a person's direct confrontation with the work. This does not apply to my political activities, where I am much less circumspect if the occasion warrants. Sloganeering and appeals to sentiment have their place. However, it is worth noting that it was precisely as immediate anti-war propaganda that I conceived of the works we've just discussed, *House Beautiful*, where my approach had nothing to do with replicating scenes of violence.

Another distinct aspect of your work is to address social and structural inequalities. From the perspective of the arts, how might we recognize such inequalities as a form of violence? And why have you also felt compelled to subvert stereotypical representations concerning those on the margins of existence?

Even if people recognize the inherent violence that poverty and powerlessness impose on others, that realization may not be at the forefront of their assessments of economic and social inequality. A steady flow of ideological messages obfuscates the nature, sources, and scope of inequality. Among those messages is a consistent stream of reductive, counterfactual, and demoralizing images of people—many of them on the margins, not of existence, perhaps, but of everyday middle-class life, but also including the majority group: women! These stereotypical representations have been "naturalized," sunk into the fabric of everyday life as simple, common sense observation. Rationalized, unacknowledged, discriminatory representations signify what has lately been called implicit bias, which cannot be divorced from structural violence. It's necessary to highlight and deconstruct these representations.

The structures of feeling, to borrow a phrase, are hung around the verities of general society, which insistently do violence to the lives and understandings of others. The opioid/heroin crisis presents an unmistakable case in point, unfolding before our eyes: when the long-suffering participants in the drug crisis (heroin and crack) were primarily poor urban-dwelling people of color, and a ferocious "othering" was the considered opinion promulgated about those populations. The victims were blamed for exhibiting failure of morality, character, and integrity; possessing outright criminal tendencies, whether learned or inherited—and countenancing poor family

structure. Liberals pitied them, documentary photographers captured their agony and ruin, do-gooders argued for them, and politicians denounced them. Once the crisis of drug dependency (heroin and opioid drugs primarily) began to affect largely white rural and small-town populations, denunciations ceased in favor of a great clamoring on the part of local politicians to obtain assistance without blame and treatment without the unconscionably harsh and pitiless policies of long incarceration and often the concomitant loss of voting rights, tied to the previous drug "wars."

Addressing the objectification of women and the naturalization of everyday forms of abuse this engenders, what have been your thoughts on the #MeToo campaign, which moved quickly from Hollywood on to the arts more generally?

I'm always interested when workplace issues come to dramatically highlight inbuilt systematic abuse. Or to put it another way, when patriarchal prerogatives, which center mostly on the bodies of young women, prerogatives that are known and tacitly acknowledged by everyone while simultaneously denied and individualized (by which I mean put down to individual quirks or predatory behaviors) are thrust into the spotlight and rendered criminal, actionable, immoral, reprehensible, and so on. And then non-celebrity women, non-executive, non-professional women, but rather employees of an entirely different service class, say, "Me too." And in fact, those women, who are women of color in far larger proportions than the middle-class or Hollywood workforce, said, "Me too," first, under the initiative of Tarana Burke, as we learned after the celebrity #MeToo movement was launched.

Actresses gained attention by insistent complaints that suddenly captured public attention (in no small part because a confessed groper, raunchy talk-show regular, and "reality"-show host became president of the country, while similar accusations of long-standing, perverse abuse by male celebrities had failed to win court cases for complainants and sometimes even to gain indictments). But this movement helped magnify the voices of other groups of women—poor women, women of color, immigrant or undocumented women, hotel maids, farm workers, waitresses—who achieved little attention or sympathy

for their stories about the sexual predations they must endure to keep their jobs.

These working-class jobs are generally in industries where people won't get cowed into signing non-disclosure agreements, since not much is at stake for bosses in regard to fire-at-will workforces. The point is clear: there are sexual and other gender-centered costs for women who venture into the paid workforce outside their own homes. The arts followed the example of Hollywood, or more properly the Anglo-American theater and film nexus, in that some high-profile men in theater, dance, radio, and television were accused of sexual aggressions and quickly let go. It is too soon to assess the validity of those dismissals. The academe, however, including art departments, have hardly followed suit.

But we've been around this "Me too" block quite a few times before: looking just at the United States, there was a concerted patriarchal and right-wing backlash in the 1980s against the women's and gay libera- tion wars, attacking abortion rights and gender identity (inciting sex panics), which met with concerted forms of pushback. The attacks continued through the 1990s, symbolized by efforts to derail Bill Clinton the candidate as a sex offender and an advocate of the (per- missive, libertine) "values of the 1960s" (including acceptance of gay rights), a narrative thread that eventually led to his impeachment as president on sex-based charges. Women continued to resist, but since the 1980s the mainstream women's movement has largely focused on the advancement of professional and other middle-class women— think of "power dressing" and "breaking the [corporate and military] glass ceiling"—mostly downplaying the defense of poor women and working mothers.

The political right, while often led by sexual predators, transgres- sors, adulterers, and so on, continued to use outrage over sexual identity and behavior as weapons to marshal their base. Finally, they settled on anti-abortion politics as their main mobilizer after younger voters increasingly accepted gender-centered matters, especially LGBTQI identities and gay marriage. Now, as a result of the continued attacks on women's bodies at the point of the right-wing spear, *Roe v. Wade* will likely be brought down at the hands of the Supreme Court. We don't know what will follow, except that once again poor women will suffer the most.

At present, we have to ask once again, and slightly tiresomely, is this time different?—will there be major change in gender relations and an end to sexual aggression and harassment? My answer is that many in the age cohort of people we call "millennials" are restive and want to see change immediately and that that's a good thing: the women's movement, like most movements, is largely peopled by young women, and this movement is widening as more women of color and transgender women take part. And now, inevitably, the predatory sexual and workplace issues have publicly converged, in light of the ever-growing importance of the culture industries on the one hand and the service industries on the other—though I will predict that middle-class women will continue to fare better than working-class women.

Before we rejoice, however, we ought to keep in mind another growing form of backlash that in many respects echoes the patriarchalism of evangelicals but is associated with racial and political grievances, often borrowing from right-wing and neo-Nazi movements, reactionary social thinkers, and their ilk. This movement of young white men, centered on the internet but all too often moving into the real world, has often viciously targeted young women also in the online world (see "Gamergate" for an exploration of one such early eruption of hatred). This cohort of enraged young men, demanding that women recognize their *right* to sexual intercourse, calls itself the "incel" movement, from self-denominated "involuntary celibates" who abet their views on the strictly neo-Nazi social media site Gab as well as Reddit and 4chan or 8chan, inhabiting the otherwise largely unnoticed corners of the internet.

We are now over two years into the presidential election victory of Donald Trump. What still seems to be a defining feature of his power has been a veritable blurring between the fictional and the real. What role do you think art plays today in this seemingly absurd and yet dangerous setting?

The man was, as you say, elected. He has always been a liar, a bully, and a braggart, and his celebrity persona seems for many voters to have given him a pass on truth. Authenticity in theatrical performance is judged not on the basis of truth value but rather on a form of "convincingness": how well he fits a familiar role—domineering, authoritarian

masculinity paradoxically under threat—as he himself has defined it. Someone like that, demonstrably of low moral character, a con man and dishonest businessman, proved able to perform it well enough to trump probity. This process is not about rationality: Democrats, in their latter-day technocratic, neoliberal mode, appeal to rationality; Republicans don't. Democrats are afraid to bait the populist beast, Republicans aren't—the Republican Party recognizes the benefits accruing to their politicians and donor class by policies supported by Tea Party passions. But I have to point out that it is our powerful mass-culture industry that helped boost the popularity and visibility of this personality type, which has in modern days included such figures as Ronald Reagan, Jesse Ventura, Arnold Schwarzenegger (not to mention those who ran as overt racists throughout the twentieth century), all men running as authoritarian-populist patriarchs before Donald Trump.

Scapegoating the powerless, our present catastrophic leader has badgered, bullied, and belittled—as a tactic for deflecting attention from searing attacks on policy on many fronts. Those in whose interest he governs have spent decades practicing the seizure of public goods and the destruction of even the idea of community. They've built grass-roots organizations on the basis of ruralism, resentment, racism, and rage; they've bought and paid for academics and think tanks to advance reactionary legislative and judicial agendas, voter-suppression tactics, racist mythologies, anti-woman and anti-LGBTQI rules, and science denialism. Like any Republican since Reagan, he ran as the opponent of the federal government itself, on the promise of crippling its reach while still somehow fulfilling extravagant promises to his followers.

As the ongoing chaos campaign continues, we have little choice but to be there too, constantly showing up, in whatever way we can. Marches, protests, and demonstrations are powerful and absolutely necessary—as is showing up at the polls. But we need an organized movement to continue agitating, not just as resistance and repudiation, but to engineer lasting political change.

So, let's keep on protesting and countering the fairy tales and lies that are so essential to the con game being unleashed on us wherever it can find an audience. Art doesn't change society, but it can crystallize opinion in the context of citizens' movements. Art in the modern era is often born of resistance.

12

The Tragedy of Existence

Brad Evans Interviews Simon Critchley, April 2018

Simon Critchley is the Hans Jonas Professor of Philosophy at the New School for Social Research. He is the author of many books that deal with violence. In this conversation, Simon discusses his enduring interest in tragedy, when it remains conceptually relevant, the importance of poetics, on to the need to engage more critically with theater.

BRAD EVANS: While tragedy has evidently preoccupied your thoughts and work for some considerable time, your latest book, *Tragedy, the Greeks, and Us*, provides your most explicit treatment of the concept. We know there is something deeply tragic about the human condition, and yet having read your beautifully written and richly provocative text, it is still apparent that there is so much to flesh out in terms of its philosophical relevance. Why did you feel it was now the right time in your life to deal with this topic?

SIMON CRITCHLEY: Allow me to try and explain how I see things and why I think this is the time for a book like this, which has obsessed me for much of the last decade. The time is out of joint and something is rotten in the states we inhabit. We can smell it. Our countries are split, our houses are divided and the fragile web of family and friendship withers under the black sun of Big Tech. Everything that passed as learning seems to have reached boiling point. We simmer and feel the heat, wondering what can be done.

My book tries to confront where we are now, as Bowie might have said, by peering carefully through the lens of Greek tragedy. Tragedy presents a world of conflict and troubling emotion, a world where private and public lives collide and collapse. A world of rage, grief, and war. A world where morality is ambiguous and the powerful humiliate and destroy the powerless. A world where justice always seems to be

on both sides and sugarcoated words serve as cover for clandestine operations of violence. A world rather like our own.

In my view, we have to try and make the ancients live again for our time. They hold up a mirror to us where we see all the desolation and delusion of our lives, but also the terrifying beauty and intensity of existence. This is not a time for consolation prizes and the fatuous banalities of the self-help industry and pop philosophy. Philosophy, as it is usually understood, is part of the problem, not part of the solution.

By contrast, I argue that if we want to understand ourselves better, then we have to go back to theater, to the stage of our lives. What tragedy allows us to glimpse, in its harsh and unforgiving glare, is the burning core of our aliveness. If we give ourselves the chance to look at tragedy, we might see further and more clearly.

This is what I think I'm up to. This book has been a long time coming and is the fruit of a kind of inversion of my views about the relation between philosophy and drama. I used to give classes decades ago at Essex on the philosophical interpretation of tragedy, from Plato through to Heidegger. This was hunky-dory, but it was at the expense of any proper consideration of the kind of *thinking* which we find in tragedies. So, around ten years ago, I began to change the way I think about the plays of Aeschylus, Sophocles, and Euripides and to read them much more closely as a distinct kind of thinking, dialectical, staged, and deeply morally ambiguous, and to see them as a challenge to that kind of thinking which we habitually call "philosophy," which begins in Plato with a ferocious exclusion of the tragic poets from the philosophically well-ordered city. So, I see this book as an extended undermining of the entire enterprise that we call philosophy. Namely, the philosophical prejudice that we can, with the use of reason, render intelligible being, or that which is, and on that basis, produce a series of moral imperatives about how to live. I see both those ontological and ethical assumptions as deeply flawed and limited. To counter them, I suggest very simply that we go back to theater and think through the kind of experience which it offers. Tragedy is ontologically opaque and ethically ambiguous.

What I find compelling about your understanding of tragedy is how it connects directly to question of meaning, and in particular, our self-realization of the insecure sediment of existence. In this regard,

the tragic appears to have an intimate connection to the question of violence and what it means to be a mortal subject. How might we rethink the very idea of violence through the lens of tragedy and its philosophical premises?

It is in tragedy that we can track the history of violence that constitutes the apparently pacific political order. This is what happens in the *Oresteia*, say, where the democratic city—Athens—tells itself a story of its origins that flows back to the cycle of bloody revenge in the House of Atreus, where wife kills husband, son kills mother, and violence is only suspended through the violent fiction of law. Tragedy is largely motivated by a rage that follows grief in relation to a situation of violence. The whole cycle of the *Oresteia* spins back to a mother's grief for the murder or sacrifice of a virgin daughter, Iphigenia. A murder which is considered necessary by the Greeks, and by her father Agamemnon, in order to put favorable winds into the sails of the ships that will go to Troy to begin a 10-year war. Wherever one looks in tragedies, everything spins back to violence as the history and nature of the political order.

In your book, there is clearly a certain intellectual debt to both Nietzsche and Raymond Williams and the influential contributions they have made to our understanding of modern tragedy in particular. And yet you insist upon a closer reading of the legacy of more Classical Greek philosophy (notably sophistry) to stake out its more contemporary resonances. What is it about the Greeks that holds a special place in this drama?

I have become more and more obsessed with the ancient Greeks as the years have gone by. I find in these texts a life and liveliness which is very often absent from their modern epigones, perhaps with the exception of Nietzsche, to whom I owe a debt in this book, especially to the opening sections of *Beyond Good and Evil*. My book is a close textual unraveling of some of the allegedly foundational texts of philosophy and what we call aesthetics, Plato's *Republic* and Aristotle's *Poetics*. I try and destabilize these texts through a careful reading. The thread that I pull on to do this is derived from texts by the Sophists, especially Gorgias, who comes closer to the form of dialectical tragic

thinking that I wish to recommend than much of what passes as philosophy. This book is primarily a defense of tragedy, but it is also a defense of sophistry against philosophy.

I'd like to bring this to the question of poetics and alternative styles for living. Nietzsche famously stated that we need art in our lives so that we don't die from the truth. How do you understand the importance of art when dealing with the tragedy of existence?

Nietzsche is half right: we need art in order not to die from the truth of existence, but in my view only art is able to tell us the truth of truth. Namely, it is only possible to tell that truth in a lie, in the manifest deception that is theater. This perhaps reveals something interesting: namely, that we can only approach the truth indirectly in and through fictions which we know to be untrue. What those fictions present is the complexity and moral ambiguity of our existence, which is hard to bear and perhaps only bearable in the fiction of a play, a story, a myth.

It's important to remember that theater begins in the same place and around the same time as democracy, that prodigious ancient Athenian political experiment of basing a society on the idea of equality. But ancient Greek theater is not in any simple way a vindication or apology for democracy. Rather theater is the place where the tensions, conflicts, and ambiguities of democratic life are presented and played out in front of the people. It is the place where the multiple exclusions of Athenian democracy are staged: foreigners, women, and slaves. Theater is the night kitchen of democracy.

Questions of refuge, asylum seeking, immigration, sexual violence, and the duties of hospitality to the foreigner reverberate across so many of the tragedies. Theater is that political mechanism through which questions of democratic inclusion are ferociously negotiated and where the world of myth collides with law. Think of the *Antigone*, where the whole play is a conflict about rival claims to the meaning of law or *nomos*. Or the trilogy of the *Oresteia*, whose theme is the nature of justice and which even ends up in a law court on the Areopagus, the Hill of Ares just next to the Acropolis. Tragedy does not present us with a theory of justice or law, but with a dramatic *experience* of justice as conflict and law as contest.

In conclusion, what then is the infinite demand we can bring to tragedy in order to rethink what the political might mean in the world today? Or if we are to demand the impossible, might we not conceive of a philosophical orientation beyond the tragic?

Beyond the tragic for sure. I think the idea of the tragic is philosophy's invention, especially the invention of post-Kantian thought in Schelling and Hegel. I try to both tell and undermine that story in the book. My recommendation is that we go back to theater, back to art, and look and observe. We need tragedies and not *the* tragic. I would say the same thing about "the political." The infinite ethical demand here might just be the old Wittgensteinian idea of "don't think, look." I want the reader to look at the ancient Greek plays or indeed at any plays—Shakespeare, Büchner, Ibsen—and to feel the pull of the aliveness which those plays animate without coming to any foundationalist or indeed principled moral viewpoint. What I see in the greatest theater is a kind of total honesty where we begin to radically question who we are and what we know, a full moral skepticism if you like. That, in our world of deafening moral certainties, would at least be a start.

13

The Violence of the Algorithm

Brad Evans interviews Davide Panagia, May 2019

Davide Panagia teaches political science at UCLA and specializes in the relationship between aesthetics and politics. In this conversation, Davide discusses the political nature of algorithms, the hidden structural violence they produce, digitalized discrimination, the development of cybernetics as a political practice, on to the militarization of the virtual and the possibility for resistance through a different critical ontology.

BRAD EVANS: Following on from your brilliant work on the importance of poetics in political thinking, more recently you have become concerned with the political nature of algorithms. What is it about such algorithms that commands your attention, and why are they important in terms of considering new forms of violence in the world today?

DAVIDE PANAGIA: First off, Brad, thank you very much for inviting me to participate in this fantastic series, and for your overly generous estimation of my past work.

In very concrete ways, the answer to the second part of your question regarding the forms of violence that emerge out of algorithmic technology aligns with some of your work on contemporary threat imaginaries. That is to say, I don't believe that algorithms offer new forms of violence per se. What they do afford is a scalar intensification on forms of governmental rationality, and all of the violence these bring.

From the 1990s there was a concerted effort from diverse philosophical orientations to attend to language as the specific medium of political life, and of political theory. Whether one frames questions around the study of discursive structures, communicative action, consensus-oriented deliberation, deconstruction, hermeneutics, speech

act theory, or psychoanalysis—what seems central to me about all these approaches that otherwise fall under the heading of "the linguistic turn in political theory" is a tacit acceptance that language (and thus the use of language through oral or written speech) is the specific medium of political thinking. My own way of approaching these concerns is to consider the aesthetics of political thinking and thus reconsider the role and function of sensation therein. And here, discovering the work of Gilles Deleuze and Jacques Rancière early on was central, because what they offer is a way of reflecting on sensation and political aesthetics in a manner that is not reducible to either an objectivist account of beauty or subjective judgment of meaning. I rely here on poetics so as to emphasize the aesthetic sensibilities at work in our normative commitments of how to think the political—or, to use Rancière's own language, how our aesthetic sensibilities partition what counts as political thinking, and thus the forms of legitimacy that authorize specific modes of political attention. Such an approach to the aesthetics of politics considers the participation of technical objects with thinking as relevant to any account of political reflection.

With this in mind, the question "Why algorithms?" to me means that we have to rigorously propose a study of the transformations and continuities of a medium of communication and power which has entered our political lives and extends beyond the traditional analysis of the instrumentalization of technical media. Any critical analysis of algorithms cannot be constrained by our normative concerns over their use. Rather, to appreciate the specificity of the forms of political violence that algorithms enable, we need to attend to the "what" and "how" of their specific forms of participation in everyday life. In short, I feel it urgent to be able to answer the question: Are algorithms political media? And if so, how? In other words, I don't think it is enough to ask, how are algorithms used for political benefit and (implicitly) political coercion and domination?

Can you elaborate more on what you think needs to be done to overcome the intellectual challenges of seeing algorithms as political media?

By means of a contrast, consider the analysis of film over the past one hundred years that offers us a rich and inexhaustible morphology of

critical insights into (among many other things) forms of directing and redirecting attention. Such forms emerge out of the technical specificities of the visual medium like camera lenses, focus techniques, editing, the quadrant system, narrative continuity, and any other aspect of film's aesthetic arsenal. By looking at what film does, and how it does it, theorists and critics alike have offered crucial insights into the political aesthetics of modern visual culture. The results are diverse theories of criticism emergent from careful analyses of what cinema is and does.

Do we have a comparable theory of criticism of algorithms? We certainly have diverse modes of criticism for the study of language, of photography, of film, of bureaucracies, et cetera. But can we say with ease that the terms and conditions of criticism for these technical systems, not to mention the normative ambitions of critique, are transferable from one medium to the other? In short, is critique a transcendental category? If not (and I do not think it is) then what are the conditions of criticism—and especially political criticism—in what I call #datapolitik? To me, this raises three challenges that I struggle with and that are central for understanding political violence in the age of algorithms.

We don't experience algorithms. We experience inputs and outputs. But not algorithms. All of our Western theories of political criticism (even the most idealist) are, as I suggest throughout my work, rooted in an experience of media. Even Plato required the medium of the cave for his idealist epistemology of dialectics and justice! Thus, all critical thinking is at some level at once aesthetic and experiential—that is, born of a dynamic between perception and sensation. But algorithms can't be perceived or sensed. And so, the question of transference is relevant: can we transport theories of criticism that we have developed with our engagements and reflections with other forms of media to the algorithm, which is fundamentally in-experiential?

Most of our theories of criticism (from Plato to Adorno), in some way, shape, or form, arrive at the epistemic insight that resistance to mediatic domination (and thus political coercion or intellectual stultification) comes via a turning away movement. Indeed, the critical gesture of turning away (i.e., negation) is crucial to any form of dialectical thinking and thus to our intuitions about political resistance and change. But one of the characteristics of #datapolitik is that it has

augured an age of ubiquity, thus making negation's "turning away" a near impossible critical posture. What would it mean to turn away from, or turn off, algorithms? And so herein lies the question of political violence today: What is the nature of this new algorithmic rationality, and what forms of violence does it introduce? And if the forms of political violence materially do not change in #datapolitik, then what do we make of their scalar magnification and intensification? Finally, what is resistance and critique in #datapolitik?

Ever since Heidegger, political philosophy has been concerned with the triumph of technical modes of thinking and how it can become a mask of mastery for systems of oppression often concealed within objective—or should we say objecting—epistemological paradigms, which work through the reduction of life to statistical measure. What do you find particularly disturbing about contemporary forms of algorithmic power? And how does it speak directly to questions of discrimination?

You're absolutely right that Heidegger gives centrality to technical modes of thinking in political philosophy. But more than the normative thrust of his reflections (which are debatable) regarding the reduction of life via the rise of what he calls "mechanistic thinking," I actually think that Heidegger's larger contribution is to show how political philosophy has always been complicit and entangled with techne. For Heidegger, technical thinking is a thinking that is fundamentally attuned to the "movedness" of being; crudely put, being is never static but always in motion. To get at your question, then, what I find particularly disturbing about contemporary forms of algorithmic power is precisely this commitment to treating difference or change as a distance between two points, and thus relying on an account of value as a quantifiable interstitial measure. The midcentury English cyberneticist W. Ross Ashby puts it best in his classic work *An Introduction to Cybernetics* when he writes: "The most fundamental concept in cybernetics is that of 'difference,' either that two things are recognizably different or that one thing has changed with time." In short, at the root of cybernetics is the measurement and control of difference defined exclusively in terms of interstitial positionality—that is, defined in terms of the distance between two points.

To bring this directly into frame on the issue of discrimination, let's turn for a moment to Andrew Ferguson's study on the rise and development of predictive policing in the United States in an important book entitled *The Rise of Big Data Policing*. Here, Ferguson is invested in exploring the high risk involved with the scalar intensification of bias that algorithmic policing can produce. (This is something that Julia Angwin, in a series of articles on machine bias at *ProPublica*, has also explored; and I am fortunate to also be exploring similar issues with a fabulous group of scholars here at UCLA at AI.PULSE.)

Risk analysis coupled with computational developments in applied mathematics and AI (especially in the areas of correlationism and causal inference) create models of prediction that are indifferent to content. What do I mean by this? Take the case of one predictive policing algorithm (used for predicting theft) that was adapted from an algorithmic equation originally used to predict earthquake aftershocks. Like an earthquake aftershock, "[a] burglary in one neighborhood might trigger a second or third burglary in that same area close in time," Ferguson writes. The idea here is the following: there is no qualitative difference between an aftershock and a crime. The pattern of behavior is correlated such that both are predictable according to the same criteria. This, because movedness (of the earth's tectonic plates and/or of the removal of property) share behavioral characteristics. What matters, in short, is mechanical movement. Predictive policing does not need either an explanation nor understanding of crime, of racial biases, economic inequality, et cetera. All that is necessary is the datafication of action and a computational calculation that correlates patterns.

Though the application of predictive policing is, as Ferguson rightly shows, a concern, what is of specific concern to me is the gesture of ubiquity described above that renders earthquakes and crime indistinct (because what matters is the movement of data points) such that both and everything can be policed in the same way. This means several things. First and foremost, it means that criminality is now not simply associated with virality (as was proposed in James Q. Wilson and George L. Kelling's "broken windows" theory that was subsequently operationalized by Mayor Rudy Giuliani and his police commissioner William Bratton in New York City in the 1990s), but also with disaster. And this means that the criminalized body is now

both a plague and a disaster. What concerns me further is how the use of algorithms for policing speaks to a truth about our contemporary condition: all of life (i.e., anything that moves on its own) is policeable because it can be datafied, tracked, correlated, and predicted. To police, in short, means to track movement.

What your question about discrimination exposes is just this fact about #datapolitik: that all movement is policeable. And thus, to the extent that algorithms do what Ashby said they did, then what we are currently living is a moment of ubiquitous policing. And this mode of policing is not the interpellative hailing that Louis Althusser had theorized—the "Hey, you there!" that stops you in your tracks. What we find in #datapolitik are practices of policing dependent on total movement and not simply on identity recognition. Thus, a curious emergence of a new political corporeality—the perpetually mobile body—is now the object of policing alongside (or, better, superimposed upon) racial bodies and docile bodies.

Mindful of these corporeal actors, I'd like to pursue further these connections between the virtual world of encoding and how it has distinct material effects upon the human body. A number of post-human scholars have dealt with the advent of digitalized bodies and how this has transformed what it means to be human, for better and certainly worse when thought about from the perspective of control societies. How much of this computational turn do you think is driven by a vision for a military diagram for society?

Part of me would like to simply answer: "All of it." But that's neither a satisfying nor particularly compelling answer. But let me suggest at least three distinct ways in which we might appreciate the computational turn in relation to the militarization of society.

The first is, once again, the issue of cybernetics and its development during the immediate aftermath of World War II. While much has been written about this, I'd like to especially highlight Orit Halpern's book *Beautiful Data* because it was that work that made me realize the importance of the connection between cybernetics and contemporary algorithmic culture. After the war, concerns emerged among military officials that American soldiers fighting in Europe hardly ever fired their weapons, and when they did, they were rarely success-

ful in hitting their targets. The result was innovations in the behavioral modification of soldiers in basic training that attempted to affect their willingness and capacity to kill. The success of these programs was staggering. During World War II, it was estimated that 85 percent of soldiers did not fire their weapons. By the time of Operation Enduring Freedom, the US non-firing ratio was reportedly zero percent. That means that within a span of 50 years, the United States successfully trained their soldiers to be 100 percent effective killing machines.

What was required in order to do so was to innovate and adapt a series of ideas and ideals that came straight out of the behavioral innovations of cybernetics—an emerging science of information control that was born of the work that Norbert Wiener and many others had been doing in developing negative feedback computations for radar targeting technology and missile firing. And here is my point: the central military contribution of cybernetics to society is the innovation, development, and application of negative feedback at every level of social life and thus the transformation of everyday life into a kind of target practice. Hence, I would say, the ubiquity of gamification for all aspects of life.

This leads to a second (and related) point concerning what we might call "cynegetic predation." This is an idea I adopt and adapt from Grégoire Chamayou's study, *Manhunts*, which is a book about the historical emergence of police logics from the ancient and classical traditions of hunting manuals to the present—one of the most famous being Xenophon's *Cynegeticus*. "Cynegetics" refers to the ancient art of training dogs for hunting. What Chamayou's *Manhunts* offers us is a genealogy of tracking and capturing techniques, practices, sensibilities, and mentalities and their eventual adoption as tactics of police predation of criminals and escaped slaves in the nineteenth century. Cynegetic predation is at the heart of the police logic of #datapolitik—to wit, the pursuit and tracking of moving bodies whose motions are, as noted earlier, identified as data points along a negative feedback loop. If this is a little too abstract and abrupt, simply think of how recommendation algorithms like the ones used at Amazon or Netflix operate so as to capture taste preferences according to a correlational feedback loop. The better they are at hunting your tastes, the more you are inclined to use their specific recommendation platform. This kind of operation is what I mean by the ubiquitous police logic of cynegetic

predation which, as I noted earlier, requires constant and incessant movement. Only things that move are subject to predation. But everything moves, including information.

The final point is the matter of logistics. And this is more or less straightforward. A networked society is a logistical society, and logistics is an ancient military development (most readily available in advice to princes' literatures on the art of war, like de Vauban's 1706 *Traité de la défense des places*) that attempts to deal with the highly complex problem of how to deploy troops and equipment in the most efficient way possible, in the quickest way possible, and with the maximal amount of effects. Deborah Cowen's *The Deadly Life of Logistics: Mapping Violence in Global Trade* is excellent on this topic, and a must read for anyone interested in contemporary violence. Crucial to logistics is the development of mechanical rules to maximize deployment effectivity—and precisely because of this, we can see how algorithms quickly became the best technology for rendering logistics at once highly efficient and ubiquitous. After all, and as anyone who has ever written about algorithms will typically affirm, algorithms are simply mechanical rules that operate within a logistical framework. Tarleton Gillespie's entry in the book *Digital Keywords* offers a helpful definition of an algorithm as

a particular kind of sociotechnical ensemble, one of a family of systems for knowledge production or decision making: in this one, people, representations, and information are rendered as data, are put into systematic/mathematical relationships with one another, and then are assigned value based on calculated assessments about them.

For an excellent recent discussion of the issue of military logistics and mechanical rules, I highly recommend Lorraine Daston's 2019 lecture "Mechanical Rules Before Machines: Rules and Paradigms." That said, I would also add this important passage from Cowen's book, which sums up the matter of military logistics, complexity, and violence today:

For most of its martial life, logistics played a subservient role, enabling rather than defining military strategy. But things began to

change with the rise of modern states and then petroleum warfare. The logistical complexity of mobilization in this context meant that the success or failure of campaigns came to rely on logistics. Over the course of the twentieth century, a reversal of sorts took place, and logistics began to lead strategy rather than serve it. This military history reminds us that logistics is not only about circulating stuff but about sustaining life.

And so, the triangle of violence of #datapolitik: feedback–cynegetics–logistics. Couple this with the operationalization of ubiquity and we can begin to observe the contours of a recursive political aesthetic of the police that (for me) requires urgent and engaged critical attention.

To conclude, I'd like to press you on the question of resistance, which you already alluded to above. If the age of the algorithm invokes a sophisticated and seductive assay of all life's movements, such that to be on the outside is tantamount to a certain social death, what alternative grammars might we draw upon to expose more fully its discriminatory and predatory violence?

As I stated earlier, I'm not persuaded that our extant critical vocabularies and concepts are sufficient to the task, principally because the utopian and idealist strand of normative criticism (from Kant to Adorno, Althusser, and beyond) tends not to focus on the metaphysics of movement but on the idea of causal influence (typically defined in terms of political coercion or false consciousness). The point here is that the available norms of critique operate on a model of determinate causality. But I think that the algorithm introduces a series of complexities that require a different critical ontology; and if I'm right, a metaphysics of movement is central to a critical ontology of the algorithm as political medium. In my own work, I explore the metaphysics of movement of the algorithm via the tradition of radical empiricism running from David Hume through some contemporary thinkers, including Richard Grusin, Samantha Frost, and Colin Koopman—all of whom articulate alternative grammars of critique to the ones available in normative idealism and/or dialectics. What I draw most from the tradition of empiricism is the emphasis it places on associationism, and hence relationality. The significant critical insight

in this regard is that forms of relation are not dependent on the terms they relate (this is Gilles Deleuze's great insight about Hume). To speak specifically in grammatical terms, the difference that empiricism introduces is an attention to conjunctions rather than oppositions.

In some recent work, I explore this difference in critical grammars in terms of the "dispositional powers" of technical objects. The matter of dispositionality—that is, a medium's powers of arranging forces and movements in time and space—is central because that's what the algorithm does: it disposes bodies, spatialities, temporalities, perceptibilities, and attentions. In this regard (and here my political aesthetic inclinations shine forth), we are dealing with a compositional technology whose task is the formal disposal of living systems, from biology to ecology and beyond: a total system of perpetual arrangement, if you will.

14

Thinking Art in a Decolonial Way

Brad Evans interviews Lewis Gordon, June 2019

Lewis Gordon is professor of Philosophy with affiliation in Jewish Studies, Caribbean and Latin American Studies, Asian and Asian American Studies, and International Studies at UCONN-Storrs. In this conversion, Lewis discusses what decolonial art means in terms of thinking about resistance, the freedoms it entails, along with the radicality of non-western artistic practice in breaking away from imperial standards.

BRAD EVANS: You have described art as being "the expression of human beings creating belonging in a world that really didn't have to have us." This understanding of art, which stands in marked contrast to art as the production of commodity fetishization, has a profound bearing on its relevance to the human condition, especially its violence. Given the definition you offer, what do you understand to be the relationship between art and violence?

LEWIS GORDON: I reject the model of art as the production of commodity fetishization. It is not that art can never be commodified or made into a fetish. My objection is that the story of art is only presented to us under specific social conditions. Euro-modern society and its celebration of capital are only parts of the human story. It is decadent to reduce art to a single element of what we sometimes do with it—namely, art for consumption.

Such an account of art is also a form of European arrogance wherein nothing exists except through the actions of Europeans or whites. Ancient humanity decorated, found ways to season their food, made music, and danced. Some did so ritualistically; others did so for instrumental reasons long lost to the rest of us; and others did so simply for

enjoyment, fun, or pleasure. Europe certainly didn't invent the idea of a "good life."

Yet the underlying question is: Why do so at all? Even if we enjoy doing something, we do sometimes have to be coaxed into that activity. I regard our species, and perhaps some of our related but now extinct cousins, as endowed with an extraordinary sense of awareness and critical possibility that haunts each moment of lived investment. The fact that we puzzle over what preceded us and what will succeed us brings forth the existential conundrum of what we bring to reality as necessary, despite our existence being contingent. For some, that occasions fear and trembling. For others, wonder. And, yes, there are those who are too busy to care. Yet even the last find pause for moments amid the ebb and flow of life in the range of aesthetic experience we have with objects and performances we call "art." Art brings value to our existence in a world through the radicality of our non-necessity. In other words, because we are irrelevant to reality, it means our value, through art, must be on our terms. Art enables us to live despite the reality and infinite possibilities of the absurd—including the absurd notion that our existence is necessary.

The relationship between art and violence, as I see it, is one of value, valuing, and being valued. The core idea is that violence properly exists where there is an attributable value, which is being both accepted and denied in the violating action. Accidentally walking into a wall hurts. Someone pushing you into a wall is violence. The latter offers two forms of suffering whereas the former has only one. The two are pain and degradation. To be value, realizing oneself as a source of value, and experience being valued offer dignity. Violence rips that dignity away. Where it emerges from sources not linked into the human world of communicated and communicable value, there is accident. Though it may be contingent that violence happens to us, it is never accidental. Where there is violence, there is, then, responsibility.

Art, among other features of human life, is a key value into the radicality of values in which we are offered a refuge from the desolate. That, however, makes us vulnerable to the experience of being thrown back into the cold, uncaring void. There is thus an empowering element in art that paradoxically connects also to the violent significance of disempowerment. All violence includes the disempowering of another.

In terms of your critical understanding, rather than focusing on the colonial practices of art, you have attended to the ways colonialism is brought to art as an invasive force. In this regard, might we see art as being, by definition, something that is necessarily anti-colonial and indeed revealing of something pre-/post-colonial in the temporality of its demands and claims upon the liberation of non-Eurocentric ways of living?

Yes. My argument is one that precisely links art to freedom. It is, however, not freedom in and of itself. It is always reaching beyond itself as a testament to our condition. This is why excellent art speaks across generations. It is only partially in its time. Bad art, however, suffers from a form of implosivity. This, by the way, is also how I define oppression. Or to put it another way, the subjugation of a life is a subjugation of its arts of expression. Human life thrives when it reaches beyond itself. Oppression pushes us back into ourselves to the point of being trapped in our bodies and eventually mental illness. What is madness but losing our mind? I also describe this phenomenon as epistemic closure. It means no longer having to learn; knowing little is to know all. This mentality could be brought to art. It collapses art or artistic practices into forms of closed idols. This is what colonialism, racism, and all forms of oppression do. That is why they are saturated with violence.

Yet there is a paradox. Colonialism and other forms of oppression are, after all, human practices through which human institutions of violence are constructed and maintained. What this means is that they could never be complete. They are attempts, as idols and expressions of idolatry, to close human reality through reducing it to one of its elements. In the case of racism, that means the narcissism, as we have seen over the past few hundred years, of white supremacy. The obvious limitations of all such efforts are that even those who built them eventually find them unlivable and seek alternatives even from those they supposedly "conquered." Colonized people fight, and part of their resistance is in their effort to reclaim their value, often through producing art that transcends the idols imposed on them. Colonial art eventually suffers the fate of all those who imagine they are the end of art, history, and thought. They become boring, unimaginative, irrelevant.

The history of colonizers who seek creativity through fusion or creolization with the aesthetic life of those they dominate is well known. It is also a misunderstood history. Many today call it "appropriation." I reject that characterization since it fails to address what it means to participate in the beautiful, enjoyable, and profound. The better concepts to use are "historical erasure," "historical misrepresentation," or, getting to the point, "historical theft." I use "historical" in each instance, because the issue is not whether some, or perhaps many, whites, for instance, participate in the aesthetic forms of nonwhites. It is that those whites have exploited the history and capitalized on those forms through commodification, historical misrepresentation, and practices of disenfranchisement. It is the addition of racism to the presentation of the art in which such forms are treated only as art when whites perform them.

The liberation of non-Eurocentric forms of art, then, is the liberation of art. I see the liberation of art as linked to freedom since that would also require the freedom of non-European peoples. The Native American philosopher V. F. Cordova argues this point beautifully in her aphorism: "The value of survival is being able to recognize yourself after you've managed to survive." Beyond surviving colonial invasion, colonized people raise, through art, an important question to humankind, as their art is compelled to address the violence unleashed on us all from such an onslaught: Given what has been done, what have we become? What, in remembering, might we offer as testaments of belonging?

"Belonging" is, after all, an unusual word. It in effect means to keep being. That requires having a place in the realm of the possible. What does that demand other than freedom?

The influence of Frantz Fanon over your work still remains powerful and instructive. When reading Fanon, I am often taken by his poetic language and how his critique invokes a truly radical imagination. We could, for example, take a whole number of passages from *Black Skins, White Masks* or *The Wretched of the Earth* and read them as poems in their own terms. What is it about Fanon, which still captures your imagination (thinking with and beyond Fanon), especially in terms of his poetic and aesthetic qualities?

Fanon was not disciplinarily decadent. He loved freedom and under-
stood that to squeeze the human condition into a single narrative, or
box would be to make us into problems. It would be a form of violence.
He understood that this was not an issue of changing players. It was—
and continues to be—about changing the game. Doing so means more
than what the game is but also how the game is played.

Fanon was critical of depersonalization, dissociation, disconnection,
and the varieties of ways human beings are pummeled out of relations
with reality—which includes each other—into the isolation and
madness of self-contained selves. Such a model is best suited for gods,
not people. Human beings require creativity, which in turn requires
possibility and freedom. He thus saw colonialism and oppression also
at methodological levels. This is why he was able to see and articu-
late truth beyond the confines of ordinary philosophical and scientific
prose. Such ways of offering truth hide their own aesthetic character
through supposed claims of non-subjectivity. In fact, the subjective
versus objective divide is loaded with fallacies since neither could
make sense without the other.

Fanon's poetic talents are evident throughout. Beyond his well-
known books published before his death, there are many essays,
editorials, poems, and even academic journal articles with poetic
resonance. Fanon understood that profundity should not be a liability
but instead an exemplification of communicability. So, too, should
humor not be a liability. Readers are often shocked at how funny he
is. Fanon, the revolutionary forensic and clinical psychiatrist was not
only a man of action but one who found time to cook, dance, and read
novels, plays, and poetry.

In the spirit of Fanon, I take some of these issues further and offer
ideas through musical composition and performance, and I also argue
that there are truths available through aesthetic forms and that theory
by itself is insufficient for a healthy relationship with reality. We also
need meaning. A problem with much of what is proffered as profes-
sional scientific and academic writing, for instance, is that they are
attempts to demythologize reality to the point of offering meaning-
less theory. I explore considerations such as truth in fiction, rhythmic
meaning, and more. I thus take seriously the meaning and significance
of myth and narrative and their importance for communication and
also critical sensibility. In other words, the world of thinking suffers

where its model is disconnection instead of connectivity. It would in effect be the performative contradiction of incommunicability as our highest aspiration.

What then does the thinking of art in a decolonial way look like at the level of everyday aesthetic practice? And which contemporary artists in particular stand out for you in this regard as pushing against the boundaries of the colonial imagination?

We should bear in mind that decolonization is always a transitional act or moment. It is the transformation of the given with an expectation of an openness of what will come. This is a paradox because where it fetishizes itself it would be a form of epistemic closure. It would in effect have to produce colonial relations in order to keep decolonial practices going. So, I only see decolonial questions as critical moments in certain forms of art but not necessarily the foci on which art must be based. My argument about art is that it must not be one thing but instead a meeting or convergence of many elements through which we live our relationships with reality. Art is, in other words, about freedom and belonging without dissociation from the challenges of life in the face of the lifeless.

Given my position, I explore a broad range of what we call "art" over the course of human existence. I try to converse with our ancestors who managed to offer us intelligibility of affect and truth from antiquity to the present. This ranges from the visual to the auditory to the gastronomic—in short, the full range of what is properly called *aesthesis*, which refers to affecting all the senses. I do not elide aesthetics because of my position on the dimensions and possibilities of meaning afforded in the practice of art among other kinds of creative activity.

So, with such a lofty goal, and given my position on relationality and the liberating dimensions of art, I must first stress that I seek such experiences from the radically local and independent to the global. As this is a limited forum, I will not belabor our discussion with the long list of works I love but will instead simply focus on some living practitioners from music and visual art.

I immediately think of the following artists in the world of music: Michael Abels (United States), Joan Baez (United States), José

Adelino Barceló de Carvalho (better known as Bonga from Angola), Peter Gabriel (United Kingdom), Abdullah Ibrahim (South Africa), Linton Kwesi Johnson (United Kingdom and Jamaica), Joni Mitchell (Canada), Meshell Ndegeocello (United States), Youssou N'Dour (Senegal), Sinéad O'Connor (Ireland), Burning Spear (a.k.a. Winston Rodney, Jamaica), Boubacar Traoré (better known as Kar Kar from Mali), Jagjit Singh (India), Tracy Chapman (United States).

I see these artists as inheritors of—if by "contemporary" you also mean the past 50 years—the African Americans John Coltrane, Alice Coltrane, Sam Cooke, Miles Davis, Marvin Gaye, Jimi Hendrix, Abbey Lincoln/Aminata Moseka, Charles Mingus, Thelonious Monk, Prince, Max Roach, Horace Silver, Nina Simone, and Billy Strayhorn, the Puerto Rican Willie Colón, the Canadian Leonard Cohen, the Nigerian Fela Kuti, and the Jamaican groups the Wailers, the Abyssinians, and Steel Pulse.

Those artists were revolutionary. Each of them took the world of the rejected and transcended genre and expected practices to offer portraits of freedom, despair, love, and sorrow. The list among those who have become ancestors is, of course, not exhaustive, and if I were to list the past 200 years, which includes artists I listen to from many other countries, the reader may stop reading.

As should be evident, I do not hold the popularity of some artists against them. You no doubt also notice there are some "white" artists on this non-exhaustive list. There have always been white artists who challenge not only the colonization of art but also the same for humankind. Those I have listed regard their commitment to freedom in their art also as forms of resistance against colonization and other forms of decolonization.

I often quip that I am the guy who likes the "B" side of albums. It lost resonance in the age of CDs and now MP3s and streaming. By the "B" side, I mean that most of what I listen to is "indie" or independently-produced music and most of my viewing is of independent cinema. There are, however, "hits" that make my list. Filmmakers—that is, director-writers (again, among the living)—include Charles Burnett, Haile Gerima, Marlon Riggs, Lina Wertmüller, Euzhan Palcy, Julie Dash, Rajkumar Hirani, Jordan Peele, Ryan Coogler, and Boots Riley.

There are, of course, artists whose works connect us to themes of freedom and belonging despite forces of crushing nihilism without

offering the theme of decolonization. Those artists are many, and failure at least to engage what they offer would collapse my analysis into an example of aesthetic and epistemic closure. Many of them get the proverbial "it" of our existence, whether through the sorrowful wails of the Spanish indie group Barbott or the majestic virtuosity of Erykah Badu (listen to her live recordings) or the South African jazz guitarist Vuma Levin, the dynamic couple of US-American jazz saxophonist Ben Barson and opera, jazz, and US-Mexican flamenco vocalist and cellist Gizelxanath Soprano, and the Japanese jazz pianist Hiromi.

I also look forward to mixed media by visual artists such as the African American Paula Wilson in Carrizozo, New Mexico, and the Salvadoran Karina Alma (formerly Oliva Alvarado) in Los Angeles, California. Additionally, there are theater projects such as the Rites and Reason Theatre in the Department of Africana Studies at Brown University, the Edinburgh Festival Fringe, and the Makhanda (formerly Grahamstown) National Arts Festival in which themes of our conversation abound.

I should stress that Levin's, Barson's, Gizelxanath Soprano's, and Alma's work also address decolonial themes. My list of novelists, poets, playwrights, choreographers, architects, and innovative chefs would also make this discussion go too far afield.

And, of course, there are the many unnamed artists who make us pause as they busk in the streets across the globe. They remind us that we emerged out of a nowhere that we made it into somewhere through producing what eventually was a work of the anonymous to everyone who is paradoxically valued, despite our all sharing the eventual fate of anonymity at the moment of our witnesses' final breath.

15

What Does an Anti-Fascist Life Feel Like?

Brad Evans interviews Natasha Lennard, July 2019

Natasha Lennard is an author, activist, and journalist whose work has been featured in many publications, including *The Intercept*, *The New York Times*, and *Esquire*. This conversation provides a critical reflection on her work and activism, the problem of fascism as a tendency, the problem with liberalism, on to the links between journalism and resistance in an age that has seen far-right violence proliferate.

BRAD EVANS: Your writings and work deploy what we might think of as a form of frontline journalism, which takes direct aim at the conceit of objective reporting. Central here has been your continued and explicit insistence about the need to confront fascism in the world. But what do you understand the vexed term of "fascism" to actually mean? And why do you think it's impossible to engage with the problem from any objective or neutral position?

NATASHA LENNARD: If my journalistic work is "frontline," I mean it in a very different sense than merely being on the ground, or present when a News Event (what gets deemed a news event) occurs. But much of the reporting I've done on social movements and activism has been from a position within or from a place of solidarity for activist groups and social justice struggle—so frontline in that sense. Perhaps better described as submerged journalism!

The idea of "objective reporting" as it's typically used in questions of journalism is dismally far away from crucial, philosophical, and ethical questions about how truth, facts, and consensus realities are built. "Objective" reporting of centrist liberal media outlets gets understandably lauded above the explicitly violent propaganda of Fox News. But

we're seeing all too clearly how this lionized journalistic "objectivity" has played into the hands of the far right; if "objectivity" is achieved through a base two-sidesism, as it so often is, we end up entertaining and legitimizing questions that should not be up for question. Like whether Black and Brown lives get to matter. A type of journalistic writing that rejects this sort of "objectivity" can nonetheless be invested in the ethical, collective building of consensus realities and truths, which outright reject the far right's genocidal ideologies.

It's beyond the scope of these few paragraphs to explain fully what I mean by "fascism," but I, as you do in your work, reject a reductive view that sees fascism only when constituted in a totalitarian, militaristic state regime (ideally from early last century!). I'm more interested in an expansive understanding of the term, that enables us to see fascist tendencies, fascist habits (the love of oppressive power, hierarchy, racism, misogyny), and how the desire for them is fostered and enabled to flourish. I'm interested, like so many activists better than myself, in fighting fascistic tendencies through the understanding that they are not habits to be reasoned with. I want to take seriously the way a desire for fascism works.

In my work, I've tried to highlight a way of thinking of "what is or is not" fascism by calling upon Umberto Eco and Ludwig Wittgenstein, to stress that definitions are built through use (language games!). So, just like I can't give you one answer to define what is or is not a "game," I can't give you a definition for "fascism" that draws a clean line of what does and does not count in perpetuity. That's the collective work of meaning-making!

I am struck by the idea of seeing fascism as a tendency, which works at the level of desire. Can you explain in more detail what you mean by a fascist tendency at the level of everyday power relations?

As you examined in your book, *Deleuze & Fascism*, there's a certain impossibility to "anti-fascist" as an identity, insofar as everyday, or "micro-fascisms," permeate so much of life under capitalism. That is, practices of authoritarianism and domination and exploitation that form us, such that we can't just "decide" our way out of them. Gilles Deleuze and Félix Guattari wrote that it is "too easy to be anti-fascist on the molar level, and not even see the fascist inside of you." "Killing

the cop inside your head," as the anarchist slogan goes, is easier said than done. But not everyone becomes a neo-Nazi. This too takes fascist practice, fascist habit; a nurturing and constant reaffirmation of that fascistic desire to oppress and live in an oppressive world. And, to be sure, the world provides that pernicious affirmation. Donald Trump is president after all. Theorist John Protevi put it well: "[A] thousand independent and self-appointed policemen do not make a Gestapo, though they may be a necessary condition for one."

I do appreciate that many of these concerns are developed in your recent book, *Being Numerous: Essays on a Non-Fascist Life,* **which shows how you clearly take the politics of emotion very seriously— both in terms of outrage and to rally against a certain liberal sensibility that often cloaks itself in the language of moral purity, while happily supporting domesticated forms of violence from a distance. What makes your critique of fascism different from the self-congratulatory triumph of liberal reason?**

As I touch upon above, I think it's a problematic liberal approach to treat fascist formations as valid interlocutors. Centrist liberals urge that we follow Michelle Obama's gracious direction: "When they go low, we go high." This means urging debate with fascists and decrying violent or confrontational interventions (decrying antifa tactics).

There is a view that sees tactical and moral value in allowing the likes of neo-Nazi Richard Spencer to publicly speak and rally, hoping that the fallacies of their hateful views are best made visible (thus crushing hate speech with debate and reason). The idea, then, is that the best way to defeat hate speech, such as vile arguments for race realism, would be to listen to it and thus allow its internal contradictions and idiocy to thwart itself. But liberal appeals to reason here will not break through to a fascist epistemology of power and domination—these are Spencer's and his ilk's first principles. And it is this aspect of fascism that needs to be grasped to understand the necessity of antifa's confrontational tactics.

In the first essay in the book, which addresses this directly, I bring up a recent video that earned a lot of liberal praise, in which the *Guardian* journalist Gary Younge, who I really like, interviewed Richard Spencer. Younge described the interview thus: "In the course of our exchange,

he [Spencer] claims that Africans contributed nothing to civilisation (they started it), that Africans benefited from white supremacy (they didn't) and that, since I'm Black I cannot be British (I am)." All of what the journalist says is correct, but that's irrelevant. In the video, Younge tells Spencer, "You're really proud of your racism, aren't you … You're talking nonsense." But Spencer is unmoved and says, "You'll never be an Englishman." A racist invested in the tenets of white supremacy as foundational will not be moved by Younge's correctness.

Meanwhile antifa interventions, which include exposing the identities of white nationalists on social media and reporting them, as well as confrontational street protests, have had success in shutting down far-right figures. Milo lost his book deal; Spencer canceled his college tour and explicitly blamed antifa. People like this are just the tip of a white supremacist iceberg—Donald Trump is president and even before him America was never great—but I think we're seeing the limitations, indeed the risks, of letting liberal demands for civility dictate how we deal with racist fascism.

I'd like to bring this directly to the question of violence as it appears in your work. Not only do you attend to the multiple ways the forces of nihilism can appear in the contemporary moment (including the harm we can do to ourselves); you also leave open the strategic necessity for violence when certain conditions dictate and leave no room for an alternative. In this regard, do you think nonviolence is myopic and actually puts itself on the side of the oppressor by not really confronting the political stakes head-on?

I don't think strategic nonviolent tactics are myopic; indeed, much crucial historic civil rights and social justice action has necessarily taken nonviolence as a guiding principle. Although it's worth remembering that Martin Luther King's principled nonviolence had the intention of bringing attention to the violent response that the white establishment would enact upon Black freedom fighters. The spectacle of violence was assumed and tactically deployed.

I think it's myopic and dangerous for supporters of nonviolent protest to disavow those who would engage in more confrontational tactics. And I entirely reject a view that (aligning with the logic of the state and capital) sees more violence in a broken chain store or bank

window than it does in a system that allows police to kill Black people with impunity. If I say nonviolence is impossible, it's not because I think everyone has to engage in riotous protest. What I mean is that in a state of affairs of vicious inequality, mass incarceration, and institutionalized racism, the background condition for so many people is already violence. At a fascist rally, when neo-Nazis can gather in considerable numbers and chant, "Blood and soil," the background state is violence. So, any violent protests against these background violences must be considered counterviolences. The rioters in Ferguson didn't instigate violence; antifa activists in Charlottesville didn't instigate violence. The violence was already there.

I am reminded here of the powerful interview Angela Davis gave in 1972 from Marin County jail. What was at stake for her was precisely the question of whose violence we condemn. The violence of the system (which was/is as you say "already there") or the violence of resistance. How do you think her voice, among others, still resonates in these troubling times?

I cite that Davis interview in an essay in the book, which looks at the (mis)framing of the uprisings in Ferguson and Baltimore, and other historic riotous uprisings for Black life. I think it's worth repeating Davis's exact words here. She said,

> If you are a black person and live in the black community all your life and walk out on the street every day seeing white policemen surrounding you [...] And when you live under a situation like that constantly, and then you ask me, you know, whether I approve of violence. I mean, that just doesn't make any sense at all.

These words are as relevant today as they were then. The media consistently attributes the act of turning to violence to people who literally cannot turn from it; whose lives and deaths are organized by it. Why not end the cycle? A better question: Is it not cruel to demand peace from those who are not permitted to live in it?

The voices of brilliant scholars and committed activists like Davis are crucial for contemporary struggle because the struggle is not a new

one: it is the ongoing, unfinished, sometimes seemingly Sisyphean fight against white supremacist capitalism and colonialism.

Bringing this back to the question of activism and resistance, you have been openly critical of the power dynamics at work in social movements, especially sexual exploitation and how the most "enlightened radical" can often reveal the most authoritarian of personalities. What advice would you give to your 16-year-old self today before embarking on a journey into the world of political activism and frontline journalism?

To think that participants in social movements, by virtue of having righteous aims, could somehow be exempt from internalizing the sexist, racist, homophobic, and transphobic habits into which society's hierarchies code us all—that would be irresponsible. Part of being in a radical leftist community, one would hope, would entail recognizing this—we can't fight that which we fail to recognize.

In my years in anarchist and activist scenes in New York, I've known so, so many women who have been harmed by posturing men with the finest intersectional, feminist rhetoric. My most abusive long-term partner both introduced me to Donna Haraway's work and gave me a book titled, I kid you not, *The Revolution Starts at Home: Confronting Intimate Violence Within Activist Communities*. Happily I think we're seeing greater scrutiny and less tolerance for this sort of hypocrisy—I'd say that's a #MeToo movement shift, and perhaps it is, but I think radical communities are rightly struggling to find a way to deal with sexual violence and manipulation without relying on (equally patriarchal and violent) criminal justice procedures that seem to animate many, but not all, #MeToo narratives.

What would I tell 16-year-old me? Oh god, she was so many me-iterations ago! I think I'd tell her that, as a privileged, white, cis-woman on an elite education track, she should pay attention to her privilege far sooner than she (I, in linear time) actually did. And that low-rise jeans look terrible.

16

Life in Zones of Abandonment

Brad Evans interviews Henry A. Giroux, August 2019

Henry A. Giroux is a renowned public intellectual, author, and critical educator, who currently holds the McMaster University Chair for Scholarship in the Public Interest at McMaster University. In this conversation, Henry for the first time discusses at length his past, how he become aware of the importance of education, and what it means to survive, resist, and escape from zones of abandonment, which continue to render life disposable.

BRAD EVANS: Henry, it's wonderful to once again be in your intellectual company and have the opportunity to discuss your important work. I'd like to also congratulate you on another book publication, *The Terror of the Unforeseen*, which has just been released by an imprint of the *Los Angeles Review of Books*. We have previously talked at length about global issues of power, politics, and violence, but I'd like to turn in this interview to questions of a more biographical nature. You often write about "youth" being targeted and yet overlooked in critical analysis, so can you tell me more about your "formative years"?

HENRY A. GIROUX: I understood from a young age that schools could be a form of pedagogical violence. This began when I was a high school student and stood out as a particularly oppressive episode in my life. School was a form of dead time, marked by racial and class seg-regated pedagogies that were mostly disciplinary and repressive. My educational (or should I say "correctional") facility, ironically named Hope High School, was segregated along class and racial lines. Poor white and Black kids were placed in the "junk" courses, played sports, and were labeled largely through what were defined as their deficits, which included their manner of speaking, dress, and other aspects of

their cultural capital. Most of us entered the school through the back entrance and played on various sports teams. Within the space offered through our participation in a high-powered basketball team, we forged strong bonds across racial lines that offered a sense of solidarity and protection from the worse effects of school disciplinary measures. Yet, this space of marginal privilege never offered up the language or modes of resistance that would allow us to fully understand or escape from a ubiquitous hidden curriculum of racist and class violence that we experienced every single day, in the corridors, at lunch time, and in the not-so-subtle message that we were not wanted at the social events organized by kids from the upper middle and ruling classes in the school. We had no language to resist our own erasure. While some of us were valued for our abilities to play certain sports, this was mere tokenism, as outside of the acknowledgment—to perform without being heard (except in our physically exhausted states)—we were unknowable. Schooling for us was not a place where we realized our capacities to be engaged citizens and as such suffered the violence of being rendered voiceless and thus powerless, at least in terms of being able to narrate our own needs, desires, and hopes. We were defined by what was lacking and paid a price for our status as kids marginalized by class and color. Being unrecognized or treated as unknowable, our sense of subjectivity was not merely in doubt, it was erased.

The school didn't, however, operate according to some special rules. The same racial and class registers were at work outside its walls, and the latter worked in tandem with how the school was organized into protected spaces for the white rich kids and zones of danger and neglect for the rest of us. The racist and class violence of schooling was reproduced seamlessly, externally and internally, adding to its false facade of normalization. It was hard for me to miss the class and racial dimensions of all of this, especially since I had ample opportunity to play in the gyms in Black neighborhoods in Providence, Rhode Island. Visiting the neighborhoods of my Black friends and playing in gyms on their turf was easy, but they could not come into my neighborhood without suffering the indignities of racial slurs or the possibility of a brutal assault. It was then I learned you cannot talk about race without class, or class without race, since both shared the violence of being judged as inferior, outside of the bounds of a quality

education, and subject to forms of social abandonment. Something too many liberals have failed to grasp with their warped notions of individual agency.

In school, we shared the oppression of being disposable, and that became evident in the dropout rates, suspensions, and criminalizing of behavior organized along class and racial lines. School for me was a blunt instrument of social and cultural reproduction, a pedagogical weapon whose aim was to serve the elite through a smoothly functioning social cleansing machine operating in the name of meritocracy. School was a place and space where our social and political agency was denied. My sense of education as a tool of critical awakening, one that was refiguring my sense of agency, first began at that moment when the lived experience of solidarity and loyalty rubbed up against my own unquestioned racism and sexism, which had a long history in the daily encounters of my youth. Sometimes the contradictions between solidarity and loyalty were tested within contradictions that unraveled the common sense of racism and sexism as filtered through the class lens and woven into the fabric of everyday struggles. Treating people as objects or understanding them through established stereotypes was being constantly enacted as I moved through high school, and would be firmly challenged as I met Black men and women who refused those stereotypes and had the kindness and intelligence to open my eyes through both their own lived experiences and their access to a critical language that I lacked. My encounter with pedagogy was through the eyes of the lived oppressed. But I didn't need to "learn it," I knew how it felt, I just lacked the critical language to explain its conditions. As I look back on that history, I believe that school as a tool of repression and segregation has in fact intensified even though (prior to Trump at least), masked by the myth in which it claimed to be more "progressive." The hidden curriculum of racism and class discrimination is no longer hidden and is on full display in the increasing criminalization of student behaviors, the emergence of zero-tolerance policies, the increased policing of schools, the ubiquity of a surveillance culture, and the massive underfunding of public education.

Given this history, when did you first become aware of the importance of education and for its liberating potential to be robbed in

the active production of compliance? I am thinking here about your personal decision to take up the pedagogical challenge yourself.

My initial theoretical and political understanding of education as a moral and political practice, as a struggle over assigned agencies and as a mode of organized resistance or, if you will as a practice of freedom, had its roots during my years as a high school teacher. A more sophisticated understanding of the pedagogical imperative as a political force only emerged while I was in college during the latter half of the '60s. I must admit that my first interest in critical pedagogy grew out of my teaching experience as a secondary school teacher in Barrington, Rhode Island. Despite the imposing structure, teachers then at least had a certain autonomy in shaping their approach to classroom teaching. At that time, I taught a couple of seminars in social studies and focused on feminist studies, theories of alienation, and a range of other important social issues. While I had no trouble finding critical content, including progressive films I used to rent from the Quakers (Society of Friends), I did not know how to theorize the various progressive approaches to teaching I tried in the classroom. All the while, my pedagogical approaches were being constantly questioned by other conservative teachers as well as by a military-styled vice principal who believed that students should sit up straight and simply allow knowledge to be drilled into them.

My lack of a theoretical language came to an end when I was introduced to Paulo Freire's *Pedagogy of the Oppressed* and from then on, my interest in radical pedagogy began to develop rather quickly. After graduating from Carnegie Mellon University in 1977, I became deeply influenced by the work being produced at the Birmingham Centre for Cultural Studies as well as the educational work being done around the sociology of education in England. In the United States, the work of Paul Goodman, Samuel Bowles, and Herbert Gintis on the political economy of schooling as well as the theoretical work developed by Martin Carnoy had an important influence on me. While I learned a great deal from these radical theorists, I felt they erred on the side of political economy and did not say enough about either resistance, critical pedagogy, or the importance of cultural politics. The structural nature of this work was gloomy, over determined, and left little room for seizing upon contradictions, or a theory of power that did

not collapse into domination. Moreover, they had a limited sense of how to theorize forms of domination, if not resistance, as not only economic and structural but also intellectual and pedagogical—that is, through the realms of the symbolic and pedagogical.

Hence, I began to look elsewhere for theoretical models to develop a more comprehensive understanding of schooling and its relationship to larger social, economic, and cultural forces. I initially found it in the work of Stanley Aronowitz, Hannah Arendt, and Herbert Marcuse and the work of the Frankfurt School. I drew upon this work to challenge the then-dominant culture of positivism as well as the radical educational theorists' over-emphasis on the political economy of schooling. *Theory and Resistance in Education* was the most well-known outcome of that work. In the 1970s and 1980s, I also developed a friendship with Donaldo Macedo and Paulo Freire. Freire's work was especially crucial in using pedagogy to open up a space where the private could be translated into larger systemic considerations and through which individuals could imagine themselves as critical and engaged social agents. For me, critical pedagogy was essential for addressing the power and necessity of ideas, knowledge, and culture as fundamental to any viable definition and understanding of politics. Pedagogy was the crucial political resource in theorizing the importance of establishing a formative culture conducive to creating the critical and informed citizens necessary for sustaining a substantive democracy. My interest in critical pedagogy took a turn as I started focusing on youth and media studies.

Pedagogy for me was no longer limited to schooling, and I started focusing on its role as a force shaping and being shaped by broader cultural apparatuses such as the internet, alternative screen cultures, mainstream newspapers, and journals. In this instance, cultural change is a precondition for changing consciousness and is constitutive of political change. I also became concerned with how the pedagogical workstations of diverse cultural apparatuses such as the mainstream and digital media produced a variety of pedagogical messages in keeping with dominant ideologies regarding the normalization of torture under the Bush administration, the refusal to name capitalism as a central reason for the chaos following the effects of Hurricane Katrina, the failure to name neoliberal racism and its ruthless search for profits and disregard for Black people as an important factor

resulting in the poisoning of the water in Flint, Michigan, and the failure to name and analyze ongoing neoliberalization of the university as an attack on democracy itself. I also theorized the importance of connecting the pedagogical imperative to a discourse of militant and educated hope, one which would provide the capacities, knowledges, and skills that would enable individuals to speak, write, and act from a position of agency and empowerment.

I am sure most working-class people who enter into academia will very quickly identify with the structural forms of exclusion you highlight. In my experience, especially in certain quarters of academia, these attempts at policing thought and to make you "play the game" (to my mind one of the most intellectually violent phrases deployed in an intellectual setting), with its normative codes and hierarchical rules, have been imposed with just as much ferocity by those who self-identify with the liberal left as those on the conservative right. I am reminded here of a wonderful quote by John Lennon, who wrote in his song "Working Class Hero," "There's room at the top they're telling you still/ But first you must learn how to smile as you kill/ If you want to be like the folks on the hill." How do those lyrics speak to your experience in academia?

The university has always been for me a difficult site to work in given its often-ruthless attacks from those who follow the established script of mediocrity and neoliberal discipline. Of course, many academics (a term which is quite problematic, after all what we do should never be "academic") are completely disempowered by virtue of being relegated to a contingent labor force. They are overworked, are paid low wages, and live in fear of being controversial, which amounts to a direct assault on academic freedom. Those dwindling few who have tenure are often comfortably entrenched in the university and more than willing to be seduced by the few privileges they have. Power is seductive, and many academics would prefer to be clever and "play the game" than stand up and fight within and against the university as an adjunct of corporate power. I have felt the consequences too often in my long vocation as an outspoken academic. But we need to remember the power of the university is about more than governance or what Foucault called "governmentality." It also reaches deeply into the desires, values, and

identifications of the people who work in higher education. Moreover, while many try to struggle with its impositions, higher education can be a most depressing space because its daily assaults are about more than policy, they are also experienced existentially every day as emotional body blocks which wear away one's sense of agency, hope, and willingness to struggle against forms of domination, especially as they emerge within the university. My resistive strategy has been to have one foot in and one foot out of the university. I work hard to produce scholarship that matters and do the best I can in my teaching. At the same time, my educational skills are put to work in forms of accessible scholarship aimed at a much broader public. In the end, these forms of pedagogical imperatives richly inform each other. What is crucial to learn here is that the task of working in a neoliberal-dominated field of higher education cannot succumb to a kind of careless and self-defeating cynicism. The university is a crucial public sphere and must be viewed as an important site of struggle and criticism, in spite of its over-determining mechanisms of control and mediocrity. History has to remain open on this question.

I'd like to press you further on the relationship between class and race as it appears in these troubling political times. If we can talk of updated forms of fascism, it seems to be working through the cracks in the crisis of white male subjectivity and the mobilizing of such devastated communities against those who have even suffered more from the politics of disposability. How do you understand white anger or resentment today?

This new updated fascist politics and capitalism, which I label "neoliberal fascism" in *The Terror of the Unforeseen*, has its roots in a long history of market-driven policies that have waged war against public goods, civic culture, the welfare state, minorities of class and color, and democracy itself. Neoliberalism has produced immense misfortune through its elevation of a savage capitalism to a national ideal that governs not only the market but all of social life. We now live in a society marked by massive levels of inequality, a landscape of deserted manufacturing jobs, the erosion of social provisions, the harsh imposition of austerity measures, the rise of mass incarceration, and a full-fledged attack on the welfare state. This has resulted in a

culture of fear, anxiety, and populist anger that feeds regretfully into the neo-fascist celebration of a toxic masculinity, white supremacy, and ultra-nationalism. At the heart of this merger are elements of a fascist politics and a war culture that produces, sustains, and reinforces a venomous, racist, and militarized white notion of masculinity that has a long legacy in the United States.

In the past, this notion of white masculinity with its racist subtext, misogyny, and warrior mentality was coded and relegated to the margins of American political culture. Under Trump, it has emerged as a badge of honor and has moved from the margins to the center of power. The loss of privilege and eroding economic status by white males is, as Jason Stanley points out, manipulated as a form of "aggrieved victimhood and exploited to justify past, continuing, or new forms of oppression." At its heart, the alignment of white masculinity with the racist discourse of hate and xenophobia has to be condemned while also understood as a mode of depoliticization. As a mode of depoliticization, this script of victimhood robs poor and middle-class whites of their sense of agency and possibilities for individual and collective resistance against the very forces of structured inequality and economic and social abandonment produced by neoliberalism.

This mammoth neoliberal assault on public life and the planet has produced widespread suffering and misfortune through an expanding network of disposable populations that work in tandem with a culture of fear and the collapse of traditional forms of community, solidarity, and civic identity. People increasingly feel isolated, experience forms of social atomization, and inhabit a crippling loneliness that make them susceptible to the lure of polarizing discourses, the rhetoric of hate, and appeals by self-proclaimed strong men who claim that they alone can solve the problems of those living under the weight of death-dealing forms of exploitation, depression, and exclusion. Bernie Sanders is right in stating that authoritarian leaders such as Trump "redirect popular anger about inequality and declining economic conditions into violent rage against minorities—whether they are immigrants, racial minorities, religious minorities or the LGBT community." This is particularly true for segments of the white male population who are constantly being told that they are the victims of a society that increasingly privileges racial and ethnic minorities.

Susceptible to calls by demagogues to express their anger and resentment at the societal selfishness, greed, and materialism that surrounds them, many white males have found a sense of identification and community in the racist, sexist and xenophobic appeals of a range of current demagogues that include Trump, Jair Bolsonaro, Viktor Orbán, and Recep Tayyip Erdoğan. While I don't want to excuse the poisonous politics at work here and its dangerous flirtation with a kind of fascistic irrationality and the toxic pleasures of authoritarianism, the white males seduced by the pleasures of a toxic authoritarianism need to be addressed in a language that not only speaks to the roots of their fears and economic securities, but also, as Michael Lerner has brilliantly noted, to those fundamental psychological and spiritual needs that have been hijacked by a ruthless capitalist disimagination machine. The underlying supports and backdrop for this racist, militarized, and toxic masculinity that appears to easily inhabit the abyss of racial purification, social cleansing, and a hatred for the other, must be understood against a neoliberal worldview that celebrates greed, elevates self-interest to a national ideal, privatizes everything, and enshrines unchecked forms of individualism and a ruthless survival-of-the-fittest ethos. There is no room in this ideological straitjacket for compassion, social responsibility, solidarity, or a respect for others and this is precisely where the neoliberal machinery of death joins hands with the white supremacist and ultra-nationalist rhetoric of fascism.

The pain and suffering of different groups under neoliberalism has to be understood not through shaming whites or other supporters of a fascist politics, but through efforts to unite these disillusioned groups across race, gender, and class divides. Those groups victimized by neoliberalism share decades of practice in which wages have been gutted, job security has disappeared, finance capital has emptied towns and cities of jobs and drained industries, and has seen the promise of a better future evaporate for their children, if not for themselves. This shared suffering has to be mobilized through a new language of critique and hope, one that aims at building a mass social and political movement that rejects equating capitalism with democracy and embraces a democratic socialist project in which matters of freedom and justice become inseparable from matters of equality and economic justice. White racism, ultra-nationalism, and the politics of dispos-

ability are the hallmarks of a neoliberal fascism that feeds on hatred and polarization of which the consequence is a social system marked by economic and political inequality and chaos. The racism and anger fueling a white version of hyper-masculinity is a symptom not a cause, and the latter has to be understood and addressed by analyzing the merger of neoliberalism and a fascist politics that is spreading across the globe.

I'd like to conclude with a personal question, which I hope doesn't sound too Freudian! If you would go back in time and put your arm around a 14-year-old boy called Henry Giroux, who is practicing alone on that basketball court, what advice would you give him?

I would tell him that growing up in a neighborhood in which the body is the primary resource for surviving will teach him many lessons about what it means to confront a myriad of struggles, but that it is the connection between his mind and body that should be valued as a source of strength in the world he will confront. I would also tell him that education takes place not only in schools but in the wider society and that he will have to learn how to cross a number of borders by mastering a diverse number of literacies extending from print culture to screen culture. I will emphasize that developing his sense of agency will take courage and a willingness to take risks and to learn how to think otherwise in order to act otherwise and that he must not fear taking a strong moral and political position, though he will often meet with unwavering and sometimes brutal resistance. Equally important, I would tell him that his own formation and sense of agency in a world filled with danger and corruption will depend not only on what he learns that will be meaningful, critical, and transformative but also what it means to unlearn certain regressive behaviors, ideas, habits, and values that the dominant culture imposes on him as second nature. I will emphasize that growing up in a society poisoned by hatred and addicted to violence necessitates that he be vigilant in refusing the seductions of power and he will have to be focused and disciplined in order to resist those forces that will relentlessly work to diminish his capacity to be a critically engaged subject. I will tell him that in order to narrate his own sense of agency, he will not only have to understand the symbiotic relationship between intelligence and self-determina-

tion. He will also have to reclaim a sense of history, open the door to dangerous memories, and take risks that enable a new and more radical sense of his own identity and what it means to be in the world from a position of strength. He will certainly have to learn what it means to live with dignity, to embrace a compassion for others, to define his life through his willingness to be a moral witness and a willingness to fight for economic and social justice. I would also tell him that he can never forget that trust and dignity can only come with a respect for and embrace of solidarity with others. I would emphasize that the greatest joys in life can be found in working with others to make the world more just, open, and democratic. I would make clear that he is not alone and cannot act as if major social problems are at heart a matter of individual choice and responsibility. He must be willing to connect knowledge to power and embrace a sense of civic courage, as James Baldwin said, "for the sake of the life and the health of the country." I would end by telling him he must learn to love with courage, reject the power of fear, and embrace his life as a journey filled with dreams of a more just and equitable world.

17

The Violence of Absent Emergencies

Adrian Parr interviews Santiago Zabala, August 2019

Santiago Zabala is ICREA Research Professor of Philosophy at the Pompeu Fabra University in Barcelona. In this conversation, Santiago discusses the politics of emergency, the idea of weak thought, hermeneutic communism, on to why only art could possibly save us.

ADRIAN PARR: In your work on emergency, you formulate an important distinction between emergencies and the absence of emergency. Can you explain what you mean by this and how some "emergencies" function as a displacement activity away from addressing the most pressing emergencies of our time?

SANTIAGO ZABALA: First of all, Adrian, thank you for inviting me to participate in this great series of interviews that Brad Evans began years ago. Speaking of violence is, as I will try to explain, also an absent emergency, itself considering how framed our world has become, how predetermined by the politics of control. The distinction you point out is vital to understanding both the daily, now almost commonplace emergencies as well as the greatest emergency, which literally concerns our existence. In order to illustrate the difference, it is useful to recall how states of "exception" or "emergency" become a central concept in contemporary culture, especially after the terrorist attacks of 9/11. In *State of Exception*, Giorgio Agamben, using the previous investigations of Carl Schmitt and Walter Benjamin, manages to elucidate a central concept for understanding and interpreting global politics after President George W. Bush's invasion of Iraq. The declaration of a state of exception, according to Agamben, not only discloses the performative expression of state power but also forecloses any possibility of meaningful democratic politics. Almost 20 years later, another American president embodies the political predicament of our epoch.

Donald Trump will not be remembered, as Bush is, for exercising extralegal powers to transform the "state of emergency" into routine political measures, but rather for denying pressing emergencies altogether. Trump incarnates a condition where "the greatest emergency has become the absence of emergencies." Among the numerous emergencies that Trump conceals, climate change is certainly the most shocking, as your own work illustrates, but his indifference toward civil and human rights has also created outrage. But how are we to interpret this shift, from "states of emergency" to an "absence of emergency"?

The problem is that the ongoing and repeated invocation of a state of emergency "blocks the representation of what is unintelligible or resistant to political theorization," as Emily Apter recently suggested. But it also creates an inability to respond to an ongoing global call to order and a return to "realism," which is promoted by right-wing populist politicians (Marine Le Pen, Matteo Salvini), and "new realist" intellectuals (Jordan Peterson, Christina Hoff Sommers). The difference between Agamben's and my theory is that I find that the absence of emergencies is not simply the result of particular sovereign decisions but rather of our framed global order, which is a system of control over the emergence of emergencies into the sphere of popular and political action. This does not imply that the world is not full of emergencies that we hear of and watch government responses to every day. Rather, the greatest emergency today is that despite being the focus of mainstream news and popular alarm, many of these are still ignored, overlooked, or rejected from the arena of action. The "absence of emergency" does not refer to the "sovereign who decides on the exceptional case" (as Agamben would have it) but rather to the abandonment of Being or existence in favor of beings and calculation (though this does include the decisions of a sovereign). If a sovereign can declare a state of exception or emergency, then the epoch's metaphysical condition—the abandonment of Being—is its greatest emergency. For too long we have been "rescued *from* emergencies," told that we are saved by temporary fixes that ignore the greatest emergency, when in fact we ought to be "rescued *into* emergencies." This should be our intellectual responsibility in the twenty-first century.

The ongoing refugee crisis is a good example, as it is intrinsically related to climate change. We are told in Europe that mass migration is a result of political instability in the Middle East, but its increase

in the twenty-first century is caused by climate change, which has become the leading cause of migration. The greatest emergency is not the refugees approaching Europe now—though this humanitarian crisis must certainly be addressed, contrary to the policies of many right-wing European governments—but rather the absence of a plan to address its causes, which ultimately lie in the global capitalist system that has caused and refuses to address climate change. As you can see, there is a substantial difference between the stated "emergency" (the arrival of refugees) and the absent emergency (the causes: the environmental crisis and global capitalism).

How might Gianni Vattimo's idea of *pensiero debole*, or "weak thought," equip us with the theoretical resources needed to critically address the myriad forms of violence taking place in the world today—violence against immigrants, women, nonhuman species, the natural world, the economic violence global capitalism inflicts, and the multiple wars being waged between both state and nonstate actors? Can the concept of *pensiero debole*, provide us with new ways of imagining and living life, a life that is more inclusive and caring?

The concept of violence is central to understanding weak thought, which emerged as a response to the Italian Red Brigades' violence of the 1970s. Actually, 2019 marks the 40th anniversary of Gianni Vattimo's idea, which he first presented in a conference in 1979 and later developed with other thinkers, such as Pier Aldo Rovatti, Umberto Eco, and Richard Rorty. As Vattimo explains in his autobiography, at the end of the '70s—when the Red Brigades were "killing people at the rate of one per day" and also threatened to kill him—some of his arrested students wrote letters from prison that were, in his view, full of a "metaphysical and violent rhetorical subjectivity" that he could accept neither morally nor philosophically. This is when he noticed that the "Nietzschean superman revolutionary subject," who was central for many French and Italian philosophers at the time, had been misinterpreted and could not be identified with the students' "Leninist revolutionary subject." Weak thought came to life not out of fear of terrorism but as a response to the terrorist interpretation of the emerging Italian democratic left, in other words, as a recognition of the unacceptability of the Red Brigades' violence.

If weak thought can equip us with theoretical resources to critically address the myriad forms of violence taking place in the world today, it's because—unlike other philosophical positions, such as analytic philosophy or new realism—it has not developed into an organized system. Systematization always entails and expresses violence through metaphysical impositions, aiming to submit all phenomena to the measures, standards, and agendas of the thought system. The duty of the philosopher, according to weak thought, no longer participates in the metaphysical agenda of guiding humanity to understanding the Eternal. Rather, it is to follow a logic of resistance meant to promote a progressive weakening of the strong and violent structures of metaphysics. Thus, weakening, like deconstruction, does not search for correct solutions wherein thought may finally come to a halt but rather seeks theoretical emancipation from absolute truth and other concepts that frame and restrict the possibilities of new existential horizons.

The "more inclusive and caring life" you refer to is manifest in weak thought's attention to the weak, that is, everything that is discharged from and exists at the margins of our framed democracies. These democracies have been building walls—not just those on borders (of the United States, Israel, India) but also, as Mike Davis explains, "epistemological walls"—in order to increase indifference toward the weak. This indifference is simply a symptom of fear, fear of the possibility of emancipation that the weak imply. I'm certain this is the reason why George W. Bush honored John Searle—a thinker who calls for philosophy's submission to science. The "thought of the weak" is always striving for interpretation, that is, to resist the annihilation of existence.

Why do you turn to hermeneutics, a philosophy of interpretation, and in particular the combination of a "hermeneutic communism," as one way to effectively challenge the many emergencies taking place around the world?

Hermeneutics is the philosophy of weak thought. It is through interpretation that we weaken the forces that promulgate the violence I mention earlier. In order to explain this, it is necessary to understand that hermeneutics in the twenty-first century cannot be reduced to a philosophical discipline, such as aesthetics, nor to a philosophical school, such as phenomenology. There is more at stake in the process

of interpretation, which transcends Hans-Georg Gadamer's disciplinary parameters and school ambitions. The world of hermeneutics is not an "object" that can be observed from different points of view and that offers various interpretations. It is a thought-world in continuous movement. If this world does not reveal itself to the perceptions of human beings as a continuous narrative, it's not simply because this is an age of alternative facts. Rather, this reticence emerges because we are not passive describers. As engaged performers, we must always strive—through interpretation—for freedom. We have inherited from Gadamer and Paul Ricoeur a philosophical stance that is continuously overcoming itself, whose applications and consequences these thinkers could not have foreseen. While some philosophers consider the recent feminist, political, and environmental developments in hermeneutics to be foreign to their philosophical projects, others find connections to their thought. I believe the revolutionary role that interpretation had in major social and political events (Luther's translation of the Bible, Freud's psychoanalytic approach, or Kuhn's theory of scientific revolutions) did not emerge from its dialogical ambitions but rather from its anarchic vein, which is present throughout its history. Interpretation is like a virus, a spreading and self-replicating antagonistic resistance to those who would impose universal "methods" or "ideals." This is why we came up with the idea of "hermeneutic communism."

Unlike other contemporary Marxists, we sought (in *Hermeneutic Communism* and *Making Communism Hermeneutical*) to outline a "weakened communism," one free of the violent connotations of historical communism in its Russian-Soviet realization. With the global triumph of capitalism after the fall of the Berlin Wall, communism lost both its effective power and any ability to justify those metaphysical claims that characterized its original Marxist formulation as the ideal of development, which inevitably also draws toward a logic of war. Today, these same ideals and a logic based on eternal growth characterize and guide our framed democracies. The weakened communism we are left with in the twenty-first century does not aspire to construct a perfect state—another Soviet Union—but instead proposes democratic models of social resistance outside the intellectual paradigms that dominated classical Marxism. Unlike other contemporary Marxist theorists, we do not believe that

the twenty-first century calls for revolution, because the forces of the politics of descriptions (as opposed to interpretation) are too powerful, violent, and oppressive to be overcome through a parallel insurrection: only a weak and weakening thought like hermeneutics can avoid violent ideological revolts and therefore protect the weak from violent suppression.

Hermeneutic communism can challenge the global emergency because it refers to an emergency, the idea of communism, that should not have returned. Slavoj Žižek is right when he suggests that communism "today is not the name of a solution but the name of a problem." When social movements in South America elected their own representatives (Evo Morales, Hugo Chávez, and many others) in order to defend the weak and apply much-needed social reforms, it became clear that an alteration of classical Marxism was possible. Although the progressive Latin American leaders never called themselves "communists," much less "hermeneutic communists," they put in place communist initiatives that proved much better at defending their economies, as Oliver Stone, Tariq Ali, and many others reported. And they supported hermeneutic pluralities, such as the recognition of indigenous and environmental rights. What is extraordinary today is that this inception of radical hermeneutic democracy and social communist initiatives has a chance to reach Europe and the United States. I do not mean the Indignados or Occupy movements but rather the possible instantiations of these movements into political parties, such as Podemos in Spain and what Bernie Sanders and Alexandria Ocasio-Cortez are trying to do with the Democratic Party in the United States.

You have developed a powerful argument for *why only art can save us*, in a book by the same name. In what way do you think art practices are well positioned to expose the very absence of emergency that you speak of?

If, as Friedrich Hölderlin said, "[W]here the danger is, also grows the saving power," we must find ways to experience this danger, that is, the greatest emergency. Art, like communism, can thrust us into absent emergencies. I consider art and communism attempts to disclose what I like to call the remains of Being. This does not mean that visual art and

communism have lost their traditional semantic meaning as aesthetic and political concepts, but they are vital for the emergence of Being, which is philosophy's goal. While I think the idea of communism has much to offer, art practices today are closer to our emergencies, in particular the greatest emergencies. This is evident in the ongoing turn from "relational" to "emergency" works of art or aesthetic theories and in artists' inevitable participation in global matters. Although the art world, like the religious and political establishment, is also a system with hierarchies and frames, it has been affected by globalization in a different way, one that through actual exchange lets works emerge for different purposes and in unusual settings.

This is evident in the different experiences of art in art fairs and in biennials: in the rigid art fairs, the viewer contemplates valuable objects, but in the biennials the members of the audience all take responsibility for an experience that concerns everyone. As Caroline Jones recently explained, it "is the emphasis on events and experiences, rather than objects, that constitute[s] the surprising legacy of biennial culture." The fact that the latest trend in biennials, which have increased markedly in these past decades, is to offer these experiences in such remote places as Antarctica and the Californian desert is an indication that globalized art demands global interventions from artists and audiences. The "globalization of the art world," as Arthur Danto once said, "means that art addresses us in our humanity, as men and women who seek in art for meanings that neither of art's peers— philosophy and religion—in what Hegel spoke of as the realm of Absolute Spirit, are able to provide."

The artists who seek to expose these meanings today are the ones whose works demand our intervention in masked and hidden global emergencies, emergencies that are concealed in the idea of their absence. This is evident in Pekka Niittyvirta and Timo Aho's installation of rising sea levels, Josh Kline's *Unemployment* exhibition, or Eva and Franco Mattes's "dark web" installations. These artists demand we intervene in environmental, social, and technological emergencies that we have not been able to confront because of the commonplace emergencies cited by the political return to order and realism I mentioned earlier. The same work of thrusting us into emergency is present in such aesthetic theories as Malcolm Miles's "eco-aesthetics," Jill Bennett's

"practical aesthetics," and Veronica Tello's "counter-memorial aesthetics," where environmental, terrorism, and refugee emergencies play central roles. The goal of these works is not to rescue us from emergencies but rather to rescue us into absent emergencies, an absence that is at the origin of violence today.

18

The Ghosts of Civilized Violence

Brad Evans interviews Alex Taek-Gwang Lee,
October 2019

Alex Taek-Gwang is a professor of cultural studies and founding director of Global Center for Technology in Humanities at Kyung Hee University. In this conversation, Alex discusses the shadow of annihilation, the caricatures reductively applied to the Korean peninsula, the importance of Korean art and aesthetics, on to the continued relevance of the Tiananmen massacre.

BRAD EVANS: We often hear politicians talking about living within the "shadow of annihilation." And yet for Koreans living on both sides of the military demarcation line, such a threat seems all too real. What does annihilation mean to people living in the region today?

ALEX TAEK-GWANG LEE: In both North and South Korea, the feeling of annihilation occupies a permanent presence in our collective imaginations. We are unified in potential destruction. Annihilation clouds every judgment. It lies in wait, concealed in everyday aspects of life. That it hasn't happened yet only goes to prove that someday down the line things might just explode. And yet its normalization is easy to glimpse at through everyday realities. Such is the terror of its distortions. But what is clear is that Korean people are living out a social horror, whose ends lurk in the dimension of the sensible. We continue to look to Hiroshima and Nagasaki as a warning for our futures. But it is so much more than the bomb. We know of its destructive potential, we have lived that nightmare, over and over. It's about the destruction of all we know, our ecologies for life. In this regard, we have come to view history like a continuous natural disaster; we await the inevitable eruption, which is never truly under our control. This infects our politics, and in many ways, shapes every aspect of our identity.

The ghost of the Korean War still hovers over the peninsula like an eschatological force that continues to shape how the world sees us. We appear like a truly schizophrenic people—advanced yet always in the shadow of annihilation. The ideological collision that gave rise to that devastating war has shaped our unconscious, leading to the types of postwar nation-building in both nations. These were consciously reductive. What people in the West tend to term the "Cold War" for us remains one of the hottest wars in history. And the borders demarcating the lines between the North and South Korea are the crystallization of the tensions of these historical process, like a fragile insect of peace precariously walking upon a razor's edge, finding no comfort in the suspension of warfare. It is not the end of the war, but the delay of its ending. It's like somebody forgot to replace the battery in our doomsday clock, but it still desires to keep on ticking.

There is often a familiar caricature we see played out in Western media today, where the South is presented as a liberal space of peace and prosperity in need of protecting, while the North a contemporary manifestation of what the United States once called the "evil empire" in the context of communism. How might we rethink such crude distinctions in terms of the history of violence?

It is very common and somewhat easy to caricature and to demonize North Korea as a "rogue state" or "axis of evil." Of course, some of the statistics in terms of poverty and starvation, not to mention the curtailment of political freedoms, are terrifying. But we can certainly say the same for many other regimes across the world. What's always struck me is how the country officially calls itself the "Democratic People's" Republic of Korea. The tautological naming of the regime in this way invites many explanations of its symbolic meaning. No doubt, there is an epistemological gap between what it is seen from without and what it is identified with within. Before passing crude judgments, we do need to know more about the internal logic of the regime, and gain a better understanding of how it works, its systems of power, its contradictions, and possible sites for resistance and struggle, which seem to elude us.

In the early 1990s, as widely reported, there was an extreme famine in North Korea. Not only was this seen as a humanitarian disaster,

but many experts predicted the collapse of the country and the fall of its leadership. But instead, the regime survived and not only that, it developed a nuclear weapon, which changed everything. If we think about this for just a second, we can see the most astounding contradictions. Through the famine crisis, the North Korean government was seemingly inoperative, failing to distribute the most basic daily necessities including food. And yet it still managed to organize itself to produce the deadliest of weapons known to humans. This would shatter the very idea that the advancement in civilization and advancement in weaponry marched hand in hand. But what does it say about a regime, about a people, which does not protest or revolt against their rulers, but instead voluntarily organized themselves to live in such conditions? Had the people learned that a fate worse than violence from the top, is the fear of a more violent situation without the state? It would be easy just to say this is all about internal oppression and the denial of all resistance. But in my opinion, North Korea is not a failed state, but the way it has reduced everything to a question of survival makes it a quintessential example of the Hobbesian Leviathan— North Koreans are a "democratic people," in the most securitarian sense. They are not a multitude, but tied to a particular social contract with sovereignty, tacitly ceding their rights to the "respectful" and "lovely" leader of the republic.

Seen this way, the reality of North Korea is not far from the liberal formulae of the early-modern Western countries. In fact, what is presented as a monstrous "rogue state" is nothing less than the ultimate incarnation of Western modernity. A state that demands total allegiance to its progressive vision, where politics is reduced to questions of pure survival, where sovereignty is the principal determinant, and where the rule of law is used in the most brutal of ways. This is not a defense of North Korea, but if we wish to criticize the regime, its violence, let us be consistent in what and how we apply our criticisms.

When developing any meaningful critique of violence, we are often drawn to the importance of arts and aesthetics. What do you think is particularly novel and compelling about Korean art when it comes to critiquing recent tragedy and the lived experience of urban destruction?

One of the cruelest episodes of violence that occurred in contemporary Korean history was carried out by the military dictatorship in Gwangju in 1980. After the assassination of Park Chung-hee, a strongman who ruled South Korea for 18 years after the May 16 coup in 1961, Chun Doo-hwan staged another coup on December 12 and attempted to take over power in 1979. However, due to the revival of people's demand for democracy, Chun and his followers could not easily reveal their ambition to get into another dictatorship. They needed an excuse to crush the democratization movements. In those days, the strongest resistance came from the universities. This was inspired by what students learned from Latin America, notably Mexico. The expelled students during Park's regime returned to the campus and started to organize nationwide demonstrations against the plot to set up another military dictatorship, which would no doubt have still been supported by Western leaders with their own claims on the region. Students calling for anti-martial law led to the gathering of some 100,000 students and citizens who participated in a huge demonstration in Seoul Station in May 15, 1980. Chun then felt threatened and forced the cabinet to extend martial law to the whole country on May 17.

The Gwangju massacre took place against this background. What began as a student uprising against imposed martial law resulted in mass killings and rapes taking place in the streets. This was an act of brutal violence carried out by the Southern regime to warn against any resistance. The Gwangju massacre was not simply the accidental enactment of state violence on innocent people, but instead the return of military atrocity in the Cold War period. The bloodbath was the revenant of global violence brought up by the geopolitics of Cold War.

The commanders of the troops sent to the city were part of the same killing machines trained in the Vietnam War and so easily ordered and routinely enacted the massacre of civilians. The clandestine special forces first fired without hesitation into the crowd who gathered around the town hall of Gwangju and stabbed the unarmed people with military knives. The parallels with the Tlatelolco massacre in Mexico in 1968 were very apparent. They even murdered a pregnant young woman who waited for her husband on the street and chased people running away, shooting guns and beating them to death. This tragic massacre, however, proved to be a catalyst for radical social

movements and paved the way toward the democratization of South Korea from below.

Many artists have attempted to overcome the overwhelming sadness and the fearful memory of this atrocity by representing or reactivating the revolutionary experiences of Gwangju. Those artistic practices have been categorized today as Minjung art. Minjung art was a radical movement which tried to abolish aesthetic elitism by engaging the political scenes from the 1970s onward. "Minjung" refers to those people who are at the bottom of society, though it also includes intellectuals, journalists, and civil rights advocates too.

There were two groups to participate in the movement: one was the Association of Minjung Artists, and the other was the Alliance of Minjung Artists. What made the difference between two societies was how one understood Minjung art. The former thought that the artistic tradition is still important to create Minjung art, while the latter believed that aesthetic convention as such is the crystallization of reactionary power to repress the revolutionary spirit and should be rejected for artistic engagement. For this reason, Minjung art has been seen as something that rejects both the influences of the West and orthodox communist propaganda. And again, the notable influence from Mexico. However, such art does have its contradictions, as it now attracts the attention of the art world, has also been commodified, and reveals the constantly lurking dilemma of recreating a tradition in a modern and appropriated form, furthering avant-garde engagement.

For instance, while the Minjung artists mantra of attacking art for art's sake, brought forth collective artistic practices such as mural painting, woodcut printing, installment, performance, and so on, it is clear that those forms of practical aesthetics were already conducted by radical avant-garde artists in the "Third World" (i.e., the Global South today), as well as China and Japan. In fact, the artistic movements in the region were categorized as "reportage art" and were clearly inclined to the utopian amalgam of nationalism and communism. Nationalism was necessary to mobilize people for the communist agenda and thus, in many instances, turned out to be the main theme of revolutionary art in the areas sharing colonial experiences. I would say that aspects of Korean Minjung art were not that exceptional then in the way they eventually shifted from a truly revolutionary rupture to the all-too-familiar bringing together of nationalism and socialism for

its political vision. The utopian assertion of the political integration mostly rendered the "imaginary community" in Benedict Anderson's sense. Minjung art was in this vein the utopian project to (re-)present a nation as an ideal commune.

A group of artists, including Shin Hak-chul, often described the nation as the pre-modern imaginary community of a rural life, whereas some artists, like Hong Song-dam, emphasized the ideal commune of an urban life enlightened in the moment of May '80 in Gwangju. Innumerable unknown artists also challenged the distinction between art and non-art, striving to dismantle the institutionalized credence of art. However, what they ultimately brought out in terms of Minjung art was the liberated nation, and so their slogans were mainly about national liberation. Huge hanging paintings depicted the history of national liberation movements and were made to agitate people, and the images they produced could easily be used for the banner of political demonstration in any site. This raises some critical questions as to why Korean Minjung artists were so obsessed with nationalism, even though some of them were supportive to workers' movements whose rights were evidently being destroyed by the state.

As I implied above, my answer would be that Korean Minjung art is nothing less than a symptomatic consequence of the repressed references to the Non-Aligned Movement in the Third World. That is to say, Minjung art is the aesthetic attempt to reimagine or re-invent the land of the forgotten people who are missing: the term *Minjung* (민중, 民衆) is the code word for "people" (인민, 人民) to avoid censorship during the 1980s. In that regard, it served an important aesthetic and political function. In those days, the term "people" often directly alluded to North Korea because of the official title of the country. However, the term "people" for the Minjung suggested something different, even though there were evident contradictions. "People" would be understood as the members of a "modern state" who make a contract with government. The term "people" presupposed here a free individual subsisting in a modern democracy; meanwhile, the term "Minjung" does not presume such an individual, but instead the equal members of national community, who were supposed to exist before the establishment of a modern state. In this sense, the term Minjung as such should be understood as a utopian solution, i.e., a symbolic act, to the traumatic experiences of the irre-

sistible state violence in reality, but a symbolic act that could also be easily appropriated.

To conclude, we have recently marked the thirtieth anniversary of the massacre in Tiananmen Square in China. The photograph of the lone protestor still haunts us and continues to paint a damning picture of the regime and its legacy of political suppression. What do those events mean for contemporary thinkers in South Korea? And what lessons can be taken from them in terms of developing a new radical imagination from outside of the Eurocentric world?

I was an undergraduate student when the Tiananmen slaughter took place. Like many in my country, I saw the scenes of violence on the television. It was a shocking image that left a strong impression and pushed many, including myself, to reflect on my naïve approach to communism, especially its Chinese variation. Before the events, students like me searched for alternative politics to solve the problem of our country, and both the Soviet Union and the Chinese model seemed a possible solution—at least in terms of overcoming economic injustice. I am sure Tiananmen for us had the same impact on some leftists here as the publication of Aleksandr Solzhenitsyn's *The Gulag Archipelago* registered in Europe in the 1970s.

When trying to make sense of the Tiananmen massacre, I encountered Walter Benjamin's critique of violence, which led me to study further the relationship between justice and law. It also made me and my friends rethink the relationship between radical politics, political change, and how this can sometimes lead to the most devastating outcomes. We would discuss Martin Heidegger's dilemma that took him to Nazism, a dilemma in which the radical imagination ends up choosing the worst of all possibilities.

But what Tiananmen also showed was that history was never determined and people do still resist. Just look at what's happening in Hong Kong today! The world that we live in is not natural and necessarily given, but shaped by many contingent encounters in history. If the so-called world order we have today is the by-product of international relations after World War II, that system is nevertheless deeply vulnerable as well. This should allow us to purposefully reflect on the rupture of the utopian impulse, even if its breaks mostly failed to bring about an

alternative regime. The lonely protestor in Tiananmen surely remains the most powerful indicator of the hidden resistance, revealing the cracks in the lineal representation of history saturated by an oppressive and ultimately Eurocentric gaze. His shadow shows how the repressed always returns. Resistance in this regard is both infinite and singular. And this infinite capacity for resistance can be the starting point for rewriting history in more humane and globally astute ways.

19

Violence Is Freedom

Brad Evans interviews Roy Scranton, November 2019

Roy Scranton is an American writer of fiction, nonfiction, and poetry. His essays, journalism, short fiction, and reviews have appeared in *The New York Times, Rolling Stone, The Nation, Dissent, LIT, Los Angeles Review of Books,* and *Boston Review.* In this conversation, Roy discusses the relationship between violence and freedom, the challenges of writing about violence, mythmaking and the concept of original violence.

BRAD EVANS: A recurring theme throughout all your writings is the problem of violence. This has included meditations on war, which no doubt was influenced by your personal experiences in armed conflict, along with wider issues concerning ecological devastation and extinction. What is it about violence that commands your attention as a writer?

ROY SCRANTON: Violence is, in itself, quite stimulating: it activates our most visceral engagement, imbues the world with portent, and freights every choice with existential signification. And it's not so much even the case that violence commands my attention, but rather that violence is endemic to the fantasy life of American culture. It's impossible to escape. So there is one sense in which my work, in its fascination with violence, is simply participating in American culture, exploring canonical tropes and themes, as it were, playing tunes from the great American songbook: "Stagger Lee" and "The Ballad of Jesse James" and "Folsom Prison Blues" and "Fuck tha Police" and "'97 Bonnie and Clyde."

But it's also true that writing is for me an esoteric process of objectification and purgation, even betrayal, in which sense my work isn't merely playing with violence, but is rather a series of attempts to

exorcise from my own consciousness the violence that has shaped it and continues to affect it today. At this level of understanding, which sometimes takes shape as intellectualization and other times as aesthetic shaping, what interests me about violence is first of all how it is a way that humans make meaning. Something happens when blood is spilled, when physical force comes into the realm of ideas, which is neither a silencing nor the irruption of irrationality, but rather a merging of concepts and substance. This is the power of sacrifice, of course, the power of trauma, the power of originary violence, the power to lay down the law. We might even say that it *is* the law: logos backed by violence.

Can you elaborate more on why you think writing about violence is an act of betrayal? Do you feel there is something dishonest about the process or at least that violence forces us to confront something our words cannot fully grasp when it relates back to its experience?

It is axiomatic to modern civilization that violence is the exception, rather than the rule, and the amount of ideological work dedicated to preserving this fiction is massive. This is, in effect, the whole point of the discourse of trauma, which insists that violence is so alien to civilized life that it cannot even be discussed, that violence warps and destroys language itself. As I show in *Total Mobilization*, though, this is actually a two-step process: first the violence is disavowed as unspeakable trauma, then it is brought back under "rational" control through the techno-medical discourses of therapeutic and psychiatric treatment. It's difficult to say, in the end, which fantastic aspect of this fort-da game is more precious: the conceit that violence is alien to modern civilization, or the delusion that we can control it through narrative.

I'm certainly not the first to expose this secret, but it seems to be the kind of thing we'd all rather not think about. More specifically and personally, I suppose, I see *Total Mobilization* as a betrayal of the sacred role afforded to veterans in American culture. There's an unexamined belief that combat veterans have, through their close encounter with violence, been witness to unspeakable revelatory truths about existence. Yuval Harari called this "flesh-witnessing," and James Campbell called it "combat gnosis." It's sheer nonsense, of course, in

strictly objective terms, but it's a powerful belief. As a veteran myself, I have enjoyed and profited from this kind of auratic power. I have also, for better or worse, spent several years trying to publicly dismantle it.

In general, I think writing as such—at least with any honesty—is necessarily an act of betrayal. Joan Didion said "writers are always selling somebody out," and I also often think of something Deleuze once said or wrote, that I must have picked up from Maggie Nelson: "What other reason is there for writing than to be a traitor to one's own reign, traitor to one's sex, to one's class, to one's majority? And to be a traitor to writing."

In your two most recent books, *I Heart Oklahoma!* and *Total Mobilization*, you focus more specifically on the relationship between violence and freedom. There is often a very reductive claim made on these connections, where the greater freedoms we enjoy the less violence we experience. How do you understand the relationship, and what message do you wish to convey about the violence of freedom in these new projects?

Absolute freedom would of course include the freedom to inflict violence on others, including sexual violence. Consider the fundamental antithesis against which the concept of freedom emerges in the modern world, which is slavery. The slave is subject to violence, the master is free to dispense violence. Thus, freedom isn't simply a freedom *from* violence, as in the liberal understanding, but is, at its heart, a way of giving meaning to the question of violence itself: what it means to be subject to violence versus what it means to wield violence.

I make this claim first to point out that suffering violence and causing violence are both kinds of experience, and second to underline the fact that the relationship between freedom and violence is not simply negative, in which more freedom equals less violence, but rather more complicated. Freedom as we understand it emerges *from* violence: revolutionary violence, originary violence, the absolute violence of the tyrant.

Total Mobilization and *I Heart Oklahoma!* approach this question from different perspectives and with different methods. *Total Mobilization* is interested in how the postwar liberal state narrativizes its relationship to the monstrous violence upon which it is founded—

mass civilian bombing, racialized murder, the atomic bomb—and how trauma emerges as a way of managing that narrative, and the conflicting metaphoric frameworks it seeks to rationalize, namely nationalism and liberal capitalism, whose contradictions were exposed by the violence of World War ii.

I Heart Oklahoma!, while still thinking about the role of violence in the postwar liberal state, is fixated on another conflict, that between the mythic freedom of "the West" and the modern state's apparatus of capture, both historically and in the modern carbon-fueled form of automobile culture. Violence in this case is on the one hand a method for achieving escape, individuation, freedom, as in the archetypal case of Charlie Starkweather—"The stranger asks no greater glory till life is through than to spend one last minute in wilderness"—and on the other hand the necessary force that captures individual violence for the sake of the social order. It's a question of who controls the violence, of how to claim violence for the individual in an increasingly totalitarian society. *I Heart Oklahoma!* is concerned with a mythic America, with the myth of America, with the idea Richard Slotkin calls "regeneration through violence," an atavistic cultural narrative which is easy to dismiss intellectually but which, as we've seen, has an astonishing vitality.

I am taken here by the issue of mythmaking, which many authors see as integral to the formation of political communities and to the justification of violence for some higher or greater purpose. Do you think there is anything particularly unique about this American myth? Or to put it another way, is there something unique in terms of what we might recognize as a distinctly American way of violence, which connects to its historical processes?

I don't know that I would want to claim that there's anything particularly unique about this American myth, except insofar as any culturally and historically specific formation is contingent on its particular determinants, which is to say unique. This is surely a trivial observation but one that's often forgotten in the drive to abstract more general principles. America was built on slavery, conquest, and genocide, and achieved its emergence as a world power in tandem with and largely through carbon-fueled industrialization. That's pretty singular.

Returning back to the relationship between violence and mobilization, I am reminded by the following two quotes. The first, by Paul Virilio (whose work on speed is also seminal in terms of any critique of both technology and traversal), stated, "All wars are wars of movement." And the second, by Gilles Deleuze, noted that "if a people are so oppressed, it's not that their rights are being denied," rather that their movements are being restricted. How do you make sense of these claims, and do they resonate in your work?

What does it mean for movement to be a preeminent mode of human expression? Carbon-fueled, industrialized mobilization forces the human lifeworld to undergo a new level of abstraction, the unification of space and time in an expanding grid, even if that grid ostensibly covers a globe, *the* globe, the rock we live on in space. Thus, the ascendance of liberalism: freedom is the freedom of movement, as it were, constrained only by the same freedom expressed by others. But the truth of movement is more complicated, not only in the sense of it being merely another form of bourgeois self-indulgence, as suggested by Jean-Luc Godard's *Le Week-end*, but in the sense of always already acting in relation to forms and history. All wars may be wars of movement, but that movement necessarily occurs in relation to geology, ecology, climate: the Ploesti oil fields, Russian winter, the beaches of Normandy, the mountains of Guadalcanal. And while movement may be a deciding factor in contests of violent force, it is not what gives the war meaning, which devolves into questions of territory and substance. Take the example of the American war in Vietnam, or Iraq for that matter: thanks to massive technological superiority, American forces never gave up freedom of movement. But it didn't matter. Because war isn't simply the clashing of tanks on a battlefield, but rather a complex mode of human meaning-making. The question in the one case is who is an Iraqi? What does it mean to be Iraqi? What is Iraq? And then who is an American? What does it mean to be American? How do these two meanings connect? How does the one group decide what the other group means, how it understands its own identity? This is less a question of movement, although we talk about guerrilla wars and different levels of movement and we could develop a totalizing framework in which we thus see clandestine movement pitted against exoteric movement, we could call

it "asymmetric warfare," but really what it should help us begin to understand is that war is not primarily about the soldiers who meet on the battlefield, but about how humans organize themselves as collective organisms within ecosystems. The problem of the refugee is not that their movement is being restricted: the problem of the refugee is that they are forced from their habitat.

To bring it back around, what's interesting to me about what Deleuze and Virilio say here is how much it relies upon a worldview in which human meaning is expressed through movement, which is a phenomenon not historically restricted to the modern era but which becomes dominant in the age of oil. Hence the very concept of "total mobilization," which emerges first with Lenin in the Russian Civil War but is most thoroughly developed by Ernst Jünger: an entire society expressing its meaning through movement, which of course is inextricable from violence. It begins to seem, following this lineage, that perhaps industrialization is necessarily fascistic, in a futurist, accelerationist sense, while also being ultimately anarchic.

One thing *I Heart Oklahoma!* is concerned with, however, is the fact that this worldview is already old-fashioned, already out-of-date. Expressing freedom through the machine, à la *The Fast and the Furious*, has been superseded, at least in the moment, by the expression of freedom as control over history, through Twitter activism, for example, or cosplay, or Trumpian MAGA. The unfolding of the internet into global human civilization is transforming human freedom and meaning-making in profound ways, in ways whose ends are as yet impossible to foresee. And yet these older ways of making meaning have not simply disappeared: they exist as substrate, and for some are still preeminent, as for the fans of the series of films just mentioned.

I'd like to conclude by focusing on the Giradian idea of originary violence. This is a pretty normalized understanding; indeed, we only need to walk into any natural history museum to see the dominant evolutionary understanding that we begin from violence played out as a historical and scientific truism, which underpins most notions of civilization. Why do you think it's important to retain this position, and what does it offer in terms of developing a viable critique of violence in the contemporary moment?

The first thing I would say is that I don't think we should "retain a position" on originary violence, but rather that we can observe as an anthropological fact the phenomenon of humans organizing their collective life through such narratives. This is one of the major arguments of *Total Mobilization*: that violence is a way humans make meaning. Violence is endemic to human history; some acts of violence are narrated as having generative power, others not so much. The point isn't to insist yet again, in some naïve way, that human society begins in violence, but rather to bring a more sophisticated analysis to the question of how such stories come about, how they change, and how they are ritualized as practice, e.g., through sacrifice or through trauma and recovery.

The second thing I would say in response to your question would be to ask what you mean by a "critique of violence." Do you mean it in the Kantian sense that Benjamin used in his essay of that name, "Critique of Violence," which is to say asking about the conditions for the possibility of violence? Or do you mean some notional effort to decrease violence in human society? In the first case, I think my analysis in *Total Mobilization* might go some ways toward helping us understand the conditions for the possibility of certain kinds of meaningful violence achieved through sacrifice. And in the second case, I would have to say that we must hope (despite quite a bit of evidence to the contrary) that understanding in itself may help liberate us from our compulsions. A better comprehension of how and why we make our collective lives meaningful through narratives of violence may allow us to inhabit those narratives with greater detachment, irony, and perhaps even freedom.

20

Slavery in America

Brad Evans interviews Ana Lucia Araujo, December 2019

Ana Lucia Araujo is a Brazilian-born writer and professor of history at Howard University, who has worked extensively on the history and memory of the global slave trade. In this conversation, Ana discusses the historical and contemporary dimensions to slavery, the issue of reparations, slavery denial, on to art as a form of counter-memory.

BRAD EVANS: Despite a significant body of important scholarship on the history of slavery (which you have contributed to extensively in your brilliant and compassionate work), there still seems to be considerable denial or misrepresentation of its brutalities and lasting effects. But before we go into this detail, I'd like to begin by asking you to return to your recently published book *Reparations for Slavery and the Slave Trade: A Transnational and Comparative History* and explain what exactly you understand "slavery" to mean. And, if possible, when would you date the birth of its system of enslavement?

ANA LUCIA ARAUJO: Slavery, as an institution and an economic system, has existed in most societies around the world since antiquity. But the enslavement of Africans that emerged with the European colonization of the Americas carried distinct traits. First, it is important to acknowledge that upon their arrival in the American continent, the Spanish and Portuguese enslaved Native American populations. But because war and disease led to the demographic decline of native populations, and because the rise of the sugar industry in the Americas demanded a large workforce, European powers turned to Africa. An enslaved workforce from Africa was no news. Since the fifteenth century, the Portuguese were trading in enslaved Africans to work on sugarcane plantations on the West African Atlantic islands of

São Tomé, Madeira, Azores, Cape Verde, and the Canaries. Drawing from these early developments in the fifteenth century, chattel slavery emerged in the Americas not in 1619 (when the first documented enslaved Africans arrived in Virginia), but indeed one century before during the sixteenth century, when the first enslaved Africans were brought to work in sugarcane plantations and in a variety of other activities in the Caribbean and other parts of the Americas.

Based on violence and coercion, slavery took different forms over time and space. But chattel slavery was an economic system and institution regulated by laws and customs that made possible the ownership of men, women, and children. Conceived as commodities, they could be bought, sold, beaten, raped, killed, and discarded. Moreover, slave owners were entitled to control enslaved bodies through use of physical punishment and psychological abuse. In chattel slavery, enslaved persons were enslaved for life, even though in some periods and places, slave owners could manumit their slaves, and in other situations enslaved individuals could purchase their freedom. In the Americas, slavery was a racialized institution. After the end of Native American slavery, only people of African descent were enslaved. In other words, men, women, and children who had the legal status of "slaves" were not at all in the same position of other groups who were victims of labor exploitation such as indentured servants, who performed unpaid labor for a limited period of time, in exchange for shelter, food, and clothing.

Despite this history, it still seems that we confront a certain slavery denial, especially in the official histories of former colonial powers who try to at least partially justify or domesticate the lived realities of enslavement. In response, might we be more explicit in our critique by addressing at every point of our discussion the *violence of slavery*?

We may have the impression that scholarly works in different disciplines have addressed much about the violence involved in the slave trade and slavery. Yet the historiography of slavery is still relatively young. Only in the last six decades, and especially in the last 30 years, have we witnessed a growing number of works exploring the history of slavery and the Atlantic slave trade. Most of the early historiography focused on slavery in the United States or on the economic and

demographic dimensions of the slave trade. These works remained confined to the academic circles and rarely discussed the experiences of enslaved Africans and their descendants, so the emphasis on the intrinsic violence of the slave trade and slavery systems was often absent from these studies.

Dissociated from the lived experiences, this historiography could not counteract the widespread myths promoting the idea that in many regions (for example, in Latin America) slavery was a benevolent institution, that relations between slave owners and slaves were cordial, and therefore that racism and racial hatred did not exist. In other words, by not reaching the public sphere, this historiography tended to contribute to establishing a barrier between the study of the slavery past and the present legacies of this past, by reinforcing the gradual erasure of the material traces of slavery in the public space as well.

In more recent years, several historians became more interested in the living dimensions of slavery, a dimension that focuses on experience, that we can call memory. These new works exploring the living and working experiences of enslaved individuals, illuminated their suffering and how violence inflicted on their bodies also shaped their minds. I think here about the works of Marcus Rediker, Marcus Wood, Edward E. Baptist, João José Reis, Vincent Brown, Saidiya Hartman, Sowande' Mustakeem, and Daina Ramey Berry, who all addressed the issue of violence in explicit ways. Many of these works attempted to construct the missing bridges between the academy and wider audiences to better engage the violence of slavery as a central element.

I also think about other studies that relied on slave narratives and works that took inspiration from and also stimulated artistic creation (music, novels, films, visual arts). Think about Toni Morrison's novel *Beloved* (1987). Inspired by the true story of Margaret Garner, she also borrowed from the work of historians and then also influenced the work of other historians such as Deborah Gray White. Likewise, the narrative *Twelve Years a Slave* (1853) by Solomon Northup inspired the production of the 2013 movie by Steve McQueen. In other words, scholarship alone will never be able to render the accurate dimension of the *violence of slavery*, but the combination with art and fiction can provide a more complex picture that better considers emotions and the suffering engendered by these human atrocities.

Why would you insist that art and fiction are important critical tools here in terms of thinking about the contested memory of slavery? Is there a need through art, for example, to reimagine the past as much as to reengage with the legacy of slavery in the present?

Perhaps the greatest problem of writing the history of slavery and the Atlantic slave trade is that historians have a hard time accessing the stories of enslaved people, who very often did not leave any written records allowing scholars to listen to their voices. Then my answer is yes, art can fill these gaps, helping us to imagine a past that otherwise we could no longer reach. Art can also help us to imagine faces, voices, actions of peoples whose names and faces were annihilated by violence. Over the last decades, the works of several visual artists in Europe, the Americas, and Africa have brought to light in a variety of ways enslaved people whose presences were erased from historical narratives. Kara Walker is one of these artists. Her work appropriates cut-paper silhouette (a Victorian medium that represents a variety of forms in solid shapes), to address how gender, race, and sexual violence shaped American history. Likewise, Titus Kaphar creates paintings portraying forgotten Black historical characters, such as Sally Hemings, the enslaved woman who gave birth to at least six children fathered by the US President Thomas Jefferson. Another African American artist, Nona Faustine, poses nude at slavery heritage sites in New York, by shedding light on how slavery existed in the US North and how this region fully benefited from the profits of slavery and the Atlantic slave trade.

When we think of some of the worst episodes of violence, for instance the Holocaust, attention rightly turns to the systematic attempts at bringing about forced displacement and eventually the annihilation of an entire people and culture. This ultimately brings us to the terrifying prospect of human disappearance and what it truly means to send life into oblivion. Might we not however look to date the history of disappearance back to the Atlantic slave trade, which would not only force us to look at the abduction of peoples in a different light, but also require a shift in our understanding of cultural annihilation?

The Atlantic slave trade and the Holocaust inform the history of disappearance in different ways. But establishing connections between slavery and the slave trade as human atrocities and the Holocaust as

a genocide can help us to begin illuminating the history of violence, disappearance, and cultural annihilation. The Atlantic slave trade followed the genocide of indigenous populations in the Americas, by imposing on African and Black bodies unprecedented forms of violence. Still, for the sake of the plantation economies these violated bodies should survive, even though during the Middle Passage, these enslaved bodies were also discarded and therefore disappeared.

In the plantations of Brazil, Barbados, or South Carolina, enslaved men, women, and children were marked, beaten, and raped. These repeated actions ultimately led to different degrees of disappearance through family separation and premature death, very often with no right of a proper burial ground. The Atlantic slave trade also contributed to opening the path for the European colonization of West Africa and West Central Africa, with the introduction of systems that also included forced labor and physical punishment. Hence, the first modern genocide was led against the Herero, Nama, and San peoples who fought German colonial rule in German South West Africa (present-day Namibia).

As during Atlantic slavery, an important component of the Holocaust included the concentrationary experience, embodied by the transportation in trains and its labor and extermination camps that are in dialogue with the confinement in slave ships and the living and working conditions in plantations. Yet, even in the most extreme cases—such as Auschwitz—resistance to physical and cultural annihilation has always been present.

Can you elaborate more on these forms of resistance to slavery? What might we learn from the history, and what does it further reveal about the history of enslavement?

In all places where slavery existed in the Americas, there was resistance against slavery. Resistance could be carried out through small actions, such as slowing down the rhythm of work, breaking tools, feigning sickness. Enslaved women individually resisted against slavery through violent actions, by killing their owners and their children, or by committing infanticide. Enslaved women had privileged access to kitchens, they could easily poison their owners and the members of their families. Either in the United States, the Caribbean, or in Brazil,

enslaved men and women organized and participated in slave revolts and formed runaway slave communities. In other words, the history of resistance against slavery shows us that enslaved individuals never passively accepted the continuous violence committed against them. Many of these stories are well known. Many others are being gradually recovered. Here again, art has helped to fill the gaps where there is not enough available information or sources.

Turning specifically to the United States of America today, why does there remain significant opposition to open public debate on the memory of slavery and the way in which slavery has been integral to "the birth of the nation," including its character and design?

Slavery was at the heart of the construction of the United States as the most powerful and richest nation in the world. Bringing this history to light exposes how much the country's wealth derived from the labor provided by enslaved Africans and their descendants. Making slavery visible reveals how the construction of the nation was based on racial hierarchies, and how despite the abolition of slavery in 1865, white supremacy survived as a system that perpetuates racism and racial inequalities. Shedding light on the US slavery allows one to draw continuities between the past and the present, and the picture that emerges from these connections is an unpleasant one.

But despite this resistance, I would risk stating that like never before, there is growing willingness to debate the issue of slavery in the public sphere and to create initiatives in the public space that highlight the atrocities committed during the era of slavery. Yet, in a society (like many others such as Brazil, France, and even England) still oriented by white supremacy, debating slavery reveals old scars that hurt as though they were still fresh. One example of how these scars remain open in a country like the United States is the wave of protests demanding the removal of Confederate monuments, most of which were constructed many years after the end of the Civil War to commemorate pro-slavery individuals, and how far-right groups have appropriated these monuments in the present to promote public views that support white supremacy and racism.

To conclude, there are numerous organizations in the world today trying to deal with the advent of what we might call "new slavery," which is to say slavery that in many ways takes on a more sophisticated and yet hidden organizational design. What do you think is new about slavery in the world today, and what can we take from history in terms of critiquing its contemporary appearances?

The so-called "new slavery" is an extreme expression of labor exploitation that continues to grow in capitalist societies. However, I think it is important to highlight that the institution of slavery that emerged in the Americas with the development of the Atlantic slave trade was racialized, and that the "new slavery" does not follow the same patterns of racialization. In theory, any individual in any society can be victim of forced labor, even though we know that some groups are more vulnerable, such as individuals who have historically lived in extreme poverty. Although today and in the past the experience of enslavement can carry many similarities, today slavery is illegal. During the era of Atlantic slavery, it was legal (at least most part of the time). Yet, it is worth remembering that in countries like Brazil many individuals who are submitted to working conditions "analogous to slavery" are men and women of African descent working in plantations and farms. Here, the "new slavery" follows the paths of the Atlantic slavery.

21

Why We Should All Read
Walter Benjamin Today

Brad Evans interviews James Martel, February 2020

James Martel is a professor of political science at San Francisco State University and the author of many books on violence. In this conversation, James discusses the continued importance of Walter Benjamin, the mythical and the divine, the critique of violence, the distinction between violence and power, on to the fragile nature of political fascism.

BRAD EVANS: For those of us who remain deeply concerned with understanding the worst episodes in human history, the life and work of Walter Benjamin still appear all too resonant. This in part has something to do with the tragedy of what he came to represent, along with the undoubted brilliance of his insight and challenges to political dogmatism. What is it about Benjamin that captures your attention as an author and critic?

JAMES MARTEL: I think that Benjamin has never been as relevant to questions of politics as he is today with the exception of his own lifetime. As I read him, Benjamin offers one of the best explanations both for the ongoing resilience of capitalism, despite all of its predations and all the instability that it creates, as well as the connection between fascism and liberalism that we are seeing being expressed today. He also offers, I think, the best way to understand how to address our contemporary moment and how to resist and upend capitalism, liberalism, and fascism all round.

In my view, Benjamin's understanding of what he calls "mythic violence" is the key to understanding all of these questions. Mythic violence is Benjamin's term for the way that illicit economic and

political power has asserted itself over all human life, projecting a form of authority out into the world that then becomes accepted as reality itself. It is mythic because there is no true or ontological basis for the powers of liberalism and capitalism; their right to rule is self-proclaimed and then naturalized so that it becomes seen as fated and inevitable. It is violent because, without a genuine basis for its authority, mythic violence must endlessly strike out, killing and hurting over and over again to establish its power and even its reality.

In describing mythic violence, I think it's very important to remember that this doesn't always refer to actual physical violence per se. The German term that we translate into English as "violence" in Benjamin's essay "Critique of Violence" is *gewalt*, a word that may be better translated as force or projection. This is important because it shows first of all that a lot of what Benjamin calls mythic violence is not actually always literally violent (although, as already noted, literal violence is a critical part of what it does). Mythic instantiations such as that are violent in a much deeper sense, with physical violence being only the ultimate and last resort in their arsenal. But it is also important to note that Benjamin is not against responding to mythic violence with an answering form of physical violence at times. In the "Critique of Violence," he tells us that even so seemingly clear a commandment as "thou shalt not kill" does not mean that we can never kill. It means, as he tells us, that we must struggle with the meaning of that commandment both separately and together and at times ignore or abandon it (that is to say to commit violence but in a way that sits squarely on our own shoulders, in a way that can't be pawned off as "following orders" or obeying dictates from God or some other transcendent form of authority).

If we keep these two things in mind (that the state and capitalism are not always physically violent and that the resistance to these things can itself be violent at times) it helps to specify what Benjamin means in terms of a critique of and resistance to modern forms of mythic violence. The key thing to resist is not physical violence per se but rather projections of some kind of external source of authority (whether it is God or gods, nature or some mystical origins) which become the basis for illicit and anxious—hence often physically violent—forms of control.

What seems important to recognize here is how these categories, most notably concerning our allegiance to the mythical order of things, are applicable to both leftist and conservative ideologies, which history shows can both author the most extreme violence.

For Benjamin, without an understanding and critique of mythic violence, any would-be vanquisher of capitalism and liberalism will swiftly become co-opted into the very same political and economic forms that they oppose, ultimately replacing one form of mythic violence with another. In Benjamin's view, the left itself is far from immune from projections of authority (and anxious and violent ones at that). Even so, there is a key difference between the left and the right for Benjamin insofar as the right is based on nothing but mythic projection, projections about racial purity, ancient (false) forms of authority and hierarchies and so on, whereas the left tends to seek to denaturalize these relationships for the sake of a different and better form of political life. Benjamin speaks of a political and aesthetic form that is "useless for the purposes of fascism," which means that it does not allow for the sedimentation of mythic projections. Instead of such projections, Benjamin looks to local and episodic forms of collective decision making, akin to what he calls "pure means" (that is to say, forms of politics that are not related to ends or teleologies which are invariably mythic).

Such a political form would indeed be useless for the right insofar as it denies and undermines precisely what the right is based on, even as it is useful for a left that sought to discern political forms that do not reproduce mythic violence. This discerning mechanism, one that allows us to distinguish between what is mythic and what is not, determining what comes from false projections on to externalities and what comes from within our own communities, is, I think, the key political insight that Benjamin offers us for our own time.

While he wasn't the first to ask what makes humans violent toward each other, we owe it to Benjamin for raising in union the two most pressing of all questions. Namely: "what times are we living in"? and "how can we develop a critique of violence adequate to these times"? What do these two questions say to you in the context of his legacy?

I think we are living in a time when the contradictions of mythic violence are perhaps especially legible in a way that has not been the case since Benjamin's own time. More precisely, these contradictions are more visible in the West and the North; even in the richest and whitest of communities, the conflation between fascism and liberalism, the violence that undergirds both systems, has become particularly evident even to those who would prefer not to be reminded of this. In much of the Global South and in communities of color and poor communities within the West and the North as well, that violence has always been plainly visible (and by design).

In my view, Benjamin helps to explain why the neoliberal order seems to be collapsing into a fascist one. For Benjamin, liberalism and fascism are not as distinct as they are usually considered to be (at least by liberals and fascists!). It's not that liberals and fascists are somehow in secret league with one another; they don't have to be for the homeostatic nature of the systems of mythic violence to function. All that is required is the common mythic form itself and the deep anxieties that this produces in the system. As the inequalities fomented by neoliberalism become increasingly apparent, a turn to more violence (and thus fascism) is required to keep the core capitalist center of mythic violence protected and intact.

Clearly, we live in very scary times, but from a Benjaminian perspective this is also a time of tremendous potential for a revived radical left politics. One of the first things you get taught in a political science department (my own discipline) is that authority weakens the more you have to demonstrate the violence that underlies it. If you have to resort to outright violence, that is a sign that the fabric of reality that Benjamin calls the "phantasmagoria" is unraveling and is no longer doing the job of producing political and economic quiescence.

This is where the opportunity for radical change comes into play. For Benjamin, even as liberalism gives way to fascism, the vulnerability of mythic systems becomes that much more exposed. The need to resort to physical violence, and, perhaps just as critically, the need for those subjected to such violence to respond with terror and awe instead of defiance becomes that much more central to the perpetuation of mythic violence. The exposure of this vulnerability may be the reason that we are seeing an increasing refusal on the part of political subjects in our time to obey or even recognize these powers as such. Today we

are seeing outbursts of resistance all over the world to mythic and neo-liberal power. In Lebanon, Iraq, France, the UK, Bolivia, Chile, Hong Kong, and so many other places, resistance is growing even as repression and state violence are growing in equal measures (as Benjamin would predict).

I am reminded here of Arendt's insistence that violence and power are qualitatively different. Whilst I do find some of this analysis too deterministic, from what you say it is important to remember the reason that totalitarian systems require so much violence is that they ultimately cannot persuade people to follow their systems of empowerment. And in this regard, totalitarian systems are marked not by their absolute power but rather by how precarious they really are when it comes to their durability. Does this resonate with the types of potentiality in Benjamin?

Yes, I think one of the most important things that Benjamin has to tell us is that fascism, for all of its terrifying appearance, is always and inherently on the brink of collapse. That is to say, that fascism is trapped by its own violence, forced to turn to a greater and greater degree of violence as it continually seeks to ground and reground itself. Usually when we think of a very violent and powerful system, we think that it is utterly in control of the situation and that it only collapses, if ever, by virtue of some externality (kind of the way that the combined force of the Allies in World War II ended fascism, at least for a moment). Yet, fascism in some sense does not even need external enemies because it bears its own vulnerability within itself. I'm not saying that a fascist regime can't last for a very long time—Franco's regime lasted for four decades after all—but rather that fascism's requirement for a display of its violence (and just as importantly, as I was saying before, the requirement that its violence be received in a way that supports rather than undermines its political authority) means that it only survives from moment to moment; each moment could be its end. It could vanish in an instant because its power is entirely mythic and not based on any collective decisions. Even though it always clothes itself in a relationship to "the people"; for this reason, I think that "populism" is not the right name for what we are experiencing in our own time. I would not call this populism but maybe something more like mythic groupthink,

which is something very different and actually maybe the opposite of something that is inherent in a collective.

I agree that Arendt's distinction between violence and power has its limitations, but I think it might be helpful here to think about the difference between what Benjamin calls (mythic) violence and nonviolence (with the latter corresponding roughly to Arendt's notion of power). If nonviolence for Benjamin is marked by a refusal of externalities, then we can see that it actually has a far more stable basis than fascism. Again, this does not mean that moments of nonviolence have a longer shelf life than fascist moments. History tends to show the opposite; the real expressions of collective power have tended to be short lived indeed. Yet this lack of duration does not itself mean that nonviolent political moments are always doomed to short forms of duration. I think that in this case, the situation is the direct opposite of fascism: while fascism is internally unstable (because mythic) and doesn't require an external threat to end (although those do help, of course), with nonviolence, the internal form is very stable because it comes out of actual collective forms of decision, which are made without recourse to externalities like racial purity, ancient history, or the like. It is in fact only externalities that can bring it to an end. Unfortunately, those externalities are all too readily found; the creation of a nonviolent society seems to always bring a fascist response. (At this point, even a liberal regime, recognizing the threat that nonviolence poses to its markets, will turn into a fascist regime until the "emergency" is dealt with.)

This sounds like bad news, but I think that in the long run nonviolence may have the stronger hand. Arendt's notion that power is always stronger than violence is very important here. As she informs us, in a clash between nonviolence and violence (recalling yet again that nonviolence for Benjamin does not always mean that it refrains from actual violence; maybe that is one big difference between him and Arendt), nonviolence will win every time. That is precisely why mythic violence is always frantically trying to assert its own existence, why liberal regimes readily give way to fascist ones, why the state must always kill no matter how benign it appears (or desires) to be. But in a way, mythic violence is the one facing an uphill battle; it has vulnerabilities that nonviolent forms do not have; all it has in the end is its own violence, and that cannot be counted on to produce its desired

results in every single instance that it finds itself confronted by a non-violent alternative.

Returning to his most celebrated essay, "Critique of Violence," while appreciating its theoretical richness, I am still nevertheless troubled by the way various scholars simply take its key terms and comport them into the twenty-first century as if the logics and rules for power and violence remained the same. What do you think is required in updating the critique?

That is such an important question. I think that Benjamin must be held in his own time even as he speaks to ours. If not, such a juxtaposition threatens to lose that critical distinction that for Benjamin is the basis for why the thought or materiality of one period of time can disrupt another (and vice versa). If we make Benjamin into a twenty-first-century thinker, then we are making him into something that he is not, and in so doing, the critical perspective that he offers us is lost as well. One example of what you are talking about that I already touched on comes from a failure to understand what Benjamin means by violence in his "Critique." (I think a related failure is to misunderstand what he means by nonviolence too.) Another example is to think that any number of actions constitute a General Strike, which for Benjamin takes very specific—and nonviolent—form.

Perhaps an even better example is the question of what constitutes what Benjamin calls "divine violence." He describes divine violence in the "Critique" as a way for God to reject the fetishism and mythic violence that is often projected on to or attributed to divine sources. For Benjamin, divine violence does not create new laws and truths but merely acts to remove false ones. In my view—and I'll admit that this is hardly a settled point—it is crucial to distinguish between divine violence and any form of human agency. As I see it, if human beings themselves can be said to engage in divine violence, then that defeats the whole purpose of exposing what is mythic and what is not. If people can be said to act as agents of God, then that simply reproduces mythic violence in a new guise. (How would you know when they are acting on God's behalf and when they are not?) Benjamin himself really muddies this distinction in the "Critique," offering that some human activities, including education, may constitute acts of divine

violence. For this reason, some thinkers, such as Slavoj Žižek, have offered that when the poor rise up and attack the rich, they are acting as agents of divine violence. I think this is a big mistake. What I'd say instead is that people act in the wake of an opening that divine violence produces. Divine violence is, in this account, what offers human beings a chance to act in ways that are not constituted by mythic violence, that is to say, to act in ways that are nonviolent. The General Strike is an example of such nonviolence, a way to say no to the entire apparatus of mythic violence.

Despite the fact that we must, as you suggest, keep Benjamin's concepts distinct from those of our own time, I think that there is a huge benefit in connecting his time with our own and thinking alongside him. For me, Benjamin has helped me to see the big picture even if I use different terms than he does to describe our contemporary political moment. The name that I would give to the projections from mythic externalities is archism, a basis for much of our political and economic structures today. The name that I would give to non-mythic and collective nonviolent practices is anarchism (a term that Benjamin himself often uses although he tended to call himself a communist). In my opinion, to speak of archism helps us to avoid the mistake of thinking that the state is the only form of mythic violence that matters. (If it were, then taking over the state would end the predations of mythic violence. Yet, as we have seen in history, such a takeover generally leads to a mere change in rulers.) To speak of anarchism offers us a way to think of a collective and widespread form of resistance that is not merely utopian but is already extant. In fact, I would say that for Benjamin, anarchism is a widespread practice, a form of political nonviolence that archism sits atop, claiming credit for the support and possibility of political forms that in reality it only predates and parasitizes.

In conclusion, I am taken by the already extant forms of resistance you allude to here. Despite the pessimism of the types, then as now, what I still find in Benjamin is the idea that people will resist what is patently intolerable and will try to retain something of the human despite the desperate weight of historical persecution. If Benjamin offers us a single lesson moving forward, what do you think this demands from us?

I think that more than offering us something, Benjamin actually takes away one of the great conceits that allows us to remain ensconced in mythic violence, namely the idea that "there is no alternative." This notion, akin to what Benjamin himself calls "left melancholia," is a kind of self-defeatism that allows leftists and those who are against violence the comfort of thinking that there really isn't anything that they can do, that leftist attempts to avoid violence all produce results that are no less violent than fascism and that therefore we must perforce make our peace with capitalism and just do the best we can. What Benjamin shows us, I think, is not only that a nonviolent life is possible, but that it exists all around us. We are actually engaged in it already. In his view, nonviolence is just another name for daily life, for the infinite decisions, agreements, arguments, and resolutions that we all make with one another each and every day and without any recourse to law or the state. This is what I like to call the anarchist life that we are already living. Nonviolence, then, is not some pie-in-the-sky utopia but an ongoing presence that we always have recourse too. We do not need to destroy everything and then start over. Rather we must remove the parasitic and mythic overlord that rules us through its violence and its lies. The greatest deception that mythic violence has ever pulled over on us is the notion (popularized by novels like *Lord of the Flies*) that if the state or other archist forms were to remove themselves from our life, we would all be stabbing one another within minutes. Benjamin shows us that it is the state itself, the veritable fox guarding the henhouse, that is the source of violence in our life. We may respond to it with various acts of violence of our own, but that is only to repeat the way that we are enmeshed in a violent and mythic order.

If I thought that nothing that I did could ever lead to things being better or different then I would probably be entitled to engage in a bit of left melancholia, to sigh over how awful capitalism is and romanticize the various failed leftist assaults on capitalism's reign. But if I knew, as Benjamin informs us, that capitalism was far more vulnerable than I thought, that I lived amid an entire network of mutually nonviolent collectivity (however much it was overlaid with echoes of state and other forms of mythic violence) then the onus is on me to actually do something about it.

I so admire the courage and clearheadedness that Benjamin displays in his last essay, "On the Concept of History." This was written in 1940, the year of his death and a year that fascism was literally coming down all around him. Rather than allow himself into being terrified into quiescence, at the (fascist) end of history, Benjamin wrote an essay where he understood time itself as defeating the linearity of history and the sense that fascism is fated and cannot be resisted. I don't think we are today quite where the world was when Benjamin wrote that essay, although that depends, once again, on who and where we are talking about, but we are clearly getting closer to this situation on a global scale. I hope that we can demonstrate the same resolve in our time that Benjamin showed in his. Even in the heart of fascism, he saw its true colors, its vulnerabilities, and the fact that it was never as powerful as it seemed. He was able to see mythic violence for what it is even when it ended up costing him his life. If he could do that in the face of Hitler, I hope we can do the same in the face of Trump and Johnson and the like and whomever, or whatever, is to come next.

22

Unlearning History

Brad Evans interviews Ariella Aïsha Azoulay, March 2020

Ariella Aïsha Azoulay is a theorist of photography and visual culture. She is a professor of Modern Culture and Media in the Department of Comparative Literature at Brown University. In this conversation, Ariella discusses the idea of potential history, the need to unlearn imperialism, the need for an aesthetic critique, on to the very meaning of art.

BRAD EVANS: I'd like to begin by congratulating you on the publication of your latest book, *Potential History: Unlearning Imperialism*, which I understand took over ten years to bring together. It offers a remarkably rich and evocative history of the problem of violence and the importance of engaging aesthetics. With this in mind, can you explain what exactly you are implying with the title "Potential History" and how it allows us to arrive at a more considered appreciation of the history of European colonization, especially concerning the forces of plunder and what you specifically identify to be the global scope of imperial violence?

ARIELLA AÏSHA AZOULAY: Thank you, Brad, indeed ten years. Let me start by saying that the book doesn't offer a history but rather a potential history of this violence. The imperial project that started in the late-fifteenth century invented history as we know it today. History became one of imperialism's most powerful reproductive mechanisms, since we all—scholars and non-scholars alike—work within its timelines and knowledge formations.

History is premised on three principles. First, linear temporality—concretized by the historical timeline—that makes the past into the sealed province of the archive. With the assistance of documents testifying to people's categorizations as "slaves," "refugees," "citizens," or

the "undocumented," people are made captives of the past. Imperial violence is said to be over, held only in the past, preventing those whose worlds have been destroyed from seeking reparations and insisting that imperial violence is still occurring. When these people do refuse to comply with the technologies that maintain this worldview, they are punished for their unruliness. Even more, history's temporality makes scholars believe that anti-imperial struggles are part of this past and can only be their objects of research, and that the people who led them belong to the past, even though many of them surround us. Sealing anticolonial formations and imaginations in the past is a constitutive thread of imperial violence that prevents people from acting in common with others across generations and places, and from seeing the existence of refusal wherever and whenever imperialism imposes its technologies.

Second is the invention of the document as a distinct ontological entity. Scholars are trained to read documents through which numerous worlds and cosmologies have been destroyed and declared gone. This is called "reading history" and finding "historical facts." Scholars look after documents like precious gold, because imperialism impaired their capacity to challenge its mechanisms without being assisted by documents. Historians cannot lodge proof without the proof of an archive, and thus they rely on the primary imperial object to challenge imperialism itself. Being allowed the liberty to interpret documents differently—to offer a new interpretation, to "read against the grain," doesn't change the documents' role as ammunition to keep racial capitalism and imperialism as unstoppable.

Third is the invention of the "new" as a catalyzer of history itself. Imperial history is the endless pursuit of the "new"—new world, new order, new man, new humanism, new markets, new resources, new styles, new technologies, new resources, new timeline entry, new everything. Seeking the "new," of course, involves clearing away people who stand in the way of imperial progress. The "new" is harmful also because it has the power to fragment families and communities by installing a generational "gap" that had not before existed, manifested in the capacity or incapacity of different members to handle "new" technologies and to catch up with their time.

I am particularly struck by this fascination with the new, which seems to be the author of so much brutality in the name of enlightened progress. How does your understanding of potential history offer something different to this imperial search to claim what's newly formed (which in itself seems to be essential to preventing a meaningful critique of historical processes)?

Given these three principles on which history is premised, potential history is an attempt to relate differently to what was made past, and to act in common—as if we shared the same time-space unit—with those who refused the initial dispossession forced on the world in 1492. Potential history is an attempt to disable the power of political concepts, institutions, and practices that relegate people's lived experience to the past, and to engage with these concepts not as given categories but as subject to people's actions, aspirations, promises. Potential history is the insistence that though people failed to stop imperialism's imposition in various places and moments, it doesn't mean that their rights—or ours—to still oppose it are gone forever.

Potential history is about recovering these rights, from each and every moment of imperial violence. Not only the right to oppose it, but also to renew and resume the opportunities and options that imperial history sought to foreclose in the past and that have been denied to the next generations. In other words, potential history is about saying that the violent world imperialism imposed is still reversible.

An example: The destruction of Palestine in 1948 and the imposition of the state apparatus of Jewish supremacy as a fait accompli. The fact that scholars collaborated with this violence and determined that Palestine had been destroyed forever should not keep us from claiming the opposite. Palestine is not the name of an enemy; Palestine is the name of a lifeworld that was impaired, and its current inhabitants and expelled inhabitants have the right to reclaim the promise of their ancestors to protect the shared life in this place against nationalists on both sides. This is discussed in the book in the section on civil alliances in Palestine.

I have been following your work for some considerable time, notably your critique of photography as a medium for understanding the contestable truths of war. In your latest study, you identify

the camera as being an imperial tool, which was integral to the colonial imaginary. Can you explain what you mean by this? And how should we think about photography today?

Unlearning imperialism, as the subtitle of the book indicates, is a very long process, and maybe not unsurprisingly, the more you unlearn, the more there is to unlearn. It requires the unlearning of almost every word that stands for a set of procedures and institutional norms that were imperially shaped. So rather than jumping to discuss "war" and "photography," I have to start by refusing the term "war" as something that delineates imperial violence as between two equal sides in a discrete period of time, and of photography as a device-based technology whose origins are associated with the invention of a certain modern device. The imperial violence exercised under the umbrella of "war" in 1945 and the violence of photography have not yet been redressed, and the survivors of massacres in Algeria or in Senegal perpetrated by the French, or the rape of German women by the Allied forces in 1945, are not over. So, it is important to question the role "war" and "photography" played in the long run of imperial violence, confirmed with the help of international legal documents and treaties.

Thus, rather than studying images *of* war, or thinking of photographs as images contained within frames, I engage with photography on the one hand as an event, and on the other, as a global imperial technology of which those discrete events are part. This transforms the mode of engaging with the archive. No longer a depository that recruits us to explain what is and is not there (as in the academic discussion of "absences" or "traces"), the archive is an imperial technology that I refuse to operate. To think about photography as an event allows me to build unruly archives, intervene in documents and create placeholders where I know that photographs should have been taken. Either they were taken and made inaccessible (and in my archive they become *inaccessible photographs*) or they are untaken (and in my archive become *untaken photographs*). The book offers a different account of the ontology of the archive, of the photograph—and more broadly of the document—and of the scholar. With this ontology we are already practicing potential history.

For example: In April and May 1945, thousands of cameras were operating in Berlin where the mass rape of German women by the

Allied soldiers took place. In the dozens of books published in the last decade on the year 1945, one can read only a few pages on this rape, and none of the thousands of photos printed in them seem to evoke this mass rape. Given the omnipresence of cameras, and the ubiquity of rape, the "absence" of images of rape is another symptom of the imperial ontology of photography that invites us to recognize violence as residing in the bodies of imperial victims. When we are trained to see photographs taken in Berlin, for example in 1945, and see in them only destroyed structures and buildings, we are made to believe that the violence of mass rape is absent from the archive. In asking myself how to reinscribe this mass rape in the photographic archive, I worked in three registers against the imperial discipline of the document: (a) locating cameras in space, and using them as placeholders of *untaken photographs*; (b) using textual descriptions retrieved from books that dedicate a few pages to the topic, and using them as captions that I print underneath blank squares I insert into those books; (c) using a diary account by an anonymous woman, *A Woman in Berlin*, written during the rape, as an index of the goings-on we can now infer in existing photographs. This diary was extremely helpful in reviewing the hundreds of available photographs of rubble in the streets, the porosity of the buildings, and the accessibility of sidewalks, as arenas of rape. When we understand that mass rape occurred in imperially destroyed urban spaces, spaces then used to impose "free market" democracy as the only possible political regime, we can now understand that in other environments destroyed in order for the export of democracy, the mass rape of women also took place.

One of the most evocative aspects of the book concerns what exactly is meant by "art" and how the term itself has distinct colonial connotations. What is it about "art" that troubles you, and how does it connect to your understanding of sovereignty as a form of engineering?

I explore the concept of "art" in the book alongside other terms such as "human rights," "archives," "museums," and "sovereignty." Though it is no secret that these terms are constitutive of the imperial project, they are still being used as transcendental categories. The status that these categories acquired facilitated the dissemination of their corre-

sponding institutions: museum, archive, and academic disciplines. Let me illustrate this by looking at the museum, with its stated purpose as a treasury of precious objects from all times and places. These objects, many of which were actually plundered from different cultures, are assumed to be examples of art, even though they had different functions among the original communities that fabricated them. Yet when they are cleansed of the imprint of their use in their communities and posed on pedestals or behind glass vitrines, these objects that formed lifeworlds now become "art." It is this particular spatiality and temporality of the museum that invites the visitor to believe that by going to the museum she can study art in different places and times, as if art is art is art. The designation of "art" is one type of imperial violence.

Thus, even when the plunder of Egypt by Napoleon, for example, is discussed, the museum is assumed to have already been there—the site par excellence for art—waiting to receive the plundered objects. What my book shows is that museums did not preexist plundered objects; rather, their availability after being plundered enabled the creation of museums. These objects are subject to a double temporal violence: on the one hand they are described as newcomers to the space of the museum, and on the other they are relegated to a past that allows their description as "old" or "primitive," part of "antiquity," unfit for the modern category of art. Not only were they often contemporaneous with Western artists, but the latter were endowed with imperial rights to access them once they were placed in museums, and to take inspiration from their craft and art.

I was drawn to art museums during my high school years through the school curriculum. I became friends with objects. I loved them and the craft behind their fabrication, but this, I was taught, was not what "art" was. To identify modern art, one had to look for the non-handicraft sophistication, the critical stance, the hand of the social critic whose allegedly radical history and stance the art expresses. A certain social distinction is promised to those who get it right. This was appealing for me as a young person raised by parents who barely finished eight years of school. I could not know at that time that "getting it right" was an imperial bargain whose unlearning I would one day make the topic of my book. My fascination with modern art turned out to be a fascination with the bargain by which people are conscripted to

the ideology of progress through art, as it moves from premodern to modern, modern to postmodern. The transition affirms the sameness of the category of art, cleansing what was plundered from the violence that made it initially available to be subsumed under the category of art. This bargain is one of many bargains implicating citizen-scholars, asking us to bracket the violence required to see art as an object of study and the scholar as an expert interpreter. This position of the scholar, or of the connoisseur of art, is inseparable from that of the imperial citizen.

To address museums' looted wealth, people now speak of restitution. It is worth noting that unlearning art, museum, and sovereignty, as my book practices and advocates, involves also unlearning the categories that are used to right imperial wrongs. Imperial wrongs are not just about the restitution of property, to give objects back *still as art* to responsible museal experts in their native countries. This notion reproduces the imperial differentiation between people and objects that facilitated the plunder and its naturalization, as well as the imperial category of art. While I'm in favor of restitution claims coming from people whose artifacts were plundered, I argue that other initiatives, predicated on the abolition of the imperial rights that enabled the plunder, are also necessary. But in tandem with such claims, as experts and scholars with privileged access to such plundered wealth, we should call on museums to disown the objects they hold and invite those separated from them to engage with them differently than under museums' protocols.

There are a number of powerful quotes that you draw upon in the book that relate to what we might refer to as the "killing of the will." This points to something that takes us beyond single acts of slaughter, with annihilation being the denial of even the will to die in the face of extreme oppression. How do you understand this, especially the willingness to die for the freedom of others?

The book insists on a correlation between massacres, genocide, enslavement, and the forced migration of people, and the plunder of objects, their forced migrations and the concomitant attempt to murder their meanings. These two patterns of violence against people and objects enable each other. In a pre-imperial world, objects did not exist only

as exchangeable commodities that could constantly migrate and be replaced by others. Objects were part of a world in which people recognized themselves, and in which their rights were inscribed through the fabrication of objects and the various types of relationships they had among and with them, rather than in official documents. Expropriating people from the artifacts in which their rights were inscribed and among which they were protected made people more vulnerable to recurring and lasting violence.

What you refer to as the "killing of the will," and which I describe in the book as this moment when the cry "kill me if you wish" is emitted and a person can actually be killed, is the peak of imperial violence: when people feel that everything else has been exhausted and there is nothing left but to challenge the perpetrators with their presence. This cry "kill me if you wish" is sometimes solely presence with no words to articulate it—that is, the cry, like photography, is an event that does not require an actual cry, an actual photograph. It can be perceived in the presence of people approaching imperial borders where they know that they may be killed. The Great March of Return in Palestine, that has lasted from 1948 until today, consists of such moments. When the objects of people who emit this cry are in the hands of their perpetrators, naturalized in museums and archives, the challenge, as I show in the book, is to reinscribe their rights in these objects as part of the discourse of rights. Often times, these precious objects in museums, can be the "missing documents" of people who are assumed "stateless" or "undocumented." They are not missing. They are there. We just have to unlearn imperialism's rights discourse and recognize their rights in these objects.

In conclusion, I'd like to turn our attention to younger children who have perhaps yet to learn the types of history that you compellingly show to be shrouded in the blood of imperial rule. Alongside our attempts to unlearn the past, how might educators rethink what is taught moving forward, especially when it comes to pedagogies of violence and peace for the young?

We have to be clear about it—it is not history that is shrouded in the blood of imperial rule, that is an abstraction. We are talking about

people, many of them children, who are targeted and murdered by imperial regimes. Let me first unpack this leap from children to students. Imperial rule devours children and pits them against their ancestors, to make them even less protected in this world; this is part of the invention of the past. Under imperial rule, children's bodies and minds are kidnapped en masse, and many of them are prevented from becoming students, kept from studying and reading and writing. Kidnapping is a constitutive part of witch-hunting, slavery, racial capitalism, adoption, orphanage, forced migration, border control, human trafficking, pedophilia, and overseas markets. Compared to all these operations, education provides a more protective environment. However, most of the curriculum in most education systems, is meant to produce good citizens—meaning docile in regard to oppressive states and markets. So, children's minds are kidnapped from learning to rebel. Their minds are also kidnapped into imperial ways of thinking. For children who have access to education in capitalist regimes known as democracies, concepts of history and progress are central to the curriculum. They learn that their ancestors belong to the past, and that they themselves are the future, meaning they have license to continue to destroy the world in the name of progress.

As educators, we must admit that education was shaped as an imperial project, and we have to ask ourselves where our commitments lie. Commitment to an anti- and non-imperial mode of teaching, requires offering our students the opportunity to unlearn not the past per se, but the past as a container in which many things—crimes, unruliness, refusal, repair, or other transmissions of knowledge—are being tamed. We need to unlearn the separation of the past, present, future tenses, and unlearn the future as a separate tense and site of progress. We have to help our students generate potential histories of violence, to engage with different objects, people, and events, not as static moments with a "proper place" in imperial timelines but as still occurring over the half millennia of imperial rule. This unlearning is necessary in order to regain confidence in one's own right to question the naturalization of institutional violence. In the spirit of Fred Moten and Stefano Harney's idea of the undercommons, we have to generate undereducation, withdraw from imperial histories, and insist on what is wrong and what is right. We have to insist on our right to redress

wrongs along with our ancestors who were harmed, even if these injuries were inflicted years, decades, or centuries ago, if the violence was not brought to an end. Undereducation, conduct by many within and outside of academic institutions, is an attempt to renew the common sense of wrong and right against its institutional rival.

23

The Crisis of Containment

Brad Evans interviews Gareth Owen, April 2020

Gareth Owen OBE is the Humanitarian Director at Save the Children, UK, having led many of its emergency operations around the world. In this conversation, Gareth discusses the changing nature of humanitarianism, the Ebola crisis, what that crisis reveals in terms of thinking about other pandemics, why the coronavirus pandemic was a case of humanitarianism coming home, on to what the future of humanitarianism looks like.

BRAD EVANS: Your extensive career working for international aid organizations has meant coming face to face with many of the world's crises. How has the humanitarian terrain changed over this period, and in particular, what have been the greatest political challenges faced?

GARETH OWEN: My experience of humanitarianism began at the tender age of 24 in Somalia in January 1993, soon after the arrival of international troops under the US-led "Operation Restore Hope." I went out to help distribute food to the starving masses and in doing so became an unwitting participant in one of the most extraordinary and hyper-masculine aid operations in history. Reflecting on this in later life has been a painful experience. The son and grandson of university professors, I was a privileged, middle-class Western kid looking to find myself on a road less travelled. I was a naïve, idealistic humanist, with a post-colonial guilt complex. I saw myself going out there to make amends for my own country's violent history by doing good in the world. I was going to war not holding a gun but carrying the olive branch of humanity. I had no sense of the political activism in which humanitarian action is rooted. I was merely acting out a rather self-indulgent fantasy. I was driven more by foolhardy impulsiveness than

courageous determination. I left Somalia soon after the Black Hawk Down incident that signaled the disastrous end game of an operation meant to "Restore Hope."

Within days of leaving Somalia, I was embroiled in another of Africa's most brutal civil wars. I was sent to the besieged city of Malange in Angola to help establish an emergency feeding program for starving children. I had no humanitarian training and knew little of the rules of the Geneva Convention or the norms of International Humanitarian Law. What I encountered there was anarchic lawlessness and extreme violence in a culture of near total impunity. It was like living life in a really bad horror movie minus the suspenseful soundtrack. Somalia had been a strangely enjoyable adventure, but Angola damaged me greatly. I came home from there in the summer of 1994 broken by trauma, a forever changed person.

Arriving home, I watched the Rwandan Genocide and the ensuing Goma refugee crisis unfold on my television screen and felt a tremendous sense of collective failure. Western powers, distracted by the conflict in the Balkans, had been loathe to engage militarily, despite the desperate calls from UN peacekeepers on the ground like Canada's General Roméo Dallaire. It was a monumental failure that had a profound effect on the humanitarian aid community too. In the immediate aftermath of the Rwanda Genocide, international NGOs began to question action based solely on the humanitarian imperative and unregulated volunteerism. This critical reflection ushered in a new era of humanitarian professionalism that sought new standards of conduct and accountability.

Appreciating the international political dimensions to interventions, how might we see the changing nature of liberal order through the lens of humanitarian interventions?

The short decade of liberal humanitarian interventions came to an abrupt end in the Kosovo crisis at the turn of the new Millennium, though there was a brief final fling by the British under Prime Minister Tony Blair in Sierra Leone. Then 9/11 happened and the geopolitical calculus changed completely. George W. Bush's global War on Terror had a hugely blurring effect on the perceptions among recipient communities towards the motives of international human-

itarian agencies. Unwillingly co-opted towards an agenda of regime change in the Western-led military interventions in Afghanistan and Iraq, these humanitarian agencies were now viewed with increasing suspicion by the local population. Hitherto, it had largely still been possible to operate in accordance with the conventional humanitarian principles of neutrality, impartiality, and independence in order to gain the acceptance of local communities in need of aid. Humanitarian agencies had the luxury of believing that these humanitarian principles created the space and trust they needed to work, and most Western humanitarians saw themselves as ultimately protected by their good intentions. But that was now gone. A new identity politics was emerging that viewed all western based institutions as potential enemies. The number of aid workers being killed in the line of duty spiraled upwards as a result, with terrorists the world over viewing aid agencies as legitimate "soft targets" in their ideological struggles against the Western Liberal Order.

Over the past decade, since the advent of the Arab Spring, there has been an upswing in the number of countries experiencing protracted conflict, for example the Syria conflict is now in its tenth year. Between 2000–2017, 27 countries had more than five consecutive years of crisis. In 2018, there were 16 counties that fell into this bracket. This has led to the largest number of refugees and internally displaced persons since World War II. In 2018, their numbers had risen for the seventh year in a row to 70.8 million (a 3 percent rise from 2017). They are forced to endure a perilous, semi-stateless existence in soulless camps or crowded urban ghettos for years on end, or embark on the long, uncertain migration road to "freedom" in the West.

Violence has always been at the root of humanitarian crises, but together with climate change, it has caused a huge growth in humanitarian need this century. At the same time, starting with the US Patriot Act, most Governments have, in the years since 9/11, introduced a raft of restrictive legislation aimed at strengthening national security. This inward-looking agenda has made mounting international humanitarian aid operations in complex conflict settings ever more challenging, as agencies are now required to meet stringent anti-terrorism, anti-fraud, and data protection regulations designed to meet domestic statutory legal requirements in their home countries. Meanwhile, almost perversely, increasing amounts of humanitarian aid money has

been offered by many of the same governments as a weak alternative in the absence of the international political will needed to collaboratively resolve conflict. This has led to a vast expansion of the number and type of aid actors in the humanitarian sector and an increasingly bloated and bureaucratic aid enterprise. In 2018, 206.4 million people in 81 countries needed humanitarian assistance and international humanitarian assistance from governments and private donors reached US$29 billion, increasing by a third since 2014. However, despite the dramatic growth, to the "old school" humanitarians like myself, it feels like the halcyon days of our noble cause are behind us, just at a time when it is clearly needed more than ever. Maybe it's just "grey-bearded" nostalgia, but the bureaucratization of humanitarian agencies has undoubtedly made our work more cumbersome. The collective cause hasn't really changed that much. Humanitarian agencies are still full of incredibly talented and dedicated people, it's just that we seem to allow "the risk management of everything," to get in our own way a lot more these days.

During the so-called "New Wars" of the 1990s, it became increasingly apparent of the need to protect vulnerable populations, including children. Whilst these efforts would be later politicized within the Wars on Terror, there was also some concern with strategies of containment, which often worked to ensure problems might be managed locally instead of allowing endangered people to freely flee from the ravages of conflict. How has the aid industry critically reflected upon these practices?

It seems the vast traumas of World War II, which created the United Nations to "rid future generations of the scourge of warfare" have been almost forgotten by now, along with the fundamental idea that international solidarity as a means of offering protection really matters. As a young man in Somalia, my limited experience meant I wasn't of great use to the 400 local guys I worked with, except for the fact that my presence offered them protection in that they could blame all the decisions that annoyed the local warlords on me. I was, in turn, ably and robustly protected from physical threat by the formidable French Foreign Legion as a key part of their UN mandate. In this way we could all withstand the wrath of the powerful, heavily armed,

and dangerous local elite. Their threat of violence was countered with a much greater threat that they respected, even though this approach created numerous problems for humanitarian actors, especially in their relationships with a local population that became increasingly intolerant of military occupation.

In the Balkans, the West soon found the situation reversed, Serbian forces could not be intimidated into compliance by an under-strength international ground force, as the Srebrenica Massacre tragically demonstrated. In July 1995, more than 8,000 Bosnians, mainly men and boys, were slaughtered by Serbian paramilitaries right under the nose of a Dutch Battalion of UN peacekeepers who seemed powerless to intervene. After the deaths of its special forces troops in Somalia, the US and most of its Western Allies had become "gun shy" in settings like Rwanda, where its strategic interests were not at stake and preferred to rely on the subduing effect of largely invulnerable air power in the Balkans. Also, in the post-9/11 environment the US could no longer afford to continue acting as the Liberal Order's global policemen. No one in the West was ever going to attempt to mount a Somalia-style military peace enforcement operation in Syria or Yemen, despite the obvious need. It would have been heavily resisted with huge military casualties. The international political will to take such risks no longer exists in the West, neither would a hopelessly defunct UN security council architecture ever allow it. The United Nation's mandated peace enforcement has become completely absent as the twenty-first century has progressed.

Instead, paying for local and regional containment has become the international community's preferred approach. In the case of Syria, neighboring host governments like Turkey, Lebanon, and Jordan shoulder an enormous burden. Although, as anyone with a rudimentary reading of history will know, such containment strategies rarely work long-term. The world's problems have a habit of visiting themselves upon you in your own backyard, as German leader, Angela Merkel, and other European heads of state found out in 2016. Of late, President Erdoğan of Turkey has threatened to unleash another wave of refugees fleeing towards the ramparts of "fortress Europe." Simply seeking perpetual containment as a way of avoiding unresolved political problems is unlikely to ever succeed. Worse still, it has shown the West up as self-interested, ineffectual, and hypocritical on the

world stage. This has had an emboldening effect on hyper-nationalistic tendencies at the expense of much needed international solidarity.

For humanitarians, such situations immediately become a fundamental moral question: to turn away and make excuses in someone's hour of greatest need is an unconscionable betrayal of humanity. The role of humanitarians is to cut through all the excuses for inaction and to just focus on the one inalienable reason to act: the imperative to protect the universe's greatest miracle, that is, human life. However, reflecting critically, the harsh truth for today's humanitarian "industry" is that a combination of donor government containment strategies and constraining legislation has brought an era of "zero risk tolerance," where compliance with an increasingly robust donor rule book is the dominant measure of trust in organizations, rather than alignment with humanistic values and the quality of their impact.

It is therefore time for humanitarians like me to break free of the narrow confines of an aid "industry," that too often had us unthinkingly doing the bidding of Western paymasters. We must rediscover our humility and pioneering activist spirit, reacquire some of our lost skepticism for the morality of state power, whilst also remaining positively engaged with international relations to garner political will towards a new international solidarity. This is not an easy path to tread, but it is the vital leadership challenge in the emergent era of the Fourth Industrial Revolution.

Mindful of the complexities regarding containment (not to mention how it plays into overtly-politicized narratives regarding sovereignty, identity, and the question of race and its colonial legacies), I'd like to now turn your attention back to the Ebola crisis in West Africa of 2014. How do you now look back upon that crisis given the problems we currently face?

It is somewhat odd to be looking back on the West Africa Ebola crisis just as the world is battling to subdue the coronavirus pandemic. I recall my Welsh grandfather telling the story of how he had to bury sixty dead Scotsman in Flanders in 1918, who died of the Spanish flu on the boat across the channel. That was the last time we have faced an outbreak on this scale.

The world was slow to react to Ebola. It was February 2014, when the first suspected cases were registered in Guinea. With a case fatality rate of up to 90 percent, Ebola is among the world's deadliest of diseases. An outbreak in such parts of West Africa was highly unusual. As the weeks wore on, the areas affected by Ebola in Guinea kept growing and new cases appeared in neighboring Libera. This too was unusual for Ebola—a disease so deadly that outbreaks normally disappeared quickly due to the human hosts rapidly succumbing before they could spread the infection very far. However, by early June, cases were also beginning to be recorded in Sierra Leone. The Ebola outbreak, far from abating, was just getting going. Though concern was rising, there was insufficient concerted action. It was not until August, when UK Prime Minister David Cameron and US President Barack Obama discussed the outbreak and the World Health Organization (WHO) declared it an emergency, that the coordinated international response really began. It had become a matter of national security. The motive of the West was containment. There was no widely available vaccine for Ebola, due to its rarity as a disease. As such, it was not a viable investment for any commercial pharmaceutical company. But presumably because of concerns over its potential use as a biological weapon, there had been enough scientific research and testing to allow for a fast-tracking of vaccine production. The economics had suddenly shifted now that it posed a clear and present danger to the West.

In any major disease outbreak the focus has to be on prevention of transmission through public health education, effective case management, and strengthening of health systems. My own organization's response to the crisis reached more than 541,000 people, including over 276,000 children. We ran treatment centers, rehabilitated water and sanitation facilities, and trained community health workers to spread the word through house-to-house education campaigns. We reunified unaccompanied and orphaned children with their families, carried out awareness-raising activities to help prevent vulnerable women and girls falling victim to gender-based violence, supported school reopenings, and provided cash grants to vulnerable households. It was a massive effort from a major international aid organization. But it was behavior change among the affected communities that really made the difference. Some of that had to be enforced by government restrictions, as we are seeing in today's coronavirus pandemic,

but much of it happened through peer education within the communities themselves.

Shortly after 9/11, Zygmunt Bauman argued that we shifted from the logics of mutually assured destruction to a mutually assured sense of vulnerability. While this was compelling from the perspective of explicit political terrorism and violence, it perhaps resonated less amongst the middle classes in terms of everyday insecurities— notably food and health (which have been a principle concern for aid workers for a number of decades). These are issues however we are now all having to painfully come to terms with. Might this be a case of humanitarianism coming home, so to speak? And what political and social dangers do we need to avoid in the current climate?

I think it is definitely a case of humanitarianism coming home. The sight of Londoners from all walks of life nervously queuing together outside the supermarket door, spread two meters apart by social distancing as they wait to pick over half-empty grocery shelves, is a desperately familiar one. I have organized such food queues the world over, but I have never stood in one myself. It is a humbling new experience. Then I went out for a walk just as the whole country was cheering and applauding our National Health Service. My heart was filled with the joy of our rediscovered shared humanity. That felt like the complete opposite of the moral blindness of modernity that Bauman so lamented. The virus does not seek to discriminate, it merely seeks to replicate. The homeless, frontline health staff, company chiefs, and even the future British king have all felt its grip. But it is still true that the poorest are inevitably always more vulnerable than the richest. So, for me, the biggest political and social danger we face is that when it is over, we all too quickly forget what the crisis is teaching us about the enormous societal power to be found in collective compassionate empathy. We cannot allow ourselves to return to our old selfish habits.

In the meantime, with millions of lives at risk, the pandemic represents a threat to the global rules-based order like no other. It's a tension being felt across all governments as they seek to protect their national interests. The organized multilateral aid system therefore needs to function better than it ever has before in support of those national efforts, or we may be about to witness its demise.

In conclusion, given these lessons and the need for better public awareness, what are your thoughts on the current crisis? And what are your hopes for the future of humanitarianism?

Today we are experiencing some of the most challenging circumstances that we have faced in a very long time. The stark lesson of Ebola is that the world has continued to invest very little in being sufficiently prepared for massive emergencies. This was my fear at the time: that the Ebola outbreak would not prove a sufficient fright to jolt the world out of its complacency. With the coronavirus pandemic, we will necessarily see a different attitude emerge. Its economic effects will be so enormous that the world will have to sit up and take proper notice. It is high time that all walks of life the world over got used to the idea that we share the same planet

Maybe the spontaneous community activism and solidarity emerging in response to the coronavirus crisis will evolve into a new culture of enduring collaborative kindness and optimism as the crisis abates. It's a great leveler. The West have had their love of freedom, independence, and individuality thoroughly upturned by these events. We are starting to feel the kind of pain and suffering that so many have felt at our hands while we have gathered around us such unimaginable riches. Maybe there'll be more humanity, more international solidarity, more international cooperation, more global leadership to tackle the great problems of the twenty-first century. These are things that we so desperately need.

24

The Violence of Poverty

Adrian Parr interviews Ananya Roy, April 2020

Ananya Roy is a scholar of international development and global urbanism. Born in Calcutta, India, she is professor and Meyer and Renee Luskin Chair in Inequality and Democracy at the UCLA Luskin School of Public Affairs. In this conversation, Ananya discusses the links between violence and poverty, spatialization, and extreme wealth inequalities.

ADRIAN PARR: Some international development agencies, such as the World Bank and USAID, are committed to alleviating and reducing the mounting global inequality gap. They tackle the extreme concentration of global wealth in a variety of ways, for instance by funding development projects, educational initiatives, immunization programs, and financing for the poor. Do you think these initiatives are effective?

ANANYA ROY: I do not think that international development agencies, whether multilateral ones such as the World Bank and bilateral ones such as USAID, are "committed to alleviating and reducing the mounting global inequality gap." As the history of development in the twentieth century demonstrates, these organizations are part of a world-system of global capitalism anchored by US hegemony. Their commitment is to the social reproduction of this system. In this sense, human development initiatives are effective because they address the worst aspects of human suffering while ensuring the persistence of a system built on exploitation and expropriation.

This does not mean that these human development efforts can be ignored and cannot be improved. In previous work, I have undertaken close engagement with the apparatus of global poverty alleviation in order to foreground imaginations and practices that have the potential

to sustain rather than drain human life. Such engagement is essential and I laud those who take it up, especially those that inhabit and trouble the apparatus of development as is the case with the feminist research collective, Ladysmith, which seeks to advance gender equality in international development programs and policies.

Yet, it is also now clear that the large shifts in human development outcomes, whether in China or Brazil, have come about because of national policies. Put another way, at the start of the new millennium, it is the developmentalist state rather than international development agencies that has had an impact on poverty, hunger, unemployment, education, and health. The story of such developmentalism is varied, from democratic demands for social entitlements in countries such as India and South Africa to sturdy bureaucracies of welfare in authoritarian regimes such as Singapore.

In the coming years, a pressing question will be where the United States sits in this global picture. I like to think of the deliberate dismantling of social democracy that took place across the North Atlantic in the late twentieth century as structural adjustment returned home. Governance through austerity was the hallmark of international development in the 1980s and 1990s, especially in Latin America and sub-Saharan Africa. Today it is the hallmark of US politics and statecraft. Not surprisingly, the United States does rather poorly on human development indicators. Not surprisingly, the various forms of death and deprivation that today make up poverty in the United States overwhelmingly affect Black, Brown, and Indigenous communities. Will such trends initiate the waning of US hegemony in international development? Will such inequality require the remaking of developmentalism and Keynesianism—whether that's in the form of the Green New Deal or something else—in the United States?

You have provided an incisive analysis of the business of poverty, connecting poverty, profits, and the exploitation of the poor. Can you describe some of the goods and services that constitute the poverty business? And, in your view, does the business of poverty lessen or worsen the burdens of poverty?

Poverty has always been a profitable business. The poor pay exorbitant prices for basic necessities, from housing to water. Redlined through

algorithms of financial risk and predictive policing, they pay more for access to the debt economy. In *Poverty Capital*, I drew attention to microfinance as a new global frontier of subprime lending. Since then, while the shine of microfinance has faded, the calculus of risk through which the poor, a social category inevitably constituted through race and gender subordination, are interpellated into global circuits of finance has not changed. One increasingly important example of such riskscapes is climate vulnerability. Poor communities are not only on the frontlines of environmental devastation, but they are also subject to exclusionary and exploitative forms of insurance, aid, and resettlement.

Do you think the ways in which the business of poverty and development contends with conditions of poverty constitutes a form of violence?

If we consider the enterprise of development to be one that facilitates global capitalism and US hegemony, then it becomes obvious that such a project not only enacts violence but also *requires* violence. From Karl Polanyi to Eduardo Galeano, there is a long tradition of critical thought that draws attention to the structures and forms of violence that are required to open markets, create commodities, enclose land, and command labor. Such violence, as decolonial thinkers such as Walter Mignolo and Arturo Escobar have shown, is both material and epistemic. At the very heart of development are systems of knowledge that valorize what can be understood as settler-capitalist epistemes and dehumanize other ways of being in the world.

Thus, what is on my mind is the role of powerful knowledge-producing institutions in the perpetuation of poverty and inequality. In *Poverty Capital*, I argued that the power of the World Bank to create and disseminate predatory forms of financialization, those that are akin to financial enclosures, lies not so much in the aid it distributes but rather in its tight control of development science. Today, such power is being exerted by mammoth foundations such as the Bill & Melinda Gates Foundation. Immune from democratic accountability and public scrutiny, foundations, whether operating on the global stage or in the United States, wield tremendous influence in determining how poverty is diagnosed and addressed. They often also facilitate

poverty capitalism or what you are calling the business of poverty. Recently, such power became starkly evident as the President of the Ford Foundation, Darren Walker, posted a statement, "In Defense of Nuance," supporting the continued expansion of the prison system and targeting activists as extremists. The piece is better read as a defense of racial capitalism, with Walker arguing that "markets have helped reduce the number of people around the globe who live in poverty" and "appreciating the current need for private capital to fund certain valuable public goods." As the abolitionist scholar Dylan Rodriguez noted in his response to Walker, this defense "illuminates the Ford Foundation's historical position as the philanthropic extension of hegemonic racial, corporate, and military relations of power."

In the affluent world do you think the suffering of our "spatially distant neighbors" is more visible than our "spatially proximate neighbors"? Why?

A few years ago, in the *#GlobalPOV* video series as well as in the co-authored book, *Encountering Poverty*, I argued that American millennials were keen to act on the impoverishment of spatially distant neighbors, a term I borrowed from feminist geographer, Doreen Massey, while often neglecting the suffering of spatially proximate strangers. In thinking about the category of "spatially proximate strangers," I had in mind the unhoused body, ubiquitous and yet invisible in our unequal cities.

Today, thinking from Los Angeles, where houselessness is at a record high, I must amend my initial statement to take into consideration the obsession with the unhoused that dominates public discourse and spatial politics. From municipal ordinances that criminalize poverty, to the vigilantism of propertied residents, there is considerable mobilization around the hyper-visibility of houselessness. Quite a bit of that action is meant to banish or contain the unhoused, an imperative now evident in the burgeoning proposals for homeless camps. Such carceral plans are not new but they have new energy as city councils repeatedly bend to the demands of homeowner associations and business improvement districts. What remains invisible though are processes of systematic unhousing, be it the deepening financialization of rental housing or growing rent burdens for working-class communities. Such

elision makes possible a deliberate misunderstanding of the unhoused not as neighbors but rather as strangers, less-than-human bodies occupying sidewalks and freeway underpasses.

I am inspired though by the political work of social movements that insist on creating new relationalities of proximity and intimacy and on disrupting estrangement. Thus, Tracy Jeanne Rosenthal, reflecting on the Los Angeles Tenants Union, shifts attention from the so-called housing crisis to a crisis for tenants. To think about a housing crisis, she argues, "encourages us to think in abstractions, in numbers, in interchangeable 'units,' and not about people, or about power." She notes that "a tenant can be harassed, evicted, displaced, broke, undocumented, fed up, or organized." The LA Tenants Union, she emphasizes, defines "a tenant as more than a renter. A tenant is anyone who doesn't control their own housing." Such an expansive definition of tenancy, one that centers social relations, is a radical and necessary step towards the visible humanity of evicted, displaced, unhoused neighbors.

Credit Suisse has reported that the wealthiest 1% own 45% of the world's wealth. Meanwhile, 64% own less than $10,000 in wealth. Tracing the history of the current global inequality gap, Thomas Piketty demonstrates this gap is not closing—indeed it continues to grow. Under these circumstances, how does social change and justice work?

The global wealth gap is an inherent feature of racial capitalism. Today's global wealth gap reflects a constellation of social, political, and economic forces, including formations of techno-capitalism and global finance. What is most of interest to me is the role of the state in such systems of racial capitalism. As Piketty himself has shown in his collaborative work with Emmanuel Saez, national and global policies have systematically contributed to the widening of the global wealth gap. In the United States, the failure to tax the hoarding of wealth is one such key policy.

With this in mind, at the Institute on Inequality and Democracy at the University of California, Los Angeles, for which I have the great privilege to serve as inaugural director, we insist on a vision of social change and social justice undergirded by a commitment to

abolition democracy. This means that, on the one hand, our scholarship and pedagogy seek to dismantle systems of oppression, from the through-lines of slavery evident in mass incarceration to the logics of settler-colonialism evident in urban dispossession and displacement. On the other hand, we journey with social movements that insist on redistribution, reparation, and representation. Whether it be models of housing justice that hinge on the resocialization of land and housing or models of higher education that demand the cancellation of student debt and the renewal of public support as college for all, our work is rooted in an understanding of the social function of property and the social (re)production of wealth.

However, the present historical conjuncture must be understood not only as an extreme instantiation of wealth and income inequality but also as the resurgence of right-wing nationalism and white supremacy. The Trump White House is only one node in a worldwide concatenation. This too is of tremendous concern to us at the institute. My own research has long been concerned with the spatial illegalization of subaltern subjects in unequal cities. This illegalization has often been embedded in regimes of immigration and foreign policy. Today, such illegalization is being swiftly amplified and expanded, turning border-crossers and asylum-seekers uprooted by US wars, into criminalized outcasts. Under such conditions, it is not possible to contemplate redistribution, reparation, and representation within the militarized borders of the United States. The struggle for social justice must be one that takes serious account of the wide geographies of imperialism and the long histories of settler-colonialism and chattel slavery.

25

The Violence of Denial

Brad Evans interviews Linda Melvern, May 2020

Linda Melvern is a British investigative journalist. For 25 years, she has researched and written extensively about the circumstances of the 1994 genocide in Rwanda. She served as a consultant to the Military One prosecution team at the International Criminal Tribunal for Rwanda, and part of her archive of documents was used to show the planning, financing, and progress of the crime. In this conversation she reflects on her experiences, and on the practice of denial that's now taking place in respect to the genocide.

BRAD EVANS: Ever since the genocide of the Tutsi in Rwanda in 1994, you have been active in terms of both the prosecution and meticulous documentation and writings on the atrocity. Your latest volume *Intent to Deceive*, offers another very sensitive and crucial reading of these harrowing events. Rather than simply looking upon the genocide as one particular episode in the history of violence, you insist that any claims for lasting justice demands our continued vigilance. What is it about this atrocity and its memory that should still command our attention today?

LINDA MELVERN: The crime of genocide—the intent to destroy a human group—proceeds in stages. The crime does not begin with extermination but with the classification of the population, with the polarization of society. The destruction of a human group, in whole or in part, requires effective propaganda to spread a racist ideology that defines the victim as being outside human existence. With the crime of genocide, the ideology serves to legitimize any act, no matter how horrendous. Genocide requires the production of hate speech. The crime requires organization, and preparation. As it proceeds in stages,

genocide can be predicted—and with an international early warning system is considered preventable.

The warnings of the risks to the minority Tutsi came at every stage of the process in Rwanda, and all warnings remained unheeded. No tragedy was heralded to less effect. In the years beforehand, no one gave the conspirators reason to pause as they rehearsed their killing methods and spread the hateful propaganda. All the while they remained safe in the knowledge there would be little outside intervention. In the space of three terrible months, April–July, more than one million people were murdered.

You have referred to the genocide in Rwanda as a "sadomasochistic inferno." Whilst the ability to dehumanize populations in preparation for their slaughter appears all too common when confronting such extreme violence, what do you think was particularly unique about this event? And how might it better inform our understanding of violence as a process?

A youth militia was central to the plans of the Rwanda "genocidaires," as the perpetrators are called. They indoctrinated the country's uneducated and unemployed youth with a noxious racist ideology known as "Hutu Power." These recruits received rudimentary training on the use of weapons and thousands were taken to military camps where they were trained to kill people at speed with machetes, and other agricultural tools. With sophisticated recruitment techniques the plan was to have Interahamwe in every Rwandan community. It was tightly controlled and organized with militia committees in every one of the country's 146 communes.

Understanding hate groups, and the irrational hatred they promote, seems essential. "All power is Hutu power," the gangs of youths had chanted in the weeks beforehand, while they terrorized the streets on motorbikes and in military jeeps, drinking beer, hurling vulgarities at Tutsi, waving machetes. "Power, power," they shouted. "Oh, let us exterminate them." When the time came, they did. The work of the Interahamwe became fully apparent when, on April 7, the extermination of the minority Tutsi was getting underway.

We need to know more about the Interahamwe, of the transition made from raw recruit to sado-masochistic killer. Most victims bled

to death. Later research showed most victims were killed by machetes (37.9 percent), followed by clubs (16.8 percent) and firearms (14.8 percent). Some 0.5 percent of the victims were women raped or cut open, others were forced to commit suicide, beaten to death, thrown into rivers or lakes or burned alive, infants and babies thrown against walls or crushed to death. There were an estimated 250,000 instances of rape. Hutu Power propagandists had targeted Tutsi women; the targeting was woven into the planning of the genocide.

At the end of the genocide of the Tutsi the militia was 30,000 strong. The Interahamwe broke the world's most atrocious records for the speed of the killing of human beings, estimated at five times that of the Nazis. A senior US official who visited Rwanda some weeks afterwards, described Rwanda as "depopulated by machete"; the militia was a "neutron bomb" for its ability to kill quickly and effectively.

What I found particularly compelling about your latest book were the similarities it suggested with the organized violence of the Holocaust. Instead of following a neat and reductive separation between European and African forms of genocide, you also show how the bureaucratization of the violence and the ability to deny the scale of the atrocity through the logics of disappearance and removal of traces of the crimes appear all too familiar. I'd like to ask you to explain more about this violence of disappearance. How has it been integral to the denial of the genocide (something that's also tragically familiar with the legacy of the Holocaust)?

The denial of genocide is the last stage of the process. It is when the perpetrators cover up and destroy the evidence, try to block investigation, and proclaim their innocence. In the circumstances of Rwanda, the génocidaires argued the killing was justified as self-defense, and they tried to minimize the number killed. They claimed the massacres were spontaneous, the actions of a fearful population. There had been an "inter-ethnic war" caused by centuries old hostilities and the situation was difficult for outsiders to properly understand.

Like those who tried to prove the gassings in the Nazi concentration camps were exaggerated, the supporters of Hutu Power are determined to minimize, obscure, and diminish what happened. In the trials of the génocidaires at the International Criminal Tribunal for

Rwanda (ICTR), there was no shortage of scholars, regional experts, journalists, and military officers who appeared to testify in court or write reports in their defense.

The pernicious influence of Hutu Power lives on in rumor, stereotype, lies, and propaganda. The movement's campaign of genocide denial has confused many, recruited some, and shielded others. With the use of seemingly sound research methods, the génocidaires pose a threat, especially to those who might not be aware of the historical facts.

The denial of genocide ensures the crime continues. It is intended to destroy truth and memory and it does the utmost harm to survivors. The denial of the genocide of the Tutsi poses a direct threat to their rights and welfare and contributes to their suffering. The promotion of denial demonstrates a callous indifference.

The genocide is not an event to be commemorated every year for the survivors, but something they live with every day. It devalues the gravity of their experiences and their memories. For them, genocide is a crime with no end.

Mindful of what you explained in terms of the politicization of memory, to what extent does the history of European colonization work itself into narratives of denial? Much has been written about the contested colonial legacy of the slaughter, but how has it been mobilized in the context of critiquing external agents and actors who have pressed for justice and reconciliation?

The European colonization of this region of Africa brought with it theories of race, and the same ideas and stereotypes that the deniers use today were widely promoted by the administrators. The genesis of the 1994 genocide of the Tutsi came some thirty-five years earlier, in 1959, when a so-called "social revolution" was engineered by the Belgian military administration and the 46-year-old Tutsi king died in suspicious circumstances. The country was put under military control and the Tutsi monarchy ousted in violence and terror with the Hutu peasantry incited to rise-up and kill their Tutsi neighbors. There was genocide conducted against Tutsi in 1963 and 1972.

The role of the Belgian military in events in Rwanda is crucial. In *A People Betrayed* I recount the decisive role of the Belgian Special

Military Resident, Guy Logiest, who ensured the Tutsi monarchy was abolished. I found some of his papers when consulting archives in Kigali. Here I found how the Belgians had institutionalized and bureaucratized the racism. A quota system had determined only a small percentage of Tutsi would be allowed further education, opportunities abroad, or employment in the administration. From 1959 the Tutsi were excluded from public life. In the vast amount of paperwork in Kigali it was clear how the control was exercised by agents of the insidious security services tasked with ensuring that people had the right race marked on each mandatory identity card and Tutsi did not exceed the quota. Political parties were created as either Hutu or Tutsi; Rwanda was considered to be a democracy with majority rule by Hutu.

When carrying out your detailed research and work, you acknowledge a very privileged access to many archived documents. Whilst I have no doubt this evidence has weighed heavy on you and raised serious questions about personal responsibility and ethics, I would like to ask how it has also changed your understanding of what actually constitutes a crime against humanity?

A crime against humanity is a crime directed at a civilian population, with attacks that are widespread and systematic. With the crime of genocide, the perpetrators have a central and distinct purpose—the elimination of a people entirely. The victim is chosen purely, simply, and exclusively because of their membership of a target group. In his landmark book, *Axis Rule in Central Europe*, published in 1944, the father of the Genocide Convention, Raphael Lemkin, explained that genocide is not a sudden and an abominable aberration. It is rather a deliberate attempt to reconstruct the world. The instigators and initiators of genocide are cool-minded theorists first, and barbarians only second.

During these three terrible months in Rwanda in 1994, nowhere was safe for the Tutsi. The wounded who sought medical help found killers waiting for them in clinics and hospitals. There were doctors and nurses who were accomplices to the killing or participated directly. Tutsi patients were taken from the wards and hacked or shot to death.

Thousands of victims believed the guarantees given to them by government officials who had urged them to congregate together to ensure

their safety. At one soccer stadium offered as a refuge, the massacre on April 18 saw grenades thrown into the crowds and machine-gun fire coming from the surrounding hills, which lasted until there was no more ammunition when the militia then came onto the football pitch with their machetes and nail-studded clubs to make sure there were no survivors. They returned the next morning looking for the wounded to kill and bodies to loot. Some 2,500 families were entirely wiped out on the Gatwaro playing field among the 30,000 people murdered.

Every Rwandan had carried a compulsory identity card that bore their ethnic identity. A series of roadblocks, part of the genocide planning, was established as the killing began in April. Each identity card was checked and anyone who was designated Tutsi was killed. But the checking of cards became tiresome, and after a while anyone who looked like a Tutsi was killed. Some roadblocks were well-organized, with corpses piled neatly alongside. Others had piles of bodies cut in pieces. Tipper trucks sometimes came by with prisoners detailed to collect bodies from the streets. Roadblocks became chaotic with drunkenness, drug abuse, and sadistic cruelty. Some people paid for death by the bullet. On one stretch of road in Kigali there was a barricade across the road every 100 meters.

In their trials their defense lawyers argued the 1948 Genocide Convention was inapplicable in the case of their clients because there had been no intent to destroy a human group. With no planning or preparation, they argued, the intent to destroy a human group was lacking, and so with no intent, the 1948 Genocide Convention did not apply.

I'd like to press you more here on your claim that "initiators of genocide are cool-minded theorists first, and barbarians only second." It's often comforting for us to think of perpetrators of extreme violence as being monstrous, irrational, and behaving in an unreasoned way. And yet we know from history that often the greatest violence is cold, reasoned, and calculated. Thinking of this in terms of the "warning signs" about the genocidal, at what point do you think that derogatory racialized language becomes dangerous?

For the génocidaires of Rwanda it had apparently seemed quite logical to get rid of the Tutsi. How else were they to retain their power and privilege? The Hutu Power extremists from the north, who for twenty

years had run the country as a personal fiefdom, did not want their way of life to end and were horrified by an internationally-sponsored peace agreement, the Arusha Accords agreed in 1993. As far as they understood the situation, they had been backed into a corner. The accords provided for power-sharing with the largely Tutsi Rwandan Patriotic Front, a highly disciplined army that in 1990 had invaded from Uganda determined to oust the racist regime.

For the extremists of Hutu Power, the peace agreement that had ended the civil war with the Rwandan Patriotic Front was a humiliation. The peace agreement provided for the demobilization of both the Rwandan army and the Rwandan Patriotic Front and a shared officer corps. It provided for the repatriation of an estimated 1 million refugees, the families of those Tutsi forced from the country in past pogroms and living in neighboring countries. The agreement provided for elections to create a power-sharing government. The once all-powerful presidency held in the name of the Hutu majority was to become largely ceremonial. The French military forces would leave and there would be disarmament. With the implementation of the agreement the extremists feared they would be held accountable for their long years of human rights abuses.

The president had sold out the farm to the Tutsi, the traditional enemy, they believed. The warnings came right at the outset with language of division and difference.

One of the most challenging issues we face in our societies today is how we educate future generations about such atrocities, so they can understand the horrors of the past in more considered ways. I'd like to end by thinking about how we might teach about this violence to younger audiences. If you were to speak to youths today about the violence, what would you tell them and what positive message would you hope they were left with to consider in their lives?

The Convention on the Punishment and Prevention of the Crime of Genocide of 1948 was the world's first human rights treaty and it stood for a fundamental and important principle: that whenever genocide threatened any group or nation or people, it was a matter of concern not just for that group, but for the whole of humanity. The Convention preceded the Universal Declaration of Human Rights

by 24 hours and it was the first truly universal, comprehensive and codified protection of human rights. While the Universal Declaration was an affirmation, the Genocide Convention was a treaty. The prevention and punishment of genocide is not a choice—it is an obligation, incumbent upon all government signatories to respect. The Genocide Convention was intended to prevent and in the worst case to judge transgressors of the crime.

Following World War II, the international community accepted the responsibility of constructing an international order aimed at avoiding the recurrence of state-sanctioned racist policies that are directed against specific groups. On December 11, 1946, at its first session, the UN General Assembly adopted a resolution formally recognizing genocide as a crime under international law. Resolution 96(1) affirmed that:

> Genocide is a crime under international law which the civilized world condemns, and for the commission of which principals and accomplices—whether private individuals, public officials or statesmen, and whether the crime is committed on religious, racial, political or any other grounds—are punishable.

The Genocide Convention enshrines the "never-again" promise, the world's response to the Nazi Holocaust in Europe and the revulsion at the systematic policy to exterminate the Jews.

The Security Council of the UN is central to the application of the Genocide Convention: Article VIII states that any contracting party may call upon the competent organs of the UN to take such actions under the Charter as they consider appropriate for the prevention and suppression of acts of genocide. The UK has a permanent seat on the Council which carries special responsibility. It is up to us to ensure that our own government abides by the Genocide Convention. It is up to us to hold accountable those politicians who fail to uphold its treaty provisions.

26

Why We Should All Read Malcolm X Today

Brad Evans interviews Kehinde Andrews, June 2020

Kehinde Andrews is professor of Black Studies at Birmingham City University, director of the Centre for Black Studies, founder of the Harambee Organisation of Black Unity, and co-chair of the Black Studies Association. In this conversation, Kehinde discusses the enduring relevance of Malcolm X, what he brings in terms of a viable critique of violence, the psychosis of whiteness, on to Black liberation struggle today.

BRAD EVANS: I think it is fair to say that the spirt of Malcolm X is alive and kicking throughout your evocative work. What is it about Malcolm's message that still speaks so loudly to your thoughts? And how has it directly influenced your understanding of violence in the world today?

KEHINDE ANDREWS: Malcolm X is one of the most important intellectuals of the twentieth century. His analysis of racism is so clear and precise that it is almost prophetic over fifty years after his death. It is not exaggeration to say that Malcolm predicted the developments that we have seen in the racial state. His basic premise was that the US and the wider West could "no more provide freedom, justice and equality" for Black people than a "chicken could lay a duck egg." Rather than seeing racist practices as a result of the failures of society, he understood them as the logic of the system. Whereas many are looking around six decades removed from civil rights legislation, surprised that racism is just as rampant, Malcolm tells us that the inequality today is a result of the cul-de-sac we went down when we tried to reform racism out a fundamentally racist system. Academia

only really catches up with Malcolm with the of Critical Race Theory (CRT) in the late eighties, with scholars outlining the "permanence of racism" in US society.

As well as expertly analyzing the problem, Malcolm provides the clearest articulation of the solution. Malcolm does more than anyone else to outline the radical nature of embracing Blackness as a political identity. Rooted in reclaiming pride in African descent and organizing Black communities to fight for liberation, Malcolm's Blackness was uncompromising. He declared the "new type of Negro" that made no apologies for being Black and refused to accept patiently waiting for society to reform itself. This is why Malcolm has resonated so much with the young and the marginalized, he is very much the voice of what he called the "field negro," who labored outside on the plantation during slavery.

In terms of violence, Malcolm turned the question away from the oppressor and back on to the oppressed, indicting the US as the main purveyor of violence on the planet. For instance, he chided Black Americans, asking "how are you going to be nonviolent in Mississippi, as violent as you were in Korea?" reminding his audiences of both America's colonial violence and their duty to defend themselves against the violence of the state. Malcolm, along with other radical thinkers articulates the legitimacy of violence in the face of oppression.

This idea of making no apology for one's existence whilst making an account of oneself as having a rightful place on earth, even if such rights are being denied, seems integral to conceiving of a more radical account of justice. It also reminds me of the Zapatistas instance that it wasn't the privilege of the state to "grant" them their rights. Inspired by Malcolm, what does justice therefore look like for you in the face of systematic persecution?

Justice can only be found in the creation of a new political and economic system. The roots of oppression are coded into the DNA of racial capitalism, the pretense that there can ever be justice within this framework is one of the biggest myths that holds back transformative change. One of the first steps for liberation is for the oppressed to define their own terms, their own perspectives, and own mechanisms for bringing about liberation. As Malcolm declared "nobody can give

you freedom," you have to take it. Unfortunately, the vast majority of Black movements are predicated on campaigning for those in power to recognize us or legislate for us. The shift from the call for Black Power to the slogan "Black Lives Matter" is instructive here. Black Power has its roots in long history of those seeking to build the capacity of Black people to build our own alternatives, be they at a local level. On the other hand, Black Lives Matter is a call for basic recognition as human beings and campaigns for us to be treated fairly. No doubt there were many versions of Black Power that were just as interested in campaigns for mainstream recognition, particularly in politics, but the radical Black Power of Malcolm made the opposite demand. For Malcolm, we stated and defined our own humanity and the task was to build a collective that harnessed Black Power in order to deliver liberation. When he died, Malcolm was working with others to establish the Organization of Afro-American Unity (OAAU), very much mirrored on Marcus Garvey's earlier movement, the Universal Negro Improvement Association (UNIA). The goal was to connect the Diaspora to the African revolution and create a society where freedom, justice, and equality were truly possible.

Mainstream media and indeed the corporate landscape find it much easier to accommodate and assimilate the legacy of Martin Luther King then the revolutionary fire and spirit of Malcolm. Cornel West has attributed this to reductive caricatures, "a sanitized Martin and a demonized Malcolm," even though towards the ends of their lives King was notably more radical than his "I have a dream" speech, whereas X was more conciliatory to dialogue, including with those who threatened his life. Why do you think it has been easier for white populations to make peace with Martin than Malcolm?

Malcolm and Martin represent very different approaches to Black liberation. Martin has certainly been sanitized but can be incorporated into the mainstream because he ultimately believed that the US could be redeemed. Malcolm on the hand was under no such illusion, and therefore advocated nothing short of revolution in order to overturn the social order. It would be wrong to overstate their conversion towards the end of the lives. They only met once just before Malcolm was assassinated and, right up until the end, he was heavily critical of

Martin because of his liberal stance. Asked on Canadian television in January 1965 whether he had called King an "Uncle Tom," Malcolm explained that because people could sue for libel over the term it is not one he would use, but he would say that "Uncle Martin is my friend." He then went on to explain how Martin's approach could not bring real freedom to Black people. Black people have disagreed with each other more than we have with white people and the two represent distinct political ideologies, with King's being more palatable to the white majority. King represents a long tradition of intellectuals and activists who have strived for Black people to gain access to the systems of power and put pressure on them to be reformed. Though this represents a challenge to the dominant, it is one that can be very easily accommodated into liberal, well-meaning, left-leaning politics of the white majority. By becoming aware of their privileges and committing to supposedly anti-racist practices, we can all march together to a brighter future. Malcolm offers no such comfort in condemning the political and economic system of white supremacy as unalterably racist, with the only solution a revolution. Whilst King embraced well-meaning white people as essential to the coalition to bring about racial justice, in Malcolm's analysis those white people who truly understand their role need to do nothing but simply move out of the way. Malcolm was clear that in the OAAU, "whites can help us, but they cannot join us."

I'd like to press you on the psychic life of power and violence you continue to make explicit in your work. You have argued that colonization and its continued imperialism reveals a certain white psychosis that is integral to the racial structuring of the world. Can you explain more fully what you mean by this and how it impacts upon the radical imperative?

The psychosis of whiteness is the entirely deluded and irrational discourse produced in order to maintain racial imperialism. The West is built on unprecedented levels of violence and barbarity. The largest genocide in history, killing up to 98 percent of the indigenous population in the Americas; transatlantic slavery that took millions into captivity and laid waste to tens of millions more; and colonial violence across the globe. The result was to create the global political economy

into the image of white supremacy with Africa the poorest, Europe and America the richest, and the rest in between in a social Darwinian evolutionary ladder. Today a child dies every ten seconds because of lack of access to food and water, almost exclusively in the underdeveloped world. Our prosperity is based on the daily pile of Black and Brown children, and the point of the psychosis is to delude us into believing that Western progress is not based on colonial violence but rather the ingenuity, determination, and science that we can spread across the globe. This is why sixty percent of the British population think the British Empire, which killed tens of millions of people, was a force for good in the world; or that the former British Prime Minister David Cameron can be proud of Britain as the nation that "abolished slavery" whilst not considering before this she had become one of its primary enforcers. Through Eurocentric education, the press, and the media, the psychosis is reinforced to make us all believe that our blood-soaked hands are clean, that in fact the West is the solution to the problem that it has created and depends on.

Psychosis is really the only way to describe the disorder and delusional logic (replete with hallucinations on film and in television) that hallmarks understandings of race and racism. Once we understand that it is a psychosis, we will stop trying to teach our way out of racism. There is no evidence or rational argument you can mobilize to convince those in the grip of a psychosis. We have been on the right side of the argument for four hundred years, to no avail. The only way to deal with a psychosis is to treat the underlying disorder that produces it. In this case that is the political and economic system of Western imperialism. Understanding whiteness as a psychosis means realizing that the only solution is revolution.

Given that Malcolm X is often still seen as a proponent of reverse racism (something I know you have also been accused of mirroring in your critiques of authors who have notably weaponized identity without attending to their own sense of embodied privilege), why should his work still command a non-Black readership? And what would you hope that a white readership might take when reading his thoughts today?

There is no such thing as reverse racism. Racism is the logic that underpins the current political and economic system and as such mobilizes the resources of power. Too often we conflate prejudice with racism. Prejudice is the act of being against someone because of a perceived category like race. But racism is the power to enact that prejudice on a social level. Lynchings in the US were in themselves acts of prejudice, what made them racist was that they were done with the support of law enforcement and the courts. They were effectively state sanctioned violence. Malcolm indicting all white people as devils, whilst part of the Nation of Islam (NOI) is certainly prejudiced but it is not racist. In fact, the motivation behind the NOI's creation myth of the white devil was anti-racist with the point being to mobilize Black people to overcome racial oppression.

One of the main audiences for Malcolm's work was white college campuses. He visited colleges across the US as well as speaking at the Oxford Union and the University of Birmingham. Part of the reason for his popularity was his condemnation of whiteness, for which audiences often have an almost Catholic self-flagellation obsession (see whiteness as a psychosis). But it was also because Malcolm's analysis and ideas were so insightful that they applied to all. Malcolm talked about racism, colonialism around the world, revolution, class, identity, and argued for radical social change. As he said, "truth is on the side of the oppressed" and the Black radical perspective is one that illuminates the real nature and conditions of society for all to see.

Malcolm also explicitly offered a route for the white majority to avoid the "racial powder keg" that was due to explode. In one of his most famous speeches "the Ballot or the Bullet" he explains that the US is the only nation in history with the ability to have a "nonviolent revolution" by simply giving Black people all that was due to them. If not the ballot, then he warned it would surely be the bullet. Malcolm's work is as valid today in understanding both the problem of racism and the stakes if there is no solution.

To conclude, I want to turn our attention directly on the university, which we know has been historically invested in giving intellectual validation to systems of racial superiority—often masked behind the language of the enlightenment and claims to scientific veracity.

What does a truly decolonized university actually look like and can it ever be achieved?

You cannot decolonize a university system that was produced by, and in order to, maintain the system of racial capitalism. The reason the university reproduces Eurocentric curricula and stark racial inequalities is because of its purpose in society. The university as ivory tower, an elite space separated from, and looking down on, the rest of world is also deeply ingrained in the knowledge and practice of Western universities. We can, and certainly should, work to make as many changes as possible in order to introduce new ideas, content and practices into the university, if for nothing more than to try to make the experiences of minority students more bearable. But in Black Studies we talk about the need to "colonize" the university, using the privileges and resource of the space to support movements for liberation off campus. The university is a major part of the problem and it will not be the source of the solution. The lesson from Black Studies, and Malcolm is the perfect example of this, is that revolutionary knowledge is produced only in the struggle for revolution in locations very distant, and traditionally by those excluded, from the hallowed halls of the university.

27

America is Not a Fascist State. It's an Authoritarian One

Brad Evans interviews Ruth Ben-Ghiat, July 2020

Ruth Ben-Ghiat is a professor of History and Italian Studies at New York University who has written extensively on authoritarianism and historic fascism. In this conversation, Ruth discusses the nature of contemporary American politics, why it reveals a number of authoritarian characteristics, the spectacle of Trump, on to the importance of history.

BRAD EVANS: Despite those who argue that mainstream fascism has been consigned to the pages of history, you continue to insist upon the need for a more urgent and considered appreciation of the term. This seems altogether more prescient given what's happening in the United States today. With this in mind, I'd like to begin by asking you what exactly you understand the term "fascism" to mean? And do you think it's useful to speak about fascism in the twenty-first century?

RUTH BEN-GHIAT: Fascism as it unfolded in the 1920s and 1930s is a political system that depends on dictatorship, on a one-party state led by a charismatic leader. It is a system of state-organized violence that preaches xenophobic nationalism, racism, class unity rather than class conflict, anti-feminism, and imperialism.

Mussolini, its creator, had been a socialist, and the original fascist movement he founded in 1919 took some elements from socialism: the idea of revolution as a lever of historical change, for example. Yet the idea, parroted by the right-wingers from Jair Bolsonaro to Dinesh D'Souza today that fascism was a left-wing movement is absurd. Leftists were the fascists' earliest and most consistent targets.

I leave the term "fascist" for these interwar movements, because to say that fascism is back today paradoxically lulls many people, who associate fascism with a regime that allows no opposition parties or press, to say, "Well, you see? We don't have that here. There's nothing to worry about."

That doesn't mean that fascist tactics have not endured, from personality cults to the designation of state enemies, to myriad other things. In August 2016, to warn about just such recurrences, I wrote a piece for *The Atlantic* about the similarities between Trump and Mussolini.

But today, authoritarianism works differently: it keeps a veneer of democracy, allowing (and then rigging) elections; it keeps a pocket of opposition; it may not use much physical violence, opting for threat and legal harassment, as Viktor Orbán does in Hungary. I call this "new authoritarianism," others call it "electoral authoritarianism," or, Orbán's own self-serving term, "illiberal democracy." We are still searching for a language to describe what is unfolding.

Like many people, I have been horrified watching what's been happening in the United States over the past few months as it moved from pandemic to an intense period of racial unrest. When describing these conditions, Cornel West even went as far as to call Trump a "neo-fascist." What has most concerned you over the past few months?

The widespread police repression happening now is the outcome of deep-seated racial hatred, long encouraged by the GOP and extremist tendencies with footholds in police and other security forces. It took a president like Trump, who encouraged those racist and extremist ideas from the moment he appeared on the political scene, to make these rogue actors feel they were legitimated by the White House and the Department of Justice—a powerful thing indeed. When Trump and Attorney General William Barr say that Antifa will be defined as a "terrorist group," it's a threat with no legal standing, since Antifa is not an organization. But it's an important message to the police, National Guard, military, and other constituencies, telling them that they should feel confident that they can treat protestors *as though they were terrorists*—i.e., with maximum force.

Without a doubt, these attitudes have their roots in fascism. I would say that Trump's administration has fascist elements, but I prefer the more capacious term "authoritarianism," which encompasses both fascism and right-wing regimes like Augusto Pinochet's, which used the military for domestic repression.

Mindful of these important distinctions, how then do contemporary authoritarian regimes differ in terms of their violence when compared to fascism in the twentieth century?

Fascism was the political expression of a view of violence as the lever of social change and history that came out of World War I. Fascism gave violence an absolute as well as instrumental value; it was an end in itself. Once in power, fascist rulers like Mussolini and Hitler used propaganda to convince their people to view violence differently, giving a patriotic and moral value to acts of persecution that protected the nation from its internal and external enemies.

Today's rulers use violence differently: outside of communist regimes like North Korea, the leaders I call the new authoritarians, like Putin, tend to avoid mass killing of their own populations outside of war. Putin uses targeted violence, like poisonings and murders, some staged as accidents, of high-level critics, while Erdoğan favors mass detention for state enemies labeled as terrorists. Torture is still practiced by both. If you factor in gun violence and police killings of people of color, the United States is of course a far more violent country in the absolute. No other country that is not counted as a "failed state" has 400 million guns in private hands, or so many militias.

When we personally met a few years ago, you brought to my attention the silhouette image of Trump entering into the Republican Party convention in 2016, which you noted was symbolic for so many reasons. How do you think about that image today?

I'm glad you brought up that image, which filled me with dread. It was all so clear: the menacing opaque figure dominating the scene; the smoke blowing around him, referencing his stardom; and the message that he would not only not be showing us his tax returns but if elected

would create a government founded on the lack of transparency, the lack of accountability, and the presence of threat.

Trump is a visual creature. Everything he does is about optics and spectacle, based on his background as a marketer, television producer, and star. Even the idiosyncratic style of his tweeting, with its capital letters, is designed to focus the eye on the slogans he wants you to remember.

Then there is the constant barrage of photos of crowds of white males operating the government. This is a kind of psychological warfare he wages every day and an undoing, through images as well as policy, of the Obama years. Like other authoritarian leaders, Trump's aim is to make things easier for financial, environmental, and sexual predators—to make it easier to harm women, for example, and erase them from existence. It is not widely known that in 2018 his government partly decriminalized domestic violence, making certain kinds of psychological and physical abuse no longer a crime. The removal of women from the photographic record of the administration links to this. More recently, the military occupation of the District of Columbia generated photographs meant to fill us with terror—like the hard-to-identify brutes who lined the steps of the Lincoln Memorial. Flooding the public sphere with unidentified heavily armed men was an effective operation of psychological warfare of the kind Trump is expert at.

A central concern throughout much of your work is the importance of memory in the face of historical denial. I am also reminded at this point of Henry A. Giroux's notion of the violence of organized forgetting. Why would you insist that the study of history is particularly important today? And how can we mobilize it to counter the effacement of not simply truth but decades of critical awareness and more humane insight?

History is essential today on several levels. First, we're living through a period of assault on the truth, on evidence-based inquiry, and the histories that respect that. Second, authoritarian states and their ideologues and trolls are organized to rewrite history to fit their needs. To return to the claim that fascism is left-wing, the agenda here is

to cleanse the right of violence so the right can more easily commit violence again.

In the research for my book *Strongmen*, which looks at a century of authoritarian regimes, a commonality of fascist regimes, seen in Pinochet's Chile, Gaddafi's Libya, and now Putin's Russia, is the aggressive rewriting of history. Mentioning the 1939 Molotov–Ribbentrop Pact is banned today in Russia. In America, there is the assault on the concept of civil rights: the term now is attached to the rights of white Christians to practice their faith and to right-wingers to be able to express themselves freely on campuses and elsewhere. It's not just the forgetting of violence in play, but the invalidation of the idea that such violence was a crime. The focus is, again, to legitimate new violence in the present.

When I engage in my own teachings on both fascism and authoritarianism from the past, I am invariably drawn to the harrowing testimonies of Primo Levi along with Alain Resnais's devastating film *Night and Fog*. While these two historical documents alone should be compulsory reading and viewing for anybody trying to make sense of the human condition, I am also mindful that if we simply begin with mass genocide and concentration camps then we are in danger of overlooking the subtleties of oppression, which can be woven into the prejudicial fabric of the everyday. In terms of developing a viable critique, how might we better connect grand ideologies with everyday forms of intimidation and subjugation?

Your question circles back to the first one and to why I don't label today's developments as a return of fascism. Authoritarianism can be thought of as a process of colonization—of civil society, of minds and bodies, and values and culture—and it happens over time, as well as with the grand repressive moments like after the Reichstag fire or Kristallnacht.

Living in a democracy under attack, I set out to track the small changes, which I do through my op-eds and interviews, to keep our attention on the changes around us happening every day. What Trump, Bolsonaro, etc., want is for us to be silent, out of fear. Instead, we've seen a flowering of protest, even under conditions of a pandemic, and a multifaceted program of legal, judicial, and other pushback in the

United States and electoral strategies that, as with the 2018 midterm elections, brought a new political class into power.

I am a big fan of initiatives that keep such resistance in front of our eyes, like Robin Bell's light projections on the facade of the Trump International Hotel and elsewhere. These are the images of a counternarrative that we must persist in recording. I have tried in my book to write the history of the present, in a way, based on my knowledge of the past.

To conclude, I want to bring this directly back to the question of violence. It is often argued that violence was absolutely necessary to defeat authoritarian regimes and nonviolence would have been completely ineffective when confronting the likes of Hitler. But what does this mean for how we counter authoritarianism today, which some maintain still requires a violent response to a violence that is uncompromising?

Research on the history of authoritarian rule shows that nonviolent protest is far more effective (Maria Stephan and Erica Chenoweth's work on this is excellent) in building support for the end of a regime. In Pinochet's Chile, communist strategies of violence backfired, costing the Party support. At the end of the 1980s, the socialists and center parties came together to stage nonviolent mass demonstrations that proved important in the campaign for a return to democracy. In many cases, my personal view is that violence plays into the government's desire to show that there are "extremists" out there, justifying power grabs and states of emergency. This is the case, I feel, in Trump's America, where the right has been lumping together Nancy Pelosi and Antifa as "the radical left" for some time, just waiting for an excuse to shut everyone up. This is not to say that armed resistance was not necessary in the context of World War II, for example, but outside of the context of civil war or international conflict it is risky.

28

The Atmosphere of Violence

Brad Evans interviews Fatima Bhutto, August 2020

Fatima Bhutto was born in Kabul, Afghanistan, and is the author of six books of fiction and nonfiction. In this conversation, Fatima discusses her family history and what it revealed to her about violence, why literature allows for a more humane engagement with the problem, the links between survival and justice, on to the role of witnessing in the world.

BRAD EVANS: It's a pleasure to be able to talk with you about your latest book, *The Runaways*, and how you particularly use literature and poetics to offer a considered political intervention. Now, I appreciate this question might seem somewhat ridiculous given the history of killing and suffering your family has experienced, but if I say the word "violence" what immediately comes to mind?

FATIMA BHUTTO: *Violence is more than just a word or even an attack. Violence is atmospheric. Like the weather, it's a condition that covers over every choice, every human process, and is integral to how we gauge and navigate daily life. To have some consideration toward violence requires that we account for these climates of action and emotion, and I suspect that's always been the case.*

Even when I was very young, before I had so many personal encounters with violence, it still was atmospheric. It was always spoken about. It never left, even if there were sunnier or darker days, you always felt its pressure. Violence for me has always been there, on the minds of everyone in my family. I would even go so far as to say it was the biggest consideration to life. How to live in an environment where violence is ever present and has shaped who I have become.

I have of course always tried to keep a distance, and that's part of the coping strategy. We try not to let violence in. But sometimes that's not possible. It can seek you out like a slowly building storm.

I fully agree that if we are to develop a viable critique of violence it is important to account for the atmospherics you describe. Indeed, while we often discuss the emotional field to politics, not enough attention is paid at an intimate level to the ecologies of violence you make explicit here. Would you say that this understanding is something you try to consciously develop with your writing style?

For me, literature was a way of engaging violence in a way that brings these atmospherics more into the open. My writing is not so much about critiquing violence as it is a means to try and survive it. I have always tried to come to terms through my work with how we travel through violence, especially how we can travel without being corroded and broken by our encounters with it. Violence seeks to break us down. Writing for me has been a form of personal resistance to this.

I think that when you live with a fair amount of violence, which is always hovering like an omnipresent threat—and, in that sense, even if it doesn't materialize in the immediacy of the moment that doesn't mean it's ambivalent—then the critique is far less important than the surviving. And what I mean by surviving is not just to be unharmed, but to not be made ugly by it. Survival is a refusal to be deformed. I just find the focus on critique alone to be too academic.

Violence has this poisonous affect, creeping into everything: every thought, every wish, every prayer, every vision. So, for me, literature is a survival practice that tries to see how other people have thought about it, been saved from it, and how one emotionally and intellectually, even perhaps spiritually, continues through life without being too damaged and ruined.

I am taken by the idea of writing as survival, especially how through writing we don't end up becoming a monstrous adaptation of the things we find so abhorrent and detestable. I do however also think we need a different understanding of the critical, which I agree can be far too academic. We know violence can create monstrous offspring with persons becoming so damaged that the violence has

fully colonized them, and that seems to be what's really at stake here. This makes me think of how we might rethink what justice actually means in these terms.

I think that's a really interesting question. I used to think in some sense that if one wished not to be colonized by violence and not just be transformed but totally remade or reborn in violence, then we absolutely needed to focus on justice. I can't say I still think this is the right way to approach it. Having been obsessed as long as I was with this idea of justice, in many ways it didn't exclude violence. It included it as part of a more holistic framework. But it was still all about violence. For me to have the justice I felt was due to me, I would have had to impose something unfair and cruel on someone else. I now see this was a distraction, even perhaps a failure. I struggled for so long with coming to terms with justice instead of focusing more on the anger and fear I felt. Justice simply allows us to carry these feelings through, as the call to find justice still allowed me to retain my anger and fear. Justice then, perhaps, is simply violence by another name or at least violence displaced.

Turning to *The Runaways*, I was taken by some of the notable references to figures from history—especially the way you introduce Muhammad Ali and Malcolm X. I am wondering here about the journeys both these icons went through, from anger to political justice. Might our problem be precisely in the way we conceptualize justice as a form of punishment or revenge? Not then justice that demands some violence, but a justice that breaks away from its very presence?

There's something that's already contained within justice that claims to have taken up beyond violence. It can be presented as comforting or even bringing about peace and harmony. But it still retains the anger. It still includes that someone else must lose something for justice to be served.

So, while there is a certain contact and closeness, what we might say is that there is a humanism to justice, the only way we seem to conceptualize it is ultimately that a perpetrator must suffer and give up something. That's why for me there was a need to abandon the

concept. I don't ever want to be responsible for somebody else's pain, however enlightened or fair the claim to justice is presented. I never want anyone to feel the pain I and so many others have felt. Maybe we could turn instead to the idea of surrender instead of justice. And by this, I don't mean forgiveness, which starts from the presupposition that you can bestow something. It's more a submission. This is not to be confused with apathy or doing nothing. To surrender is to continue.

This makes me think about the role of witnessing, which again I know is so close to your family history. How does witnessing enter into this condition, especially in the contemporary moment? And what is the role, if any, that you think literature has to play when dealing with the witnessing of violence?

Right now, it seems like it's almost a frenzied act to be a witness. We are at a point where nothing means anything anymore. Everything can be said, but nothing meant. Everything can be seen, but not changed. This means there's no real accountability for the violence, even though everyone can see it. People can be violent in a hundred different ways and still sneak through any attempts to characterize them as being violent or even slightly perverted. That's why today, to claim to be a witness seems almost like a hysterical act which everyone is in on.

When I began writing, I actually started out in journalism and working on articles. I was in Lebanon when the 2006 war with Israel happened. While I was distressed, the experience taught me that the act of witnessing wasn't about me but about being alert to the lives of others. And this wasn't about some grand narrative or revealing some massive truth. It was being alert to the small details, the intimate fears and worries at a time when violence could come from any direction.

When I then later wrote *Songs of Blood and Sword*, my feeling about witnessing changed slightly. I already promised my father I was going to write this book a few days before he was killed. Given the circumstances, however, I never wanted to write the book, at least not in that way. But I was compelled to write it, largely due to the unaccountability and corruption of the trial. And so, I understood that if I didn't write the book things would be erased from history. This wasn't about justice. It was about ensuring the past remained truthful. So here, the act of witnessing was more than reporting—it was all about preserv-

ing. It was about a realization that memory is so thin, fragile, and untrustworthy that it can simply vanish within a generation.

This does raise a very important consideration concerning what we are actually bearing witness to. Bringing this on to a more conceptual terrain, I've noted in your work that in a marked difference to, say, Hannah Arendt, you argue that power is violence, especially when it's linked to a sense of immunity and to being able to operate beyond the law. Can you explain more what you mean by this?

I always have such a visceral reaction to that Arendtian claim. In my experience, power in all its forms contains violence. It's never so easily separated. Power structures violence. It legitimates it. Gives immunity from it. And I don't just mean political power. Power can structure violence in a relationship, in the home, in a workplace, or in any other network of human relations. It can even happen between a man and a dog.

Violence is coded into power. And it is the imagination of power that brings forward the desire for violence. It's like that idea about power corrupting. I don't think you need power to be corrupt. The allure is enough. The very idea itself is corruptible. And it always carries a potential for violence. I think at this point in the world, it's so obviously transparent that violence accompanies power.

This is really what concerned me in *The Runaways*—or more accurately I really wanted to look at the opposite of this. What about the violence of the powerless? How might we understand this process? And what about the ways violence has this incredible ability to seep into everything? I have been thinking about what Helen Garner says in *This House of Grief.* Paraphrasing, she says the world is full of men whose hearts are broken and who have no way of expressing this to themselves. And those are the men who become dangerous to themselves and the world. Stepping over into this world has been my focus and concern for a number of years now. This is not about the kind of violence I have experienced. It has a different feeling. It has a different frequency. It tells a different story that moves across different terrain.

What I also try to convey with the book is perhaps the idea that you cannot run away from anything. This is especially the case with violence. Believe me, I tried; it doesn't work. The past is always

trying to catch up with you. It's not possible to escape the violence of your past and the history you carry. That doesn't mean to say you can't feel uprooted. This again is something I can relate to. Though it is strange to say now, but when I look back upon my time living in Syria, I remember it fondly as a time of peace. I certainly didn't feel as hunted there.

Somewhat anecdotally, I was in Karachi a few years ago and was coming back home from a wedding. The street coming up to my house was closed, and there were armed paramilitaries (who are not some rogue but federal force) policing the area. For someone who grew up in Karachi in the 1980s when it was very violently policed, this episode brought back all the memories of "Operation Clean-Up," which was as disturbing as it sounds. In fact, I was even more affected as my father was killed on the street in front of my house. Having been stopped on a number of occasions by these rangers who insisted my street was a no-entry zone, I eventually made it home and turned on the television. There was absolutely no reporting of any incident, the same was the case for social media. So here you have a situation where on a major street in the city, the Rangers could effectively shut things down. In that moment, I realized that they can do anything to anyone. There was nothing at all about what was happening on a major street on TV, in the news, not that night, not the night after.

Back to your concern with the violence of the powerless and the dispossessed, how would you respond to criticisms that in the work (especially due to its literary qualities) you are complicit in humanizing violence?

We've had over 20 years of the condemnation of those who commit violence. This was part of the essential trope that either you are with us or you are against us. Of course, we are against violence, but we still haven't stopped it. And for all the screaming and shouting, we still have no understanding as to why someone would pick up arms, not only against strangers, but against their own world, their own families, their own brothers and sisters. One of the things that haunted me when writing *The Runaways* was: How much anger do you need to be in to set fire to pretty much everything you have known?

The work of literature is to pay attention to the most intimate moments in the life of another. It is to be attentive to the moods, the tensions, the failures, the emotions, the aspirations, and the outrage felt. But regardless of the subject, you can't do this without a certain compassion and understanding. Literature requires an empathetic eye. And I think it's what we need in our understanding of radicalism today. We are not going to get anywhere if we simply point out how superior we are to it, which in turn means impressing how superior our violence is to it. This is something the West has missed entirely. It has been too busy presenting itself as a counter-image to radicalism, like a foil, without even questioning why radicalism has become so seductive. They really don't or don't want to understand how an entire generation can be swept into its embrace. And yet, tragically, this is something that organizations like Daesh truly understand. Their argument is not a hysterical one. The argument they present is incredibly seductive. What they offer is a claim to dignity, a vision for a life in a world where people feel they don't fit, and a way for someone's voices to be heard. Yes, they offer you power and violence and all that ugliness, but Daesh understands loneliness and is able to convert it into a message of agency. It is all about communicating a message of power—you won't just be a leader of men but will be a king, you won't just have power but control and violence over the lives of others. But when you think about it, this is a pretty modern argument. This is not to praise them. On the contrary, to say they are modern should be the condemnation.

In conclusion, I'd like to really press you on your literary influences. If during this period of global lockdown, you could have kept only one book with you, what would it have been and why would you choose it?

I had to think about this, and it was difficult. If I could have chosen only one writer, I would have taken James Baldwin. But I couldn't pick only one of his books. I had the same thought with Toni Morrison. It still seems cruel to have only one book, so I'm going to give myself two options: *Beloved* or *The Fire Next Time*.

29

The Inherited Memory of Art

Adrian Parr interviews Mark Bradford, March 2020

Mark Bradford is a Los Angeles-based contemporary artist best known for his large-scale abstract paintings created out of paper. Bradford received his BFA from the California Institute of the Arts (CalArts) in Valencia in 1995 and his MFA from CalArts in 1997. He has since been widely exhibited internationally and received numerous awards. In this conversation, Mark discusses the connections between violence and art, the importance of inherited memory, and what it means to work as a Black artist in America today.

ADRIAN PARR: There is an energetic materiality to your work; where the body and gestures of the artist vibrate with and against the everyday materials that make up your work, triggering what could be called an aesthetics of violence. Do you view the relationship between violence and your work as representational; reactionary; or even the intrinsic condition of art, the very mechanics of art's contemporaneity at work?

MARK BRADFORD: I can see how some people might experience a violence in my work, but that isn't so much about the artistic techniques. I've always described my creative process as being playful, and I think what people read as "violence" is generally a response to the physicality of the work—the process of excavating, of scraping and pulling through the layers and layers of paper or layers and layers of meaning and history that my work addresses. It's a reductive process and I would say that metaphorical violence emerges, if at all, when the work lives out in the world and confronts the issues and institutions that I'm trying to approach critically.

I would say that the perception of violence in the work is just the nature of a contemporary art practice that challenges existing struc-

tures of oppression. I investigated identity and economic oppression in my early merchant poster works. These were pieces made out of posters that you find in low-income neighborhoods that market a sort of predatory service that only certain people need. "Cash for cars" or "We buy ugly houses." I explored the disproportion in health services in my exhibition "Scorched Earth" at the Hammer Museum in 2015.

More recently with "Pickett's Charge" at the Hirshhorn Museum in Washington, DC, I started looking at historical narratives and the ways that the stories we tell about ourselves allow and even encourage oppression. At the Gettysburg National Military Park, the original "Pickett's Charge" by Paul Philippoteaux is a heroic display about the Confederate army's final charge on Union forces at the Battle of Gettysburg. I was surprised at how the framing of the original piece focused on the heroism of the Confederacy without much acknowledgement of what the war was about: the right to own people.

These power structures are deeply ingrained in society, and I think quite honestly that the experience of an "aesthetics of violence" can sometimes be a projection from an audience that's uncomfortable facing the violence that's systematically perpetrated against marginalized people by the very power structures from which some of my audiences might benefit.

Modernism celebrates the individual experience of the artist, and more often than not, the heroic interiority of the white male artist's experience. Although you work within the language of abstraction, your work exceeds the interiority of abstraction. Would you like to speak about how you navigate the move from autonomous moments of artistic production to the social context in which your practice is mobilized?

I don't do anything special to navigate the move, I just do it. I've always said that you can't apologize for yourself. Just be yourself, and you belong in whatever room you find yourself in. I think the move away from a focus on the heroic interiority of the artist is actually really simple: All it takes is turning your attention outward and starting from what's in front of you. Perhaps it's easier for me because, like so many others, I was not taught from such a young age that we can define our

own subjectivity. Some people take this for granted, but ownership and self-definition are privileges that many people don't grow up having.

Other people have already unpacked modernism and these ideas better than I ever could, but the "heroic interiority of the artist" isn't really fertile subject matter for many people. The kind of modernism that you're referring to assumes a certain modern subject full of the potential for self-determination. You only get to this starting point through privilege. I also think we're beginning to understand as a culture how we all exist at the intersection of power structures that define us without us even being aware, and this is one of the places where my process starts. We don't enter the world as undefined subjects. My creative process is how I unpack and address that.

Similarly, modernist painting treats material as blank and full of potential, but my style, which has sometimes been called "social abstraction", begins with surfaces that are already loaded with their own meaning: end papers, merchant posters, rope, caulk, billboards, salvaged plywood.

Then, the techniques of excavation are all also loaded in their own way: sanding, power washing, bleaching. They're the techniques of workers. When your starting point is so loaded, moving from that interiority to the social context just makes sense.

The process of belligerent erasure; a restless reconstitution of the remnants of artistic production; a raw honesty arising from the layering of materials; a loud aggression tensioned with silent pauses and tender touches—when taken together these aspects of your work prompt us to not only engage with the spatiality of a painting, its two dimensionality; but also the plasticity, duration, and temporality of painting. What is your attitude toward the role feeling, memory, and affect play in your practice?

I'm very interested in history and myth, which are essentially collective, inherited memory. And certain mediums have been used historically to define how we understand our past, like public war memorials and statues. "Pickett's Charge" is one of the pieces where I address this most directly. I keep coming back to it because it's the work that academics have taken the most interest in. When I created that work, I used a number of techniques to disrupt the audience's perception of

the underlying scene, to make them question how history is written and remembered.

I started by sending an image of the original painting to a printer that specialized in billboard printing. The process of blowing up the picture to fit the wall makes all the pixels visible. When you stand up close, your mind can't process the full scene because the image dissolves in the pixels. It only starts to make sense as you put a physical distance between yourself and the piece, which is also metaphorical. Add to that the techniques of pulling and tearing that I use, and you only get limited sections of the painting that come in and out of focus depending on our proximity in time and place to the original.

I also hope that people sit with this work, because the more time you spend with it, just like history, the more you get out of it and the further you're able to take your understanding of it.

We're at a particularly challenging moment as a nation and globally, in part, I think, because we are spending so much time on questioning who we are, what it means to be an American or a global citizen, and what we want that to look like moving forward. The more time we spend on reconsidering these inherited narratives, the more the picture comes into focus and the more we can see how our shared memory is up for re-evaluation.

How do historical and social struggles, and more specifically your experience as a Black man living in America, inform your practice as an artist?

I don't think there's a way for me to make work that isn't informed by my personal experiences, but I think that's true for everyone. We just don't notice it when it's work created by people who own the dominant narrative. When there's a lack of diversity in the artists we celebrate, it's easy to only see connections between personal experience and creative output in the work of Black and Brown artists.

I want to be careful, though, because this doesn't mean that work created by artists from diverse backgrounds should only be read in relationship to their backgrounds and identities. I think it's more powerful to allow everyone to create according to their own imperatives. Going back to my earlier point, this idea that somehow someone can choose when and how their identity influences their creative

practice, or that there can be a creative practice not influenced by one's personal identity, is again a privilege that isn't afforded artists who fall outside the dominant culture.

In closing I would be interested in hearing your thoughts on art, joy, social change.

For me, joy grows from a place where you find people who will celebrate you and not simply tolerate you. The highest joy comes from building your own family through the people you meet—people who understand who you are and what you have to offer, and who celebrate you. I try to bring this into everything that I do, because joy can only grow out of that space.

* Note this interview was conducted before the killing of George Floyd and subsequent protests.

30

If You Look Closer, You Will See

Brad Evans interviews Isaac Cordal, September 2020

Isaac Cordal is an artist who uses miniature sculptures called Cement Eclipses amongst urban streets to criticize modern society. He has exhibited widely across the world. In this conversation, Isaac discusses a number of his key works, what the miniature format has to offer in terms of subverting public space, on to the pressing question of ecology.

BRAD EVANS: Throughout much of your work, from the tyranny of education, to homelessness to ecological catastrophe, the realities of violence are depicted in their stark and all-too-human forms. Before we go into the details of this, can you explain what you understand "violence" to mean? And why do you believe it is important for artists to deal with such issues?

ISAAC CORDAL: Violence today has changed its external appearance; it is more interiorized, like a small micro-organism attacking us from within. Violence, like politics, is omnipresent in each of our daily acts, but despite its televised appearances it is not always made explicit to us, even if it continually limits and controls our way of being. We have normalized this violence. While there are traces of it in our DNA since remote times, this violence can also be seen as surgical. Contemporary violence is incisive. We live in societies, for example, that use fear as a way to create complex systems of control. We manufacture fear in order to make people submissive. Fear is the most visible aspect of this surgical type of violence; it paralyzes and controls us, within us.

In a way we are still somewhere lost in the cortical night, outdoors, alone, besieged by the uncertainty of an existence that surpasses us, that bends us, vulnerable to its desires. I think the phrase "Beauty is always domesticated terror" by Régis Debray expresses this predica-

ment very well. We live permanently in that visceral tension between calm and anger.

But violence takes many different forms, and that's what I try to address in my work. Let's consider stock markets that administer a more elaborate form of violence, which leaves no visible traces and blurs any sense of responsibility, but which enslaves us mentally and physically. We no longer perish on the battlefield, countries are bought, their debt is appropriated as a form of conquest, the future of their citizens is mortgaged, that is, people are made submissive, their souls are taken away and they are turned into slaves.

But this didn't happen overnight. Our societies have been built on violence, and that heritage, that colonial hangover which is capitalism today still remains. Voltaire said, "civilization does not diminish barbarism, it perfects it." What is the air we breathe if not toxified by this continued attempt to seek out such perfection, right?

In the age of the spectacle, it is often the case that the spectacular is required to demand our attention. Art is no exception to this, as many have sought to either sensationally shock or capture our attentions through the production of works which due to their size simply cannot be avoided. You, however, work with a different and more intimate method. Can you explain to me why you have chosen the more miniature style for engagement, and what you think it offers in terms of focusing the attention?

I reduced the scale of my works mostly for logistical reasons. But this too can also be political, I have learned to see. This small format gives me more freedom of movement so that I can carry the sculptures in a backpack for example. They are like stowaways. Normally a sculpture tends to be big, and heavy because of the materials, and I realized that semantically my sketches (the previous model to make it big) already worked well to talk about the topics that interested me. So, I turned to making the sculptures in cement and I found it interesting to use the urban space as an extension of the studio, as its "natural habitat." The fact of reducing the scale turned the street into a kind of scenery that added to the work; it was part of the composition and the sculptures mimicked it perfectly. Cement fascinates as a symbolic material—it

distances us from nature, there is no longer any possible camouflage for us.

I also like to play around with the inversion of space. Art is after-all a matter of perspective. The small format makes the sculptures blend into the space, creating an interesting optical effect, in a way the sculptures get bigger and the city gets smaller. This is perhaps what Gilles Deleuze had in mind when talking about the micro-political.

In cities today everything is forbidden or about to be forbidden, we can hardly participate in its construction in any way, we are mere spectators. This is part of the great aesthetic colonization of every aspect of life. And in that sense, I found interesting the idea of people meeting the sculptures in a casual way, if you look at them, you see them and if not, then nothing happens. We have to introduce contingency, the unexpected, into our fight. These interventions seek a more random gaze, without imposing anything. There are too many equestrian sculptures besieging our cities.

Can you explain more about this use of cement and how the built environment adds to the drama of art? Is it your intention to expose more fully the brutalism of city landscapes?

We see cement everywhere, and yet how often do we really consider it? And yet it does often return and get exposed in times of tragedy. Just think of the images after the fall of the Twin Towers, where people appeared covered with dust like some apocalyptic attire.

The cement is part of that trail of destruction that we leave behind as we go along, we tarmac nature so that it does not rebel, to extinguish it with a concentrated ingenuity. Many cities today are full of ruins of the most recent mishaps. In Spain, for example, with the real estate boom, many buildings were built that have remained unfinished due to the economic crisis. They have become ghostly spaces, without inhabitants, that speak of a new concept of ruin, a brand-new ruin. Perhaps these are the monuments of modernity.

But also, nature has a way of warning us and reclaiming what was hers. Too romantic perhaps given the current events in Brazil, but I am reminded that the roads of the Amazon were always in a battle with nature that slowed down the progress of industry. Nature could

outlive us. Yet we seem intent on destroying her just as we are destroying ourselves.

I'd like to now turn to your powerful and compelling series *Follow the Leaders* that addresses the coming environmental catastrophe and the poverty of the political imagination. How did this work come about and what message do you hope the work conveys in the viewer?

Progress has left a spectral trail in its path, a denatured landscape, on which we continue to move forward, surely until it all ends. The idea of this series of works is based on a personal reflection on that trace that we leave as we advance, on paying attention to facts in order to mitigate their side effects as much as possible. Reflecting on the role that our leaders have in this drift in which we are immersed. It is all politics.

I have made several installations under the same title. One of them is a ruined city full of businessmen, around two thousand sculptures living together among tons of debris. For me one is a metaphor for a system that does not work, collapsed on its own pillars.

Follow the Leaders is a series of installations in which I choose a social stereotype; a representation of middle-aged businessmen as a metaphor to reflect on decadence, patriarchy and power. In this society where the system of patriarchy dominates and manages everything, it seemed important to me that the project was represented by man, through a kind of aged and lost Adam in a greyish paradise, where apples no longer grow.

This grey character is a counter aesthetic, arguably a more truthful aesthetic to the elegant looking collective that manages the world. We need to expose the violence of these unimaginative beings sitting on their salaries, those who write the fine print, those who enjoy bureaucracy as a trench; my task is to represent this stereotype in its decadent stage. Today in the cities we see many characters like this, they are everywhere, the prototypes, talking on their mobile phones with little regard for others, running big companies, with gestures of magnates, with airs of a conqueror, yet in a limbo of appearances.

While some might see in my works a depressing vision, my intention is quite the opposite. I wanted to work with current issues,

of a "political nature," to talk about reality, about the problems we have as a society, but also in my own micro-political ways to try as much as possible to change the inertia of events. I do like to see my work as an attempt to reflect upon the world through sculpture, and through these small-format characters open a space for a new public conversation. I am interested in art as a form of combat. Using creation, irony, and humor, it can fight to offer an alternative reflection on society.

My vision perhaps is an army of miniature Bartleby's all chanting from below, "we'd prefer not to!"

In another of your installations, "The School," you address head-on the question of education. Drawing upon Deleuze's notion of the control society, the work has been explained in terms of highlighting how thought itself has become part of system of enslavement. How would you explain this in respect to an education in art and the humanities?

The education system is moving away from the promotion of critical knowledge to become an industry closely linked to the needs of exploitative systems of production. Explaining it in a sculptural way, the education system is a kind of matrix, a mold, which proposes identical copies of a model of knowledge. A model firmly related to profit.

With this installation I try to reflect on this system of education and the uniformity it creates, like a form of human laboratory where the students are nothing more than lab-rats who can be prodded into various impulse reactions. The school is a huge library turned into a factory, and a factory turned into a site of medical experimentation. And what becomes of knowledge is a virus stalking each of the workers/readers.

In this regard, we need to continue to defend the arts and humanities for the sake of the human condition. After-all what is their purpose if not to make students question their relationship with the world? We need to keep hold of the idea that education is about creative experimentation and not for an experiment imposed by those already in power. If we need any form of surgical intervention it should simply inject a dose of freedom due to their connection with creation and affirmative experimentation. We know that indoctrination kills. And

it does so more effectively when the system is no longer the object of study.

I should also acknowledge that when making this installation I was influenced by the reading of Nuccio Ordine's essay called "The Usefulness of the Useless," which ring alarms about a society in which those areas of knowledge that do not produce immediate benefits are disposed of in accordance with the prevailing dictates of what has fleeting value.

I'd like to end by asking you about your remarkable Land Art sculptures in the forests of Lapinjärvi, Finland. Whilst these ghostly figures are also dramatized in the extreme ecological setting into which they were placed, they do seem to speak both of the terror and beauty of existence. If these figures could speak, what would they say to the world?

That installation was done in a week in complex weather conditions, the mud was freezing, the daylight was short, and we had to load all the material on foot. We spent time in the dark in the forest and in that sense the connection with nature and the elements was sharpened. Looking back, I think what was more interesting about the work was the whole process than the final result. I had the opportunity to work with a team of people who, despite the exhaustion of the effort, always had a smile on their faces.

The sculptures were located in a felled part of the forest, there was something both eerie and magical about the spectral silence. When everything is frozen there seems to be a tension in which nature seems to be watching us. We could be terrified by this, but only if we fear her and believe nature needs to be tamed. The sculptures seem to reflect that drive that exists between a denaturalized humanity and a dehumanized nature.

31

The Revolutionary Potential of Pacifism

Brad Evans interview Richard Jackson, October 2020

Richard Jackson is a professor of International Relations and Director of the National Centre for Peace and Conflict Studies (NCPACS). In this conversation, Richard discusses the history of pacifism, why it's a form of true revolution based on solidarities, what it reveals about violence, on to the possibility for non-violent ways of living today.

BRAD EVANS: Susan Sontag observed some time ago that to believe in pacifism put you on the side of the politically delusional. Indeed, even recent engagements such a Judith Butler's *The Force of Non-violence* still leaves open the idea that under certain circumstances violence is necessary. Can you explain to me what pacifism means to you as a political doctrine?

RICHARD JACKSON: Pacifism, like any other philosophical approach, represents a range of positions. Some forms of pacifism are problematic and rightly the subject of criticism. But to dismiss pacifism as a whole out of hand because of some bad examples is like dismissing socialism because of North Korea. For me, pacifism provides one of the few approaches that has the realistic potential to transform our violent global and domestic orders towards a more positively peaceful and socially just future. This is because pacifism—specifically, revolutionary pacifism—contains, as Peter Bloom argues, the possibility of expanding social possibilities beyond prevailing forms of political power rooted in domination.

Violence is a form of domination which expresses and, in its effects, constitutes, a kind of dominatory relationship; and the use or practice of violence can really only reproduce and reify a dominant form of

power. Pacifism, on the other hand, with its commitment to nonviolent forms of political relationship, maintaining means–ends consistency, commitment to human dignity and equality, and so on, inaugurates new forms of political action and a new kind of political power that is not rooted in domination or the elimination of enemy others. It reinvents the social order, rather than simply resisting it, reforming it or reproducing it. In contrast to violence, pacifism helps us to escape the stagnant fate of permanent revolution, as Peter Bloom puts it, in part by dissolving current forms and practices of power. From this perspective, I believe that a radical pacifism is one of the only truly revolutionary approaches we currently have.

Could you provide any meaningful examples of this to evidence the revolutionary potential you explain?

Certainly, there are few if any empirical examples where violent revolution created the conditions for the revolutionary transformation of society in the direction of positive peace and social justice. Violent state capture by revolutionaries most often leads to a new round of violence against the class enemies of the new state, and ultimately, the reification of violence as the dominant mode of political power. Growing empirical evidence about the long-standing and inherent failures of violence, and the practical political successes of nonviolent movements, suggests that it is actually the supporters and practitioners of violence who are most often the tragic idealists. How many times have we heard that a bombing campaign here, or an invasion there, or a drone strike against a terrorist cell will work this time (unlike the last time) to bring security, peace, democracy, and so on? How many military failures does it take to convince us that violence is actually a very poor tool of politics, and one that is highly unlikely to actually make things better?

I have written about this elsewhere, as have others like Stellan Vinthagen, but a key problem here is that the practitioners of violence misunderstand the relationship between violence, force, and power. The truth is, having the ability to inflict harm on others does not automatically translate into power or coercion; violence is as likely to produce resistance as it is to produce submission, and its effects are always unpredictable. Conversely, lacking military capabilities does not

mean an inability to exert power and coercion; it is perfectly possible to make a highly armed military dictatorship back down or reverse a decision through mass nonviolent action, non-cooperation, shaming, economic boycott, or other nonviolent forms of coercion.

I would also respond that the argument that certain circumstances make violence (which we should acknowledge means in reality the deaths or injuries of human beings) *necessary* is deeply problematic and requires a more rigorous interrogation than it normally receives in a lot of contemporary philosophy. For one thing, it implies the ability to see clearly into the future and make a judgement on history: only a response with violence will work in such a situation; other responses will definitely fail. At the simplest level, this is a denial of the range of historically documented forms of resistance that are possible, as James Scott among others reminds us, even in the most oppressive situations. It also denies human agency and creativity; it's a kind of ethical determinism. More importantly, it involves, in many respects, an epistemic certainty (or one might even say, arrogance) that pacifists are unwilling to adopt. Because violence is irreversible, it requires, as Gandhi puts it, a belief that one has access to the Truth: you can kill someone because you know the Truth, namely, that they deserve it, that they will not change or stop without it, that it is the only action that will work, and so on. Pacifists, on the other hand, adopt an attitude of epistemic humility or reflexivity which says that it is precisely because as humans that we don't have access to the Truth, and because we frequently make mistakes, that we should not act in ways that are decisively irreversible. Instead, we should try our best to act in ways that are experimental and open to correction. Nonviolent political action can always be reversed and redirected, if it becomes obvious that an error has been made; political violence, on the other hand, cannot be undone and its consequences will change the world—most likely for the worst, as Hannah Arendt put it.

A last point here is that, strangely, virtually everyone has agreed that violence has no place in the family, in schools, in hospitals, in social interaction, in domestic politics—in all aspects of our daily lives. Ontologically, we are all practicing pacifists and every single day we do our best to avoid punching, stabbing or shooting people we know and interact with. We are horrified if violence in any way touches our schools and children. And yet, in a highly dissonant way, collec-

tively we participate in and legitimize the practices of war which bring violence into other peoples' schools, homes, hospitals, and daily lives. Pacifism provides me with a way to live holistically and morally consistently, without this absurd dissonance where we have worked so hard to reduce violence in all areas of social life—apart from foreign policy.

One of the most familiar criticisms of pacifism is that it effectively puts you on the side of the oppressor. Part of the understanding here is that pacifism is ultimately a form of inaction that completely represses more direct forms of resistance to oppressive power. How would you respond to these criticisms?

There is no doubt that some forms of liberal pacifism or in other cases, so-called "passive resistance," have in practice and in theory functioned in ways that suppress movements for social justice or reified the existing neoliberal order. The work of Sean Chabot, among others, has highlighted the way in which many recent so-called "pragmatic non-violent movements" have largely functioned to reinforce neoliberalism and the existing unjust order. Few of the Arab Spring movements, for example, have resulted in new societies characterized by greater social justice. Again, however, to dismiss the whole breadth of pacifism on the basis of this is ignorant, willful or otherwise. I cannot think of any major pacifist thinker or practitioner who actually expresses such a view. The idea that Gandhi or MLK supported inaction and being on the side of the oppressor is laughable. The core of pacifism is to resist oppression with one's whole will, as Gandhi put it. It's just that pacifists believe that nonviolent resistance is more effective and more ethical than violent resistance because it maintains a consistency between means and ends, and is more likely to be genuinely transformative of the political and social order.

Perhaps more importantly, this objection reveals something about the kind of dichotomous thinking that supports the existing violent global political order. The idea that there are only two choices—either one violently resists oppression or one is complicit in it—is part of the epistemology of the current violent order where everyone is either for or against, friend or enemy, good or bad, and has a grievable or ungrievable life. It is a kind of thinking that suppresses the long history of resistance from people who were not able to openly resist

forcefully, or who were forced to collaborate for reasons of long-term survival. It is also a kind of thinking which can get people killed in hopeless violent campaigns, and which historically has led to national cycles of violence as each new generation learns that violence is the primary tool for political renewal. Pacifism, on the other hand, refuses to construct rigid categories of people, truth, and action. Instead, it calls for the exercise of courageous, creative, solidaristic forms of power that transforms those very categories in ways which open up the possibility of new forms of political community—ones not based on exclusive and dichotomous categories. It also opens up new possibilities for transforming conflictual relations and breaking cycles of violence; for turning enemies and opponents into collaborators or even friends; for changing antagonistic relationships into agonistic relationships.

I also find this argument extremely unreflective of the reality of employing violence itself. How do oppressed people resist violently? In order to use violence effectively in a resistance campaign, you have to purchase arms from arms dealers (or get a superpower to sponsor you); an arms production economy is necessary (with its diversion of resources from other social needs); you have to train people to kill (notwithstanding all we know about PTSD and veteran suicides); you have to centralize power in the military commanders; you have to define enemies worthy of elimination; you have to justify the sacrifice of human life culturally; and so on. In other words, you have to create an entire social system based on legitimate mass killing that will reproduce itself over time. There is by now a wealth of evidence to show the long-term harm and destruction that occurs in a society which constructs and maintains a military force—before it is even used, and even more so after it is used. The harms and costs of military force are never factored in, as far as I can see, when people throw out the missive that an armed response is needed to every oppressive regime or situation. The empirical reality is that most armed revolutions result in a great deal of human suffering, followed by decades of further violence and human suffering. To my mind, there is a desperate need to explore alternatives to this endless cycle of violence. Part of constructing new social possibilities means ruling out those actions and processes which we know will simply result in reification of the existing violent order. We must think of forms of resistance and political action which will not result in a society where arms companies who manufacture killing

machines for profit exist and flourish, and where thousands of individuals are routinely morally injured and mentally scarred in the process of learning how to kill.

From our conversations, I know you are trying to argue in your work that pacificism is actually more than resistance and that it reveals a truly revolutionary potential. Can you explain to me what this means and how it allows for a rethinking of violence?

I hope that my answers to the previous questions provide a number of reasons why I think that pacifism has genuine revolutionary potential. The main reason is that pacifism's refusal to be limited by an ideologically motivated notion of what constitutes "realistic" political action provides the opportunity to "revolutionize revolution," as Peter Bloom puts it, moving it beyond the tired cycle of periodically replacing one dominatory elite with another. Political action is always constitutive, which means violent political action will constitute itself materially and culturally in the end. This is obvious when we look at the entrenched war system, as well as the history of revolution. The expansion of state militaries, and the practices of war, violent revolution, peacekeeping, and humanitarian intervention have in no consistent way made the world order more positively peaceful or even less violent—notwithstanding Pinker's dubious decline of violence thesis. It is only through a radical commitment to nonviolence, and the exploration of alternative nonviolent and nondominatory forms of power and political action that we can expand social possibilities and move towards the creation of revolutionary communities. In taking such an approach—one rooted in epistemic humility (instead of the hubris of ideological certainty which we see in most political philosophies), and a commitment to ethical consistency and the maintenance of human dignity and equality—pacifism radically transforms political ontology in ways that violence can't (given that existing political ontologies rest on a foundation of violence, as Dustin Howes demonstrates). Moreover, there are numerous examples from history of movements and communities that have revolutionized their politics in exactly these kinds of ways. Pacifism is, therefore, genuinely revolutionary in the way it constitutes new forms of power and subjectivity. Violent political action, whether in pursuit of conservative or revolutionary aims, neverthe-

less functions to reify the underlying form and practice of dominatory sovereign power.

A key issue here is the question of violence, force, and coercion, and the differences, if any, between them. This is also where some forms of pacifism have in the past failed to be revolutionary, but have retreated to a kind of reformism that leaves oppressive orders intact, as Shon Meckfessel has shown. Personally, I would make a distinction between force and violence, where it is possible to force people and institutions to change without physically harming the bodies of other human beings or indeed acting in a way which will lead to their physical harm. By way of example, a pacifist movement could forcefully prevent a police officer from going to work and oppressing people on behalf of the regime without necessarily physically harming them. They could blockade the police station with their bodies, for example. However, if this forceful physical coercion resulted in the police officer losing their income and threatening the survival of their family, then the pacifists must also offer alternative employment or social support. This approach has the potential to achieve a political goal, maintains the dignity and equality of the opponent, offers a new kind of political relationship, works towards transforming a dictatorial system, and so on. It has the potential to constitute a new kind of politics, while avoiding passivity and inaction, and while using collective power and coercion in a radically nonviolent way. The point is that power and coercion can be exercised in nonviolent ways which will, because action is constitutive and prefigurative, create new forms of power, politics, community, and so on.

Of course, this all requires a sense of humility and experimentation, and a willingness to admit mistakes and change course when the circumstances demand it. It requires a continuing commitment to searching for truth, as Gandhi put it. This search for truth—or, we might say, other truths about what is politically possible—is at the heart of my pacifism. I refuse to be constrained by the ideologically motivated consensus about what is possible in politics, what human nature purportedly is, and all the other myths whose aim is to preserve the current order. I believe instead in human agency and imagination.

In conclusion, I'd like to end on this issue of imagination. Why is it so difficult for us to imagine a world without violence? And what can we do to bring about a more peaceful imaginary?

There's no single or simple reason for this lack of imagination, and it is something of a puzzle, given that we have no problem imagining a family life, and a work life, and a social life free of violence. As I said, in daily life, we are all practicing pacifists and cannot imagine going back to a daily reality where men would regularly beat their wives and children, fought duels down on the common, beat up members of rival political parties, watched public hangings or burned animals alive for entertainment after dinner. It is strange that we now think that inter-personal violence and domestic political violence is abhorrent and has no redeeming value at all, but raining down bombs on other peoples' children is somehow acceptable or even heroic. This is a twisted and dissonant kind of imagination we now hold.

I believe a major reason for this problem of imagination is our culture and way of life which saturates our waking lives with the core myths of innate violence and militarism every single moment. Our culture tells us every day in a myriad of different ways that humans are innately violent and aggressive, that force is necessary for security, that there are just wars, that dying in war is heroic, that justice requires violent retribution, that the willingness to use violence is inherent to masculinity, that sometimes (often, in fact) violence is necessary to defeat evil and protect the innocent, that pacifism and nonviolence is idealistic and can encourage aggression, and so on. These messages are endlessly told to us in school, in our histories, in the media, in political speech, in movies and entertainment, in our public statues, in our everyday language and metaphors, in our gender performances, in our religion, in our children's toys and cartoons, in our literature and art, in sport—in practically all areas of social, cultural, and political life. Of course, this is not to say that there aren't pacifist novels, movies, art or examples from history such as Gandhi. But such narratives and knowledge remain subjugated, in Foucault's term; such stories are considered naïve, unscientific, and unrealistic. It is considered child-like to believe that violence is avoidable, and nonviolence can provide security—although, strangely, it is not considered child-like in the context of the family, or domestic social life.

The effect of this saturating discourse of the naturalness and necessity of violence, ultimately, is to constrict our imaginations, limit our ethical horizons, and provide legitimacy for a limited set of policy responses to violence. In a real sense, what is needed is an insurrection of knowledge, again as Foucault puts it, to bring to light all the historical examples of successful nonviolent action, to highlight the strong philosophical case for pacifism, and to expose the hypocrisy of decrying violence in the domestic sphere while promoting it in foreign policy. We need to teach the history of pacifism in schools and universities, and make documentaries about nonviolent movements and tactics until there is an equal number of documentaries about nonviolence as there are about war. We need more artists, filmmakers, novelists, video-game makers, comics, and other kinds of artists to produce work on nonviolence—or at least work that challenges and deconstructs the myths and misconceptions about violence. We need further academic research on all the non-warring societies throughout history, and on the successful forms of unarmed peacekeeping currently going on in places like South Sudan, Colombia, and Sri Lanka. And then we need the media to tell us these stories every day, and to focus on the stupidity and failures of violence.

Following this, we need investment in institutions, technology, and equipment and training for nonviolent action. Robert Holmes makes the point that we cannot really know whether nonviolence could be as successful as violence until we are prepared to invest the same material and intellectual resources into nonviolence as we currently do into the military sector. I am convinced that we don't even need parity to find this out. If we spent even a few billion dollars on nonviolent peace force research, technology, and training, and moved just ten percent of all scientists currently working in the military sector to working on nonviolent technology and systems, we would very quickly see that violence hardly ever works, it produces more harm than good, and that nonviolent alternatives are available which are both more effective and more ethical. The war system and war culture we have built up would then quickly dissolve. Of course, all those who profit directly from war and militarism would resist this, but they could take up employment in the peace-industrial complex.

As a pacifist, I consider it my duty to try and spread this insurrectionary knowledge about pacifism and nonviolence, and hopefully,

expand peoples' imaginations so that such a move away from militarism and violent culture could begin to seriously happen. It is, of course, already happening in numerous communities around the world. There are anarcho-pacifist communities and activist groups, as well as anti-war and anti-militarist groups and activists, all over the world. Many of them have been in existence for, or follow on from, movements that have been around for hundreds of years. A key goal today must be to try and build networks and coalitions to spread this insurrection of pacifist theory and practice.

Index

Thanks to our Patreon Subscribers:

Abdul Alkalimat
Andrew Perry

Who have shown their generosity and comradeship in difficult times.